BLACK GIRLS ROCK!

BLACK
GIRLS
ROCK!

BLACK GIRLS ROCK!

OWNING OUR MAGIC. ROCKING OUR TRUTH.

EDITED BY

BEVERLY BOND

37INK

ATRIA

New York London Toronto Sydney New Delhi

37INK

ATRIA

An Imprint of Simon & Schuster, Inc.
1230 Avenue of the Americas
New York, NY 10020

First 37 INK/Atria Books hardcover edition February 2018

37INK **/ ATRIA** BOOKS and colophon are trademarks of Simon & Schuster, Inc.

For information about special discounts for bulk purchases, please contact Simon
& Schuster Special Sales at 1-866-506-1949 or business@simonandschuster.com.

The Simon & Schuster Speakers Bureau can bring authors to your live event. For
more information or to book an event, contact the Simon & Schuster Speakers
Bureau at 1-866-248-3049 or visit our website at www.simonspeakers.com.

Interior design by Amy Trombat

Manufactured in China

10 9 8 7 6 5 4 3 2 1

Library of Congress Cataloging-in-Publication Data is available.

ISBN 978-1-5011-5792-9
ISBN 978-1-5011-5793-6 (ebook)

In loving memory of my soul sister Marjory Smarth,
who radiated Black Girl Magic and inspired me
to "live true and dance free"

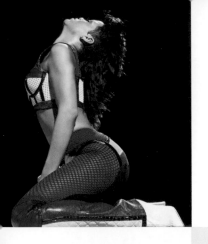

CONTENTS

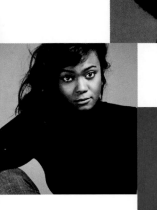
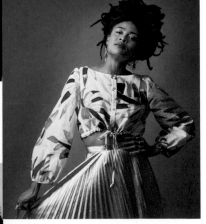

BEVERLY BOND

THERE IS A PALPABLE BLISSFULNESS IN OUR MAGIC. BLACK GIRL MAGIC IS A power and energy rooted in black ancestral traditions, spirituality, and sacred feminine wisdom. It is the fire in our spirit, the life force in our "womb-dom," and the elixir in our holy water. You hear it in the cadence of our speech. You feel it in the weight and woefulness of our blues, but also in the encompassing protection of our love. Our astute discernment and our intuitiveness is also part of the magic. It is a grandmother's conjuring. It is the church lady "catching the spirit." It is an auntie's gift of sight that enables her to accurately foresee a loved one's pregnancy, just because she dreamed of fish. Our magic exists in our leadership, in our ability to make a way out of no way, to stand firm and deliver, and to speak truth to power. It lives in our collective journey and can be attributed, in part, to our shared resistance, our survival, and our remarkable resilience.

My love of black girl magic, beauty, fierceness, and realness was inspired by one of the most beautiful women in my world, my mother. Everything about my mother—from her sense of fashion and style to her luminous smile, her dark-brown skin tone, her perfect rhythm, her impeccable dance skills, her intellect, her worldliness, her love of black culture, and her free-spiritedness—attested to the beauty of black women. To me, she was the definition of black girl magic. She had a particular magic about her, and she was intent on giving it to me. In keeping with a long tradition of black mothers, her special mojo was the ability to make something out of nothing, a gift that has been passed down from black mothers to their daughters for generations.

I witnessed firsthand the incredible fortitude of black women through my mother's example. The heavy history of black people in America has caused black women to have to shoulder more than their share of the burden of keeping their families intact. My mother was no different. Like many single black mothers, she carried the full weight of the responsibility of being the sole provider. The pressure on her was enormous, but she did it anyway and shielded me from her burden.

My mother wasn't a formal educator, but she was, by far, my best teacher. She was a cultural connoisseur, a student of black genius, which she shared with me. She educated me about the richness and diversity of the legacy of black people by harnessing the tremendous cultural and historical currency found in our creativity, resilience, and heroism. Music was her passion. Every Saturday when we cleaned the house together, she would dig in the crates and teach me about all sorts of music, and I loved it. She played everything from Curtis Mayfield to Kurtis Blow. She would play world music artists such as Hugh Masekela, Babatunde Olatunji, and Celia Cruz. She'd play an array of jazz, blues, and soul greats like B. B. King, Nina Simone, Betty Wright, Ruth Brown, Earth, Wind & Fire, Chaka Khan, Booker T. & the MG's, Phoebe Snow, Jimmy Smith, Roy Ayers, James Brown, Donny Hathaway, and so many others. It was this early exposure to and study of our art that set the bar for my musical palate and that would help me to grow into a music enthusiast and curator.

Not only did this Saturday ritual give me an incredible education in the richness of our music but I also gained a deep appreciation for our composition and creativity and an immense love of black ingenuity. I paid attention to the intricacies, the subtleties, and the grandness of our rhythmic expression. I could hear the heartbeat in our drums. I could feel the heal-

ing in our "soul." Our symphony was part philosophy, part spirituality, part jubilation, and part testimony, blended with euphonious and harmonious melodies. I realized that the genius expressed through our song was a pathway to connect us to our higher selves. Our music was prayer. It fed our spirit, it fueled our consciousness, and it grounded our humanity. It was the pulse of the black experience, and it was magnificent.

In addition to developing a deep love for our cultural contributions, my passion for justice and equality for black people was also cultivated by the things my mother taught me. She exposed me to black history that wasn't taught in schools. She always countered and corrected false or limited information about black people's meaning to the world. She taught me that our story didn't begin in slavery. She dispelled the myth that we have a white savior to thank for freeing us. She made sure I understood that black people who were enslaved were not docile and submissive and that their fight for freedom and survival was incessant. She educated me about the abolitionist movements of Harriet Tubman, Nat Turner, and white allies like John Brown. She made sure I didn't belittle the tragic history of slavery and its lasting impact on the black community. Instead, she made me look directly at the unfathomable cruelty of our tormentors and their descendants. She made me aware that we were owed something, and that the debt had never been fulfilled. She explained the multicentury head start our subjugation and disenfranchisement gave to the white beneficiaries of slavery. From my mother's lessons I understood the lingering effects of systemic oppression and institutional racism. She never let me forget that our freedom was not free. People fought, sacrificed, and died for our liberty. She taught me about the Civil Rights Movement and its key players, beyond Martin Luther King Jr. She made sure I also knew about sheroes and heroes such as Mary

McLeod Bethune, Malcolm X, Marian Wright Edelman, Julian Bond, Huey P. Newton, Angela Davis, and Stokely Carmichael.

My mother was intentional about affirming me. She knew from experience that the world was not fair or kind to women, and was even less kind to black women and girls. She was aware of the negative depictions of and disparaging societal messages about black girls that I would be up against, and she did not want those messages to undermine my self-esteem and self-worth. She wanted me to embrace the pluralism of humanity and to see myself as valuable, powerful, and worthy as everyone else. She always emphasized the fact that everyone was uniquely beautiful, but she also taught me that our black girl beauty had more layers, flavors, textures, colors, and hues than anyone's, so that made us much more dynamic. The most valuable lesson she taught me early on was that all human life traced back to black women. We were the first. We are the prototype. We carry the "Eve gene." Therefore, we hold a divine place in the universe. I've always held that truth at my center.

As a single parent with limited resources, my mother didn't have the privilege of leading by her own experiences and examples; however, she always had the conviction to lead by spirit and best intention. She imparted intangible values that transcended our hardship and used the treasures within her reach to empower me. She instilled in me the ability to recognize the beauty and abundance all around me, beyond material things. She fostered and strengthened my intrinsic qualities, like compassion, gratitude, humility, and empathy. She encouraged creativity and excellence. She gave me tools that helped to nurture my spirit and my humanity, tools that helped guide me on the path to uncovering my magic.

In my mother's attempt to find better opportunities, better jobs, better housing, and better schools, we moved often. I moved almost every year of my life, from preschool through ninth grade. Many times I went to two schools in a year. I was always the new girl, which meant that I was usually one of the least-popular students in the grade. To survive, I learned to *lay low* and observe my surroundings. As a result of my nomadic lifestyle, I became extremely shy and introverted, but also self-reliant and more of an independent thinker. I never became a part of a clique or hung with a specific crowd. This helped me develop a sharp sense of perception and a keen awareness of my surroundings. I constantly took note of the similarities and differences between the many places in which I resided. I lived in urban, suburban, and rural areas. I went to private and public schools, predominantly white suburban schools, mixed schools, and majority-black urban schools. These varied environments gave me unusual insight into multiple ways to experience blackness. I didn't realize it then, but I was engaged in a different kind of education. I was learning to recognize social patterns. I studied cultural and social norms and developed the ability to see the things that influenced them. What I noticed most was that regardless of the environment, the messages about black girls were the same. There was an unspoken social hierarchy that existed that placed black girls firmly at the bottom. This social grading of black women and girls is just as prevalent today.

I became hyperaware of the devaluation of black womanhood in our society that pushes our narratives to the margins and overlooks our value. From childhood, we are inundated with messages that exclude diverse representations of black girls. In everything we are exposed to, from the image on the cereal box to the toys we play with and the television shows we watch, we see few positive reflections of ourselves. Our physical features, our intelligence, our contributions, and our history are minimized. This lack of inclusion sug-

gests to society that black womanhood doesn't matter and that our narratives are insignificant. This purposeful omission of our stories undermines our sense of value, beauty, and belonging. While this is at last slowly changing, generations of black women came of age under this conditioning.

When society does not acknowledge your complexity, aesthetic, accomplishments, and historic legacy, it affects your sense of self and the way you frame your identity. It affects the way that people see you and the way that society treats and values you. This slow and constant denigration of identity affects all aspects of our lives and impacts a whole range of decisions that are made about us. The effects range from who is deemed beautiful to who gets disciplined to who gets honored and celebrated to who gets expelled to who gets protected to who gets hired to who gets promoted to who gets loved. It gives others room to treat us poorly.

These subversive messages start as early as elementary school. In our formative years, we begin to develop ideas that are influenced by social norms. Our attitudes develop about what and who we like, and what is good, bad, popular, and pretty. We learn that white is associated with innocence, purity, and goodness. We learn that black is associated with evil, violence, and badness. For girls, dolls are important, and we developed our earliest concept of beauty from the dolls with which we played. Because of our social conditioning, white dolls were preferable. We considered white dolls the prettiest, the smartest, and the most worthy of praise, adoration, and safekeeping. The harm came when we then applied these influences to real life.

When I was in second grade, there were two girls in my school—Leslie with the blond hair and Amy with the brunette hair—who were considered the definition of pretty. Their features were sharp.

Their skin was pale, their hair long and straight. Their noses were narrow, their eyes were blue, and their lips were thin. They were the products of their European ancestry. In my opinion, they were pretty, but not more so than any other pretty girls of any ethnicity. In this mixed elementary school, however, they were it. There was no space for any other girls to be beautiful except for girls who looked like variations of Amy or Leslie. In other words, white girls were pretty, and they were the standard by which everyone else was measured. By nearly everyone's judgment, including that of the black kids, this standard was an accepted fact. It was also accepted as fact that black girls, especially those who were the furthest away from this Eurocentric look, were the least beautiful. This standard of measuring beauty was an indignity with which black girls had to live. Starting as early as preschool and continuing throughout our lives, our beauty has been constantly measured against an impossible metric that sets us up for a lifelong battle. Black girls are taught from childhood that our kinky, coily, nappy, unruly hair needed to be smoothed out, tamed, controlled, managed in order to make it decent and *good*—even if that meant putting harmful chemicals on our scalps. black girls were also told that the darker our complexion, the more unattractive we are.

For black girls, this insinuation that we are not aesthetically appealing damages our confidence and self-esteem—but the message to white girls is equally harmful, because it reinforces a belief that their humanity matters more than that of others, which is a pillar in the foundation of white privilege. As a result of this imbalance, black girls grow up painfully aware of the relationships between race, gender, and privilege.

When I attended majority-white schools, I noticed the glaring difference in the way white kids didn't have

Mary Arthorlee Bond.

to battle the same kinds of social and emotional barriers that impacted their self-esteem merely because of their color. They didn't have to fight to be affirmed. The world automatically affirmed and acknowledged them. The institutions and messages were all aligned to put them first and to make them the standard of all things good. Their confidence and audaciousness came from that affirmation. They knew that they belonged, they knew that they could be great, and they knew that they looked the part.

I experienced this firsthand. When I attended those schools, I was invisible. I simply didn't exist to my white classmates. Students would look through me as if I were a shadow. Even when they made callous, racist remarks, they didn't care whether I was within earshot. Standing on their pillar of privilege, they could choose to ignore the humanity of black students, because it didn't affect their social standing in any way.

The black students who were in those spaces had to constantly negotiate their blackness in relation to their White classmates. It is a burdensome undertaking to go into a space of learning and have to figure out how to *just be* before you even get to your lessons. In these spaces, we had to be conscious at all times of our hair not being too unruly; our vernacular and tone not being too aggressive; our intellect not standing out too much; our reactions not being too emotional; and our manner not being too stylish or distinctive. We always had to tone it down, to hide our culture, our point of view, our politics, and our interest. We learned how to code-switch in these spaces in order to not appear "too black" to our white peers. Unfortunately, some of us had to navigate in this environment by disappearing into the shadows; others chose the "performance of blackness" and played up stereotypes in order to appear to be the cool black friend; and some would ingratiate themselves to their white peers

in gratitude for being accepted as the token black friend. The isolation, combined with neglect of our history and contributions, often thwarted our positive identity development and left many of us without a formula for existing on our own terms.

While all black students struggled to fit in these environments, black girls in these spaces often existed in isolation. black boys could be accepted more easily, because the stereotypes associated with them made them more visible and sought after. Their athletic prowess, or just the idea that black boys were cool, made them more attractive and acceptable. None of the stereotypes associated with black girls were attractive. If black girls wanted to be visible and acceptable in those white spaces, they had to assimilate. Rather than accentuate their blackness, they had to diminish it.

Sadly, the all-black schools I attended were not sanctuaries from the challenges of identity, color, and acceptability. In these schools, the problems were twofold. First, there were clear structural pressures that clouded our ambition and undermined our academic achievement. We had substandard resources and overcrowded facilities. The conditions were tense, and led to environments that were less conducive to learning. Second, in addition to the physical conditions of the schools, some aspects of the lessons being taught were equally damaging. We suffered from the same neglect of real black history that I experienced in white schools. Even in these all-black environments, the lessons reinforced the notions that black history belonged on the margins of real history, that black life didn't matter, and that all things white were important. Even there, black students were left uncertain about the terms of acceptability.

This uncertainty only added to our skewed perceptions of beauty and value. We internalized archaic notions of colorism and deep-seated intraracial prej-

udices that were passed down to us and reinforced in every generation. These internal battles and distorted ideals have plagued black people in America since slavery, and have often undermined our collective identity.

In these mostly black spaces, terms like "redbone," "good hair," "nappy hair," "black and ugly," and "high-yellow" were all part of a regularly used divisive language that kept us in conflict. Although we were all affected by those distorted ideals, here, too, gender mattered. black girls bore the burden, because we were the ones who were constantly being judged based on our aesthetic. Although the boys were also victims of this conditioning, they still sat in judgment of black girls, as if they wore black better. This only added to the fragility of our self-worth. I became even more aware that neither society nor we embraced the full range of our beauty. This was a regular part of a black girl's conditioning growing up.

Strangely, it was in these strained black spaces that I also saw black girl magic most clearly. It was in these spaces where I saw the foundation and emergence of our magic as it took form, grew, and thrived. Our magic materialized even with the burden and the tensions. Our magic was forged in all the pain and complexity.

When black girls could be black girls with black girls, we became a force. Even if there was tension, there was an unspoken language, solidarity, and camaraderie among us that centered on our cultural connections and black girl traditions. We were among ourselves, and our magic was free and unconstrained. It was not toned down, and it didn't need to be masked. It shined through the games we played, the dances we made up, the hairstyles we created, and the truth and realness we conveyed. black girls bonded in our creativity, our ingenuity, and our self-expression. Our bonds reflected our genuine connectedness. We curated our own happiness through communal activities that fortified our sisterhood. We tended to each other. We learned to cornrow, box braid, finger wave, and twist each other's hair, and made our hairstyles expressions of our beauty and our skills. We were gifted, resourceful, and imaginative. We took our inheritance of *making something out of nothing* and escalated it to new heights, as had the generations before us. We took two clotheslines and made Double Dutch a community rite of passage and an international performance sport. black girl cheers weren't the simplistic, flat "go team" cheers that I had experienced in other schools. black cheerleaders' steps, dance routines, chants, and attitude were a mesmerizing and zestful representation of our fierceness. In these all-black environments, I could see more clearly what black girl magic looked like when it was nurtured by our tribe. Here, we were in formation. I understood this tapestry. I belonged to it. I could see in my sisters what I saw in my mother, what I saw in my village of caretakers, what I saw in our sheroes, and what I saw in myself. There was just something beautiful and boss about the essence of black girls. When our humanity had been ignored and devalued, we tapped into a deeper source: our divine feminine power and the ancestral wisdom that embodied our meaning. Born out of pressure, our magic was fresher and more robust. We rocked not just in spite of it but also because of it.

It was this personal journey of observation, resistance, and affirmation that led me to BLACK GIRLS ROCK! The essence of BLACK GIRLS ROCK! was born from the black girl magic that was passed down to me by my mother from her mother and her mother's mother and a long line of black mothers. Because of what I was taught, combined with what I experienced and witnessed, I was able to more easily cast off the deceptive and restraining depictions of how the world

defined us. I was able to design a narrative that affirmed my existence and substantiated what black girl beauty, genius, and magic looked like. The efforts of my mother and the rituals and lessons of black women liberated me, enlightened my spirit, and ensured that my potion was not diluted, that my magic remained potent. Black girl magic was so deeply ingrained in me at such an early age that any negative narratives about black girls never stuck for me. I didn't believe the lies. I couldn't even ingest them. The strength of my identity, the depth of my lessons, and the armament of my spirit allowed me to recalibrate the measures of my humanity, womanhood, blackness, and beauty, to re-center my balance of power.

This abundance of black girl juju that was instilled in me is what guided me to walk in my purpose and ROCK my truth. It is what gave me, an extremely introverted, hesitant leader, the fortitude, vision, and determination to manifest a space for black women to shine for all the world to see.

My initial idea for BLACK GIRLS ROCK! was to create a T-shirt displaying all the black girls who've rocked in the world. As I wrote out the names of this vast array of black girl excellence—Harriet Tubman, Ida B. Wells, Marian Wright Edelman, Dorothy Irene Height, Oprah Winfrey, Angela Davis, Beyoncé, Queen Latifah, Lauryn Hill, Nina Simone, Diana Ross, Toni Morrison, and more—I realized that this idea was much bigger than a T-shirt. In that moment, looking at all those names and reflecting on their stories, I felt their spirits were speaking directly to me. I had an epiphany. I thought "This is bigger than me. No one has ever told us as a group that we are special, so we need to tell ourselves."

I have curated this book to serve as a visual and editorial companion to the multifaceted BLACK GIRLS ROCK! movement. It speaks to women who are eager to see themselves represented holistically, women who are invested in the empowerment of other women and girls, women who are seeking their divine purpose and who are driven to reach their personal standard of excellence.

The book includes colorful editorials and insightful essays featuring some of the most dynamic thought leaders and influencers of our time. Throughout each chapter, the book highlights the breadth of black women's contributions to society and celebrates the diversity, power, fortitude, spirituality, and tenacity illuminated in the contributors' inspiring narratives. The women in this book represent the tip of the iceberg in terms of the quantity and quality of influencers, power players, and change-makers doing important work today. No one book could contain them all.

Black women have always been nurturing, guiding, and leading. We have added flavor and texture to living. We have opened doors for marginalized people. Many of the privileges that others enjoy rest on the heroism, the bravery, and the suffering of black women who offered the world an unprecedented example of triumph, sacrifice, leadership, strength, bravery, wisdom, and spirituality. We have contributed greatly to the advancement of women and to the advancement of our communities, yet have flown under the radar of mainstream media and history. I created BLACK GIRLS ROCK!, a mentoring organization, because I realized that the condition of black girls could change only when we were the authors of our own stories. I created BLACK GIRLS ROCK! because the black girl image needed a remix. The phrase is not just ornamental, something with which we can cloak ourselves in vanity. It's a critical affirmation. Much like "Say it loud!" and "Black Is Beautiful" were iconic creeds of the 1960s and '70s and the post–Civil Rights era, BLACK GIRLS ROCK! has become the black-girl-power mantra for the twenty-first-century black woman.

Radical, disruptive, beautiful, and provocative, BLACK GIRLS ROCK! has grown into a holistic movement that reflects the current climate of social and political revolution, in which the intersection of gender and race equality lies at the forefront. This movement is in the vanguard of a cultural paradigm shift in which black women are affecting world culture in ways never before imagined.

This book, BLACK GIRLS ROCK!, is a convening, a summoning, a rallying cry to ignite in us what has been suppressed, dismissed, or forgotten. It is a reminder to ourselves of who we are. It is a reminder to the world of the spectrum of brilliance that black women possess.

This book is here to help every black girl struggling to see her brilliance to dispel the fog. It is designed to help lift the many black women who are bogged down with societal pressures and who feel the burden of carrying more than their share of the weight. This book exists also for the black girl who already knows her magic to inspire her to continue to walk in her purpose. It is for every black girl—and every other girl—looking to see her treasure within.

The women in this book give the world insight into the brilliance, beauty, power, magnificence, and splendor of black women. They are examples from all corners of the Black Diaspora; they are truth tellers, truth seekers, master teachers, healers, movers and shakers, visionaries, warriors, creators, innovators, freedom fighters, survivors, philosophers, prophetesses, oracles, and champions. They are our sheroes. They represent our mastery and our champion spirits. They showcase the beautiful complexity, depth of diversity, rich cultural traditions, and bountiful contributions of black women. They remind us of our collective magic. They are the example and the reminder that we are now and forever a force in this world, and we absolutely ROCK!

INTRODUCTION

MICHELLE OBAMA

FORMER FIRST LADY OF THE UNITED STATES OF AMERICA

EXCERPT FROM 2015 BLACK GIRLS ROCK! AWARDS SPEECH

I AM SO EXCITED TO BE HERE AT BLACK GIRLS ROCK! TO ALL THE YOUNG women here tonight and all across the country, let me say those words again—Black girls rock! We rock! We Rock! No matter who you are, no matter where you come from, you are beautiful. You are powerful. You are brilliant. You are funny. Let me tell you, I am so proud of you. My husband, your president, is so proud of you. And we have such big hopes and dreams for every single one of you.

Now, I know that's not always the message that you get from the world. I know there are voices that tell you that you're not good enough, that you have to look a certain way, act a certain way; that if you speak up, you're too loud; if you step up to lead, you're being bossy.

You see, when I was a girl, I had parents who loved me and believed in me, but those doubts still worked their way inside my head and my heart. And I was always worried about something: Does my hair look right? Am I too tall? Do I raise my hand too much in class? So when folks said that a girl like me shouldn't aspire to go to the very best colleges in this country, I thought, *Maybe they're right*. But eventually, I learned that each of those doubts was like a little test—a challenge that I could either shrink away from or rise up to meet.

And I decided to rise. Yes, I decided to rewrite those tired old scripts that define too many of us. I decided that I wasn't bossy, I was confident and strong. I wasn't loud, I was a young woman with something important to say. And when I looked into the mirror, I saw a tall and smart and beautiful black girl. And that, more than anything else, is what I want all of you to know. I want that for you. I want you to live life on your terms, according to your own script. I want you to use those tests in your lives today to make you stronger for the bigger challenges tomorrow. Because, trust me, those challenges will come. No one just glides their way from success to success: not me, not President Obama, not anyone being honored here tonight. Anyone who has achieved anything in life knows that challenges and failures are necessary components of success. They know that when things get hard, that's not always a sign that you're doing something wrong—it's often a sign that you're doing something right. Because those hard times are what shape you into the person you're meant to be.

So one message that I want to leave you with tonight is this: the secret to everything in life—every aspiration, every opportunity—is education. It's education. There is nothing more important than being serious about your education.

That's the reason I am able to stand here tonight—because, look, I worked hard in school. Education was cool for me. I did my best on every test, every paper, every homework assignment.

And I want every single one of our black girls to do the same—and our black boys. I want them to do that all the way through high school, then college, and then beyond. I want you to work as hard as you can, learn as much as you can.

That is how you'll go from being black girls who rock to being black women who rock. That is how you will unleash the genius and the power and the passion required to rock your communities, to rock our country, to rock this world., I love you all. I believe in you all. And I am confident that you all will shine brightly, lighting the way for generations of girls to come.

Thank you all. God bless. ⚡

I.

FEMME NOIRE

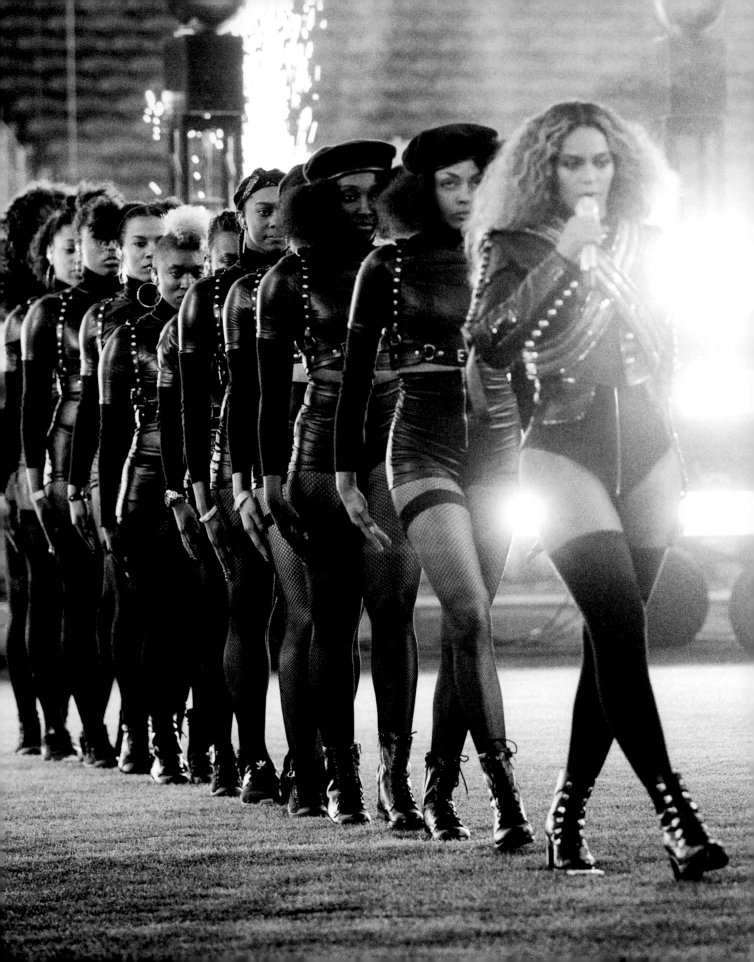

BEYONCÉ

FORMATION

Award-winning international pop icon, singer, songwriter, actress, feminist, and philanthropist

"If you had told me eighteen years ago, when I first started my career as a black feminist writer, that we would have a moment when a black international pop star phenom would publicly—not privately—claim herself a feminist, write about it, publish it in the Shriver Report, *and have feminist signage behind her on a world-tour stage, I would not have believed it. When I say I couldn't have imagined Beyoncé, the feminist pop icon who is captivating the world with her Black Girl Magic, I mean I truly couldn't have fathomed her existence. Every time she opens her mouth, I want to cry. She is my feminist dream, literally the thing I would have gone to sleep and dreamed I could see one day. And now we're in a moment when it absolutely has happened. Feminism has a pop-cultural platform."*

—JOAN MORGAN, black feminist writer

JOAN MORGAN

HIP-HOP FEMINISM: THE REMIX

Feminist writer and author

MY PROCESS IN BECOMING A FEMINIST IS VERY DIFFERENT FROM THAT FOR this generation of young girls, who are emphatically declaring that they are feminists at sixteen or who eagerly decide that they're feminists during their first women's studies course, when they're eighteen. Part of this is because they've grown up with a new wave of feminism that's being illuminated visually on social and digital media platforms. This allows them to feel like it is okay to have a feminist lens and license. I didn't have that growing up. There was nothing in my South Bronx, working-class world that made feminism even a part of the conversation. I wasn't really exposed to it until college. I went to an elite university, and there they produced some renowned feminist scholars, Judith Butler being one of them. But feminism still didn't speak to me when I was there. I found feminism to be really white and drab. Later, in my courses, I was introduced to black feminist writers and authors such as Hazel Carby, an incredible black feminist thought leader. Much of black feminist scholarship owes a huge debt to her. She was one of my professors, and I adored her, but I still couldn't digest or embrace feminism as an ideology. Not until I *had* to.

As a young writer, without even having the proper feminist language, I knew I was really committed to writing for black women—young black women in particular. When I started writing about hip-hop feminism, I didn't know that I was "bringing a gender analysis to my music criticism." I didn't have that language. I just had a lot of passion, a lot of fire, a big mouth, and a platform. Very quickly, because I had those things, I was *labeled*

feminist, and I actually had to decide whether I was going to embrace that label. But, really, I became feminist because I was a writer. My first published article was for the *Village Voice*, and it made the front page. I mean, it was the first article that I had written, *period*. I fell into the assignment because I had gotten into an argument with my boyfriend, a very established black cultural critic and staff writer for the *Village Voice*. He was writing an article on the infamous Central Park jogger case called "Blacks' and Women's Voices Not Heard." New York City was incredibly racially polarized over this case at the time. I would never say New York City is completely without racism, but it's generally not the predominant thing we experience when we walk through the streets. The *Village Voice* was doing a special feature on the case, and my boyfriend's focus was on race and media coverage. I thought this was a good angle, but there was no gender analysis in his piece. "Look," I told him. "The point is that rape is a crime against women, regardless of race. It's a crime of power. If it had been a black female investment banker jogging through the park, her blackness wouldn't have prevented her from being targeted by a rapist. You are talking about the racialization of the media's coverage without recognizing that gender is at the center of this." After our argument, he went back and told his editor my perspective. She thought it was a great idea, but it was no longer *his* original angle. So, she told him if I could write it and submit it in under thirty-six hours, she would run it. And that's what happened.

I didn't even own a computer then, so I had to go to the *Voice* to use theirs, after all the "real writers" had left. I started at nine or ten o'clock and stayed until about three o'clock in the morning. I didn't know anything about writing a think piece or a profile. I didn't have any experience or training. I just wrote it. And then it was published in the *Village Voice* and the byline read, "Joan Morgan, Black Feminist Writer."

What? I had to quickly figure out if I wanted to wear that title. And I did. I accepted the label, justified it to myself, and haven't looked back.

Part of the reason it's not difficult for me to claim feminism is because I don't get caught up in the politics of words like that. There has always been an overindulgence in semantics, but that's not where I'm rooted. I had to spend a lot of time answering to people who asked why I wasn't an *Africana*-centric feminist or a womanist. I don't really care about any of that. I don't care what you call yourself; the real question is: are we doing the work?

Today, our daughters are armed with language, theory, and actionable practices that I could not have imagined for myself at sixteen, seventeen, or eighteen years old. Part of that is because they've had the advantage of growing up and seeing a feminism that works for them. I think we are experiencing a new wave of feminism being led by black women's voices. This is the next wave of feminism. In many ways, feminism has been mistakenly and inappropriately hijacked in the cultural imagination. It has been co-opted as this "thing" that belonged to white women in the seventies, but we know that feminism is more expansive than that. I decided long ago that white women don't get to claim feminism as their own and that we, black women, don't get to exempt ourselves from feminism just because we misunderstand it as something that "belongs" to white women. We have to eradicate this fictional image of a white bra-burning feminist and reclaim our history.

When I think about African American and Caribbean history, when I think about Ida B. Wells, Sojourner Truth, Anna Julia Cooper, and others—they are our history makers and they were all feminist as fuck! ⚡

REBECCA WALKER

THE THIRD WAVE

Feminist, writer, and *New York Times* bestselling author

THE WORD *FEMINIST* IS HAUNTED AND TINGED WITH A RACIST HISTORY that is unavoidable. It alienated a lot of women early on, especially women of color. It created barriers, and had such a negative connotation, which is why my mother put forward the idea of *womanism* as a different form of feminism. She wrote, "Womanist is to feminist as purple is to lavender." This idea was, in part, a response to the fact that *feminism* didn't fully capture the voices, perspectives, or issues of black women. She was saying that black feminism was deeper in color, richer in meaning, and broader in its impact and inclusivity. For this reason, *womanism* felt much more comfortable to me in so many ways, but unfortunately it was erased by white feminists because that form of feminism had been shaped in a way that didn't really demand that people become anti-injustice.

Today, being a feminist has become so popular, practically a trend. *Feminism* has become a buzzword in pop culture, and it's become commercialized: packaged and sold on paraphernalia as a brand. Somebody is making money from this current craze, and I hope it's women. But I'm just not sure that this type of "feminism" is going to solve the problems of the women whom we claim to care about. Although it's hip to be a feminist now, we have to ask: what does that really mean? When you tell me you're a feminist, are you my ally just because you say that? How far are you really willing to go? Are you going to show up in those communities that need to make sure their children are not deported? We have to be careful about the commodification and the trendiness of the feminist movement so it doesn't become just a cool thing that is empty of any real subversive meaning.

At different stages of my life, I've shifted the lens through which I view women, feminism, and the issues that matter to us. My early work with third-wave feminism looked at young women's lives through an intersectional lens. That meant making sure we examined everything from environmental issues and how they impacted women, girls, and families; to discrimination based on sexual orientation; to racism and different socioeconomic opportunities available to women. I think that this work is still relevant today.

Now, as a mother, I am deeply connected to these issues and more cognizant of the kind of support we need as women in every phase of our lives. As a mom, I'm more aware of and concerned about things such as affordable high-quality child care, health care, and access to healthy food. I am also deeply concerned about things such as having a brown son and how empowered the police force is to harm black bodies without consequence. I am concerned about what the future militarization of our country will look like and how drafts are going to impact black and brown children.

What I'm saying is that women's issues are not this special stand-alone list of "women things." All the issues in the world that affect women's lives are in fact feminist issues. Everything that is happening in terms of the degradation of our culture, our communities, and our planet has an effect on women because they impact our health, the integrity of our bodies, the psyche of our families, and the overall welfare of the world in which we live.

When I founded the Third Wave Fund, what I was trying to do was make sure that the women's movement did not just stop with the female body or with a specific set of concerns that were not defined by all of us. I wanted the feminist movement to be more inclusive, multi-issued, multiracial, and multicultural. I needed those who called themselves feminists to believe in the equality of black and white people. I needed them to believe that the justice system is flawed and that climate change is real. I wanted the organization to be not only about equal pay, equal rights, and abortion rights, but also intersectional, and to include racism, homophobia, and environmental justice.

It was also important for those of us in the third-wave feminist movement to define ourselves not in opposition to second-wave feminism, but to suggest continuity. That was the whole point of calling ourselves the "third wave." We wanted to allow the individuation of our generation, so there wasn't an assumption of sameness, but also to acknowledge our connection to the previous generation and the benefits of their work.

Today, when I look at what's happening with feminism, I find it compelling. It was so interesting for me to watch the Women's March on Washington in January of 2017. I felt very encouraged looking at all those faces and listening to some of the speeches, but I also noticed that the speakers often spoke to only their own demographic. I wanted every white woman to get up and say, "Keep your hands off my body and stop harassing black men, and stop dumping toxic chemicals in poor neighborhoods!" I wanted them to speak to all these issues, and I was disappointed that they didn't.

When I show my son clips from the Women's March, and he sees that it is all about girl power, how girls should be safe and girls should have equal rights, he is supportive of those things. However, he cannot help thinking about the impact of his race on his rights and his power. He cannot help thinking, "If a policeman pulls over a white girl, is that the same as a policeman pulling me over, a black boy?" or, "Are white women as concerned about my black life mattering as I am about their equal rights?" I am raising

my son to be an ally for women's issues, but I am also hoping to help shape a future for feminism that is more accountable to our allies—a feminism that is more pluralistic, intersectional, and reciprocal in its justice seeking.

So, I believe the language really needs to be sharpened and evolved. It doesn't need to veer into some kind of humanism that doesn't include and doesn't celebrate girls. But it needs to become something that honors the struggle of all of us. I think that's the key of Latina feminism and of black feminism—we don't ever see ourselves as separate from our families. Independence is not the goal. When you look at the great writers and scholars of multicultural movements throughout history, the goal has always been about how we can help keep our families intact and how we can heal collectively.

As a feminist, all my work has been focused on healing this sort of "wounded feminine" in some way, whether it's by creating a sense of wholeness in oneself, nurturing oneself back to stability after suffering trauma, or being able to really advocate for oneself in the many situations in which we find ourselves. I think my work has been focused on empowering women from the beginning, so whether it's through activism or writing or teaching or making television programs or creating films, I think that I'm always going to be trying to repair the world to the best of my ability. I'm always going to strive to heal others through the voice of this body, which is a woman's voice. That is my magic. ⚡

I am also hoping to help shape a future for feminism that is more accountable to our allies—a feminism that is more pluralistic, intersectional, and reciprocal in its justice seeking.

MELISSA HARRIS-PERRY

NERDLAND

Writer, professor, and political commentator

BEING ON AIR AT MSNBC FOR FOUR YEARS WAS SUCH AN ENORMOUS PRIVILEGE, especially when I think about the fact that those years were during the Obama administration. My team of writers and producers was made up of predominantly young women of color in their twenties and thirties. They came in with a very strong womanist and feminist worldview. They were living and breathing it; they were reading about it on their social media and in their academic worlds, listening to it in their music and creating it in their art. They were engaged and they pushed me to be edgier, more intense, and more critical. Our unique lens as women gave us the ability to cover sociopolitical topics that other shows didn't tackle. We focused on issues that mattered to us as women and as people of color, issues ranging from police brutality, to Black Lives Matter, to voting rights and the Obama administration.

Melissa Harris-Perry debuted during the last part of President Barack Obama's first term and ran through most of his second term. To be a black woman with a platform like that during the first black president's term was humbling. It was just extraordinary to have

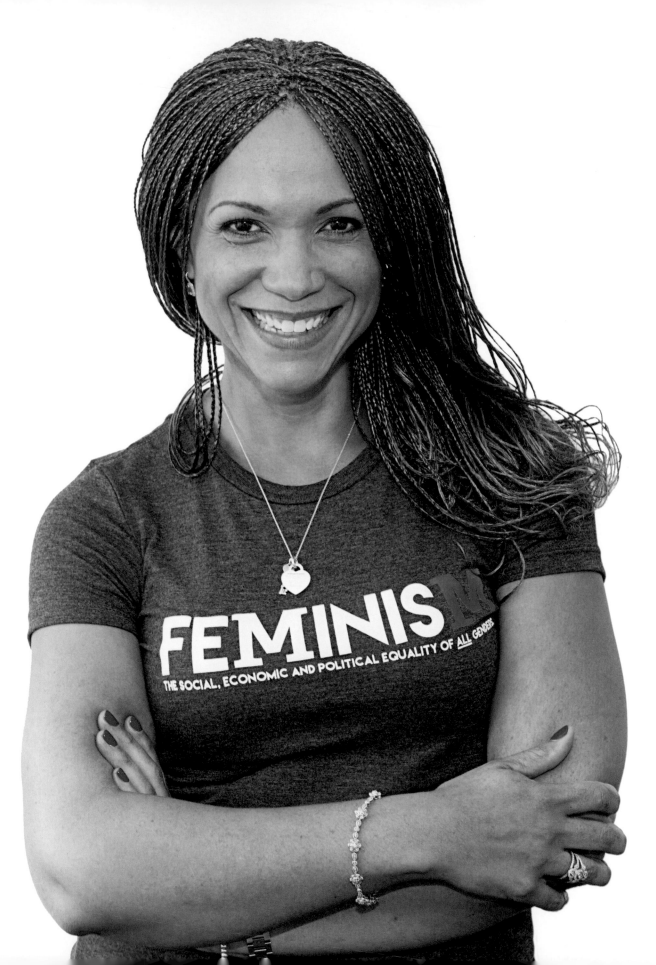

had an opportunity to report on this historic moment in time—to analyze it, to criticize it, and to cheerlead for it.

The Obama era and its relationship to blackness in this country was much like the experience of being black at a historically black college and university. When you are black at a white college, you are aware of it 100 percent of the time. On white campuses, black students have to represent a more singular monolithic notion of blackness because they are constantly pushing against the administration, the teachers, and other students to make "the black voice" be heard. However, at an HBCU, most everybody is black, so you don't have to fight against systemic oppression, racism, or microaggressions in the same way. You can just be black in five, six, or ten different ways. So, having a black president and First Lady generally gave black people the autonomy to be more pluralistic and to shine in a multitude of ways.

The First Lady and the First Daughters' unique position in the world also offered a narrative regarding the beauty, intelligence, and complexity of black women and girls, and it created an unprecedented interest in our experiences. Now there are all these empowering messages about black girls that are freeing us up to analyze deeply what it means to be black women in all our richness. In certain ways, it was liberating.

Today, as black women, we can actively make declarations where we define ourselves boldly and broadly. It is great that we feel so powerful and comfortable in our own skins, and yet there is still a critical need for us to pay more attention to the ongoing victimization of black women and girls. Have we fully fathomed or addressed how vulnerable black women still are due to the violence we face in our society personally and structurally—violence ranging from domestic violence to sexual assault to state-sanctioned violence to school-based violence?

The dangers, traumas, and pains we experience deserve attention, resolution, and healing. It seems as though our society either does not quite understand how prevalent our victimization is or does not care. I've used my platforms to tackle some of the most egregious stereotypes and misconceptions about black women. I've dissected issues and ideas regarding our place in American society, and I've highlighted our voices in mainstream spaces that haven't always included our stories. I want the world to celebrate our black girl magic, but the world must also recognize our black girl vulnerability. So, I use my voice as a writer, scholar, and public figure to highlight both these polarities. I'm the person who says what needs to be said. Even if you don't agree with me, I'll make you think. ➤

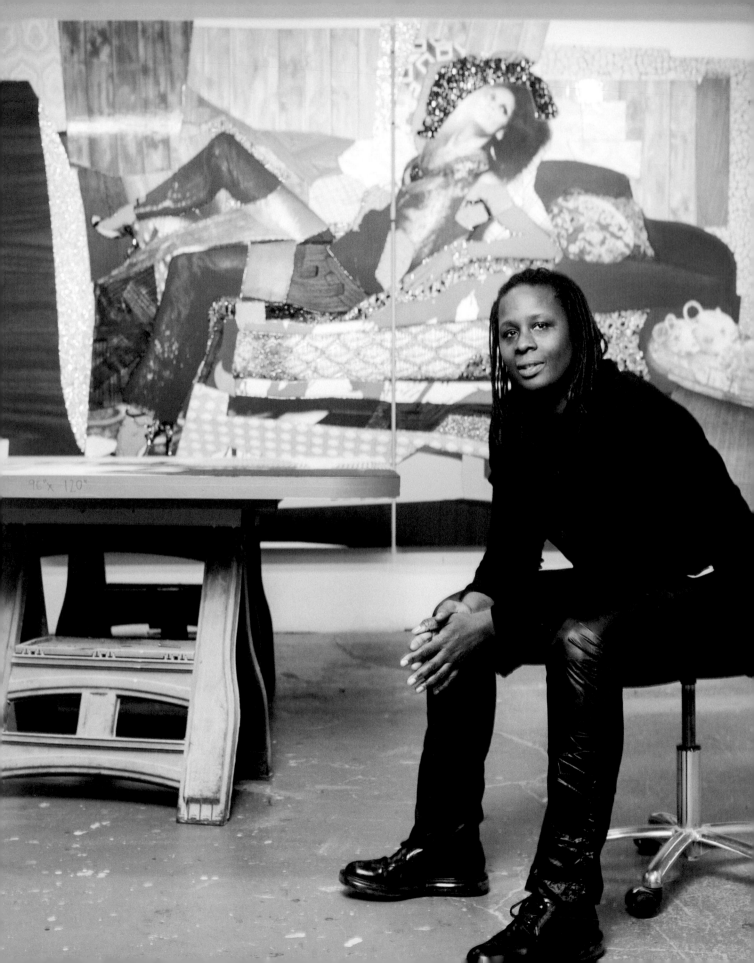

MICKALENE THOMAS

ART IMITATES LIFE

Multimedia visual artist

WHEN I WAS A STUDENT IN THE NINETIES, I SAW CARRIE MAE WEEMS'S *Kitchen Table Series* at the Portland Art Museum in Oregon and decided to shift from prelaw to fine arts. At that time in my life, Weems's work, which called upon a familiarity of family, love, gender dynamics, and sexuality, resonated with me. It ignited a willingness to create, and a new awareness of how important it is to use your own experiences to make art.

My pieces integrate performance art, painting, photography, and collages, but my process often starts with photography. Photography helps me capture and conceptualize my ideas and develop the compositions and formal aspects of my paintings. Some of the photographs are incorporated into collage, the foundation for my paintings that allows me to add greater complexity to a composition. I play with rhinestones, enamel, oil and acrylic paints, silkscreen, and other, secret techniques in my painting. Experimenting with different techniques and different genres of painting such as pointillism and aboriginal art helped me grow my signature style.

I developed my identity as a queer black woman with the help of Audre Lorde's writing. Her work became a point of reference for my work when I was a graduate student at Yale University and fortified my foundation and self-awareness. Since then, I've become more comfortable with affirming myself as a queer, black, female artist. I am unapologetic, abstract, Afrofuturistic, in-your-face, conceptual, mystical, shape-shifting, fiercely generous, and unstoppable. Most important, I love what I do and I have fun doing it.

History, whether it is art history, political history, or cultural history, allows you to gain an understanding of the language that has developed and where you might contribute to the discussion. I could choose to enter into the discussion at any historical point, but art from the late nineteenth century and the early twentieth century is of particular interest to me. I see it as the root of the formal discussions in art today. Around this time female models start to assert their own identity and presence through the gaze, and, at least in the contemporary discourse, the sitters for the classic genre nude cease to be anonymous props and begin to insist on their individuality with their gaze.

I draw inspiration from images canonized in turn-of-the-century art. Part of my drive comes from a desire to claim these celebrated images of beauty and reinterpret them in my own way. I insert the figures of black women, who have been marginalized throughout the history of Western art, onto the canvas. By selecting women of color, I hope that I am literally raising their visibility and inserting their presence into a broader conversation, one that breaks down the barriers of stereotypes put upon the black female body.

Because I began my work with a focus on representing subjects who are largely absent in the traditional art canon, namely African American women, I have a kinship with the pivotal figurative painters whose work I often use as a reference for my paintings. I feel it is imperative to interact with these painters. As my work has developed, I've continued returning to the past as a way to determine what's missing, and I've added to this conversation by painting the figures whom I find most interesting. By participating in the conversation with artists such as Matisse, Manet, Romare Bearden, Balthus, Courbet, or even Warhol and Duchamp, I create the context in which I want my work to be seen rather than having my work be considered a commentary piece or a departure from something else.

AUDRE LORDE

SISTER OUTSIDER

Audre Lorde was an enigmatic and prolific poetess who passionately defended feminist, lesbian, and civil rights through emotional prose. Unafraid of expressing fear, anger, racial and sexual oppression, love, and urban neglect, she epitomized hope for a better humanity.

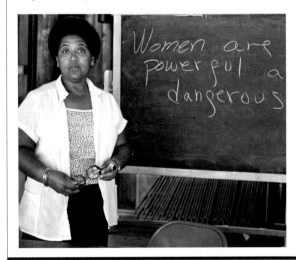

II.

BLACK
GIRL
MAGIC

RIHANNA

ON ANOTHER LEVEL

Singer, songwriter, actress, entrepreneur, and philanthropist

I BELIEVE THAT GOD PUTS US ALL HERE FOR A REASON. WE ALL HAVE PURPOSE and are all here to fulfill that purpose individually. We tend to forget this because the world is so big and it can be so confusing at times, or we can easily become tainted by society. As someone who is in the public eye and who is constantly scrutinized, the thing that keeps me sane, the thing that keeps me humble, keeps me going, and keeps me successful, is that I stay true to myself. I only know how to do that. The minute that you start learning to love yourself, something begins to happen inside. You begin the process of becoming confident and free. Although people don't always refer to me as a role model, I believe that my journey as a liberated, carefree black woman can inspire a lot of other young women to find the courage to be their authentic selves, and that is half the battle! I am so grateful that BLACK GIRLS ROCK! celebrates us in a world that doesn't acknowledge us enough. All girls rock. Black girls—we are just on another level! ⚡

—Adapted from her 2016 BLACK GIRLS ROCK! Awards speech

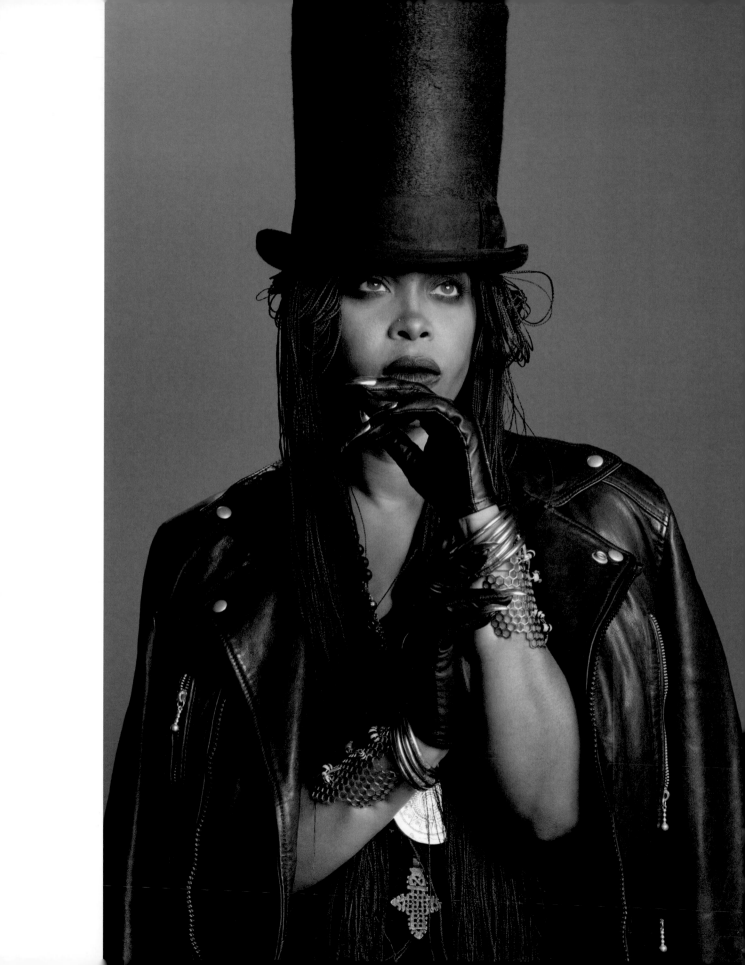

ERYKAH BADU

I STAY WOKE

Singer, songwriter, award-winning producer, DJ, and doula

"BADUISM" IS MY BLACK GIRL MAGIC. IT'S EVERYTHING I'VE LEARNED over time that has motivated and inspired me. The urban legends about Erykah Badu are hilarious. And that's what they are: urban legends. They say that I can make a man change gods. They say when you get with me, you have to choose between wearing crocheted pants or carrying a man purse. They say that I have a box that can change people like alchemy. In fact, they say that I have a super box. They say that if I get with a rapper, either he's going to become the best rapper of all time or he's going to lose his abilities as a result of being caught up in my evil web. I get blamed for both things. People always ask me, "What are you doing to these guys to make them . . ." What? Grow? Change? Evolve? Here's my secret. Y'all ready? I listen to them.

Perhaps they are drawn to my energy because they see themselves in me—just a spiritual reflection of another human being who wants to grow. Conceivably, we are electromagnetically drawn to the experiences we need most to get us to the core lessons that ultimately help us to evolve. It just depends on what a person's growth requires at that particular time. Sometimes it's easy; sometimes it's not. There is a balance within us all. I'm feminine but I'm also very masculine—and I honor both those parts: you know, the left brain (analytical, technical, and social) and also the right brain (artistic, creative, and emotional). They're two bodies that connect together. We cannot have one without the other, and I think maybe when one acknowledges those two things, you get the ultimate expression of being a human *here*—a person here.

Balance is key in helping me reach my highest self in all my endeavors, being a mother, a doula, a writer, a performing artist, a reiki healer, or a master teacher. The term *master teacher* comes from the old Negro churches. That's what they called the pastor of the church. It ain't just "anybody." A master teacher is simply someone who speaks a "word" from a place of truth. A master teacher is someone who is awake and has the ability to see things from an observation deck and to tell it like it is—a Queen Afua, a Louis Farrakhan, a Dr. Jewel Pookrum, a Mahatma Gandhi, a Dr. Sebi, a Caroline Myss. *Master teacher* was also a term that was yelled out in church when the pastor had said something that touched someone, that they found relatable. So, more than a title, it's an affirmation or a co-sign.

When I say "master teacher," it encompasses my understanding of what's right. It's my understanding of how the spiritual body and the physical body meet, and of how we can use our wisdom, knowledge, and experiences to inspire, heal, and guide others to find their purpose and the path to their highest selves. My song "Master Teacher" has this call-and-response where I say, "What if there was no niggas, only master teachers?" and the affirmation is "I stay woke!" The song poses a very important metaphysical question: what if we all were attuned to ourselves, to each other, to nature, and to our divine path? I stay woke.

The song itself was born out of a need to "witness" to one another about the feeling of "easiness" that true awareness and divine understanding of self and surroundings, or "wokeness," brings to our existence here on this school called Earth. When it comes to this particular song, I walked into a "church" that was already in session. Georgia Anne Muldrow, Sa-Ra, and Bilal, my comrades and fellow "Wokeians," were already chanting "I stay woke." Georgia had hypnotically freestyled her lyrics to this song. Though they were personal to her experience, they related to us all. I was so moved by this that I just had to testify and bring that "Baduism" perspective to the altar. None of us could have known what an impact these three words would have on the shaping of a historical revolutionary movement. I just knew, intuitively, that the world needed the three words "I stay woke."

Being woke, aware, and connected is a part of my spiritual journey. I don't know where it comes from. It's just how they made me, whoever *they* are. It's my truth. I think it's always been a part of my consciousness. I remember looking in the mirror when I was four or five years old—around the time when you discover that you're really conscious, that you're here—and then again at around twelve or thirteen, and seeing myself aged and alive, but it was the same conscious being looking out at me. It was the same awareness. That awareness never aged; the body and circumstances around me did. With that awareness, there has been this desire to evolve or to eliminate the things that do not support the evolution of the person I'm looking at in the mirror. And I've carried that desire and that intention with me for as long as I've been conscious.

The concept behind my "Window Seat" video was to honor consciousness, examine growth, and strip away the effect of groupthink on our society. Groupthink is a psychological phenomenon that occurs when groups of people conform to a collective opinion because they feel safer in numbers, even though this often results in harmful and irrational decision-making. A great example of groupthink is the Jesus and Barabbas story. When Pilate presented Jesus and Barabbas to a crowd of spectators, he asked them, "Whom amongst these two should be crucified and whom should be freed?" The crowd chose to free Barabbas, the career criminal, and to crucify Jesus, the Messiah, teacher, and healer. This was not

because Jesus was guilty of anything. The crowd was simply in a state of groupthink created by the Pharisees' propaganda against Jesus. They wanted to be aligned with those in power, instead of with truth and justice. They were afraid to think for themselves.

The same kind of groupthink occurs on social media today. People jump on hot topics using hashtags about issues that they weren't even passionate about two days prior and that they certainly aren't well versed in. They jump on the bandwagon just to get more "likes," followers, and retweets, or to appear "on trend" or part of the in-crowd. I saw early on the implicit danger of digital media platforms becoming spaces where public opinion was being shaped and formed by groupthink.

For the "Window Seat" video, I was totally inspired by an indie group called Matt and Kim, who, a year earlier, dropped a video of them walking through Times Square and removing articles of clothing in broad daylight. It was a contagious act of freedom. I wanted to be a part of this movement. I began talking to Matt and Kim about how I wanted to take their idea to a sociopolitical platform in the form of performance art. I wanted to create a story line that challenged the notion of groupthink and its effects on society. I wanted to show myself shedding ideologies that were no longer necessary or useful. So in a courageous act of freedom and personal evolution, I removed my clothing in the video to symbolize the shedding of the things that no longer served me. Each article of clothing I removed represented something I needed to free myself from. So, as I took each step, I shed something that I had learned but no longer needed.

Something about religion or something about education, and the sweater came off; something about nutrition, and the pants came off; something about relationships that I didn't need or parenting

that I didn't need but I followed just because a group said it was the right thing to do, and my bra came off. I did this until I was stripped naked.

I was able to do the shot only once, because it was filmed outside, in the middle of downtown Dallas. I was petrified! It really was a scary thing to do. Who wants to do that? Who wants to be naked in public? Not many of us think our body is perfect. I also knew that it would be criticized or *anti*-cized or misunderstood, but I still felt it was important, that something would be learned from it.

I wanted to make sure that my nudity wouldn't be seen as a random act of rebellion just for the sake of rebelling or an act of nonconformity just to be different. I wanted to make sure that I was clear and dedicated— that I was married to those things that I shed so that I could truly divorce them. And after I shed them, when I got to the very end of the video, I was assassinated, because that's what happens when you don't agree with the group and when you shed the ideas of the group. They assassinate you in some way, especially if your resistance can infringe upon the group's finances or the group's perceived well-being.

After the assassination, the camera panned around—right in time for my resurrection. I walked toward the camera with these golden braids. I had been renewed. I wanted to make sure that I was smiling at that point. This was supposed to symbolize that although I had been physically killed by groupthink, I had been spiritually freed. The idea was that an individual could be freed from groupthink, be resurrected, and live on.

That was the intent—but what had happened was, my booty distracted the whole thing! Dudes were like *day-aaammmm*! That wasn't quite the reaction I was going for. What's so funny about this is I didn't even know how I looked walking. None of us has seen ourselves walking naked. Then, when I saw the

video, I was like, "day-aaammmm," too! See, 'cause nudity can be quite confusing when not packaged for the consumption of male entertainment. But I was cool with the final product, happy that both sides, the sociopolitical and the sensual-erotic, met in one place. That's what performance art is all about. People don't have to agree with it. They don't have to like it or dislike it, as long as it creates dialogue and some kind of movement. That's what it's about, and that's what I think the video does.

To every woman on her journey, I say each step is the way. That's *dao de jing*. Each step that you take toward yourself when you are on your path, which is more inward than outward, is the right way. Everything starts organically, you know; the answers are right in front of our faces. Nikola Tesla calls it sympathetic vibration. Like–weighted things vibrate toward each other, and if you are desiring something, it usually starts to vibrate toward you. ⚡

Conceivably, we are electromagnetically drawn to the experiences we need most to get us to the core lessons that ultimately help us to evolve. It just depends on what a person's growth requires at that particular time. Sometimes it's easy; sometimes it's not. There is a balance within us all.

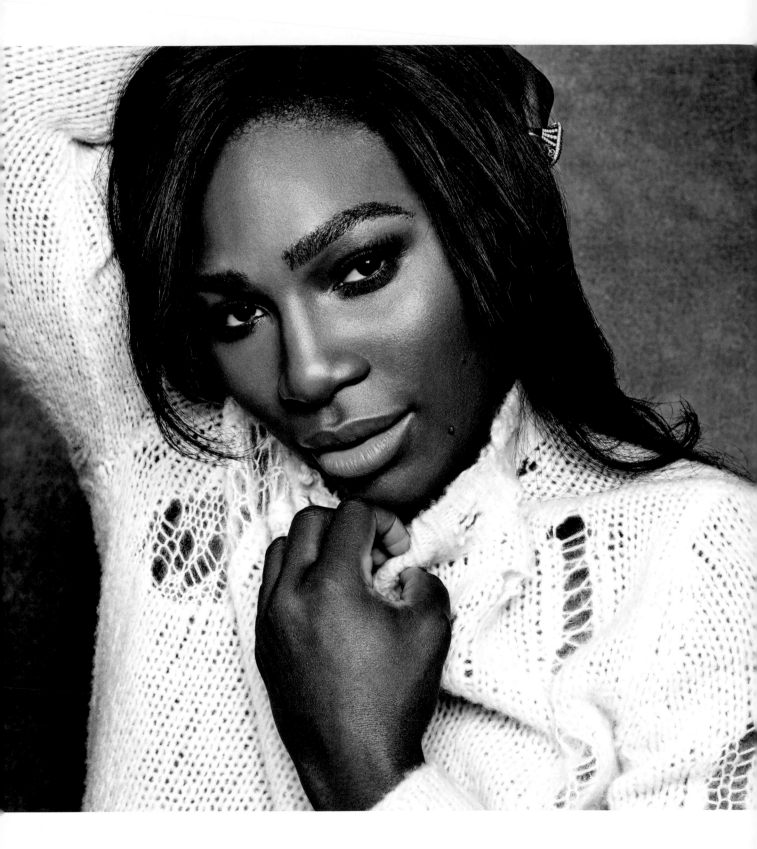

SERENA WILLIAMS

THE CHAMP IS HERE

#1-ranked women's tennis player in the world and four-time Olympic gold medalist

I AM UNAPOLOGETIC ABOUT BEING AN EMOTIONAL, STRONG, PASSIONATE, and expressive woman. On the court, I exude emotion. That is my job. That is how I feed myself. When you're doing something you love, you're passionate about it. And if you're not, maybe you're just not obsessed with it enough. I love showing that passion on the court. It builds excitement within me and for everyone watching. If you think about Tiger Woods— when he first came on the scene, he pumped his fist when he celebrated, and everyone thought that was weird. A golfer? Pumping his fist? Now everyone is pumping their fists in the air. Passion is infectious, and people who love what they do aren't afraid to show it.

I think being exposed to competitive sports at an early age is really an asset for girls and their development. Playing sports builds confidence, creates self-awareness and pride, and makes us feel we can accomplish anything, especially if we put in the work. I believe that hard work builds discipline, and discipline develops character.

Losing also develops character. I've learned how to pick myself up after a loss and process what I can do differently on the court to win the next time. Each loss shines a new light on an opportunity to get better, and that's what I've always tried to do. Be better. I tell people to dream as big as they can and to not be afraid to dream bigger than big. The hard work I've been doing all my life has made me a game changer. My sister and I both have helped to shift the sport of tennis in a new direction, much like those who came before us did—players like Arthur Ashe, Althea Gibson, Billie Jean King, and Monica Seles.

When my sister and I entered professional tennis, we came out of the gate winning,

and that jarred a lot of people because they were not used to seeing two black girls in this sport, let alone dominating it. I've been faced with questions about my hair, my fashion choices on the court, my attitude, my physique, and even my talent. Mentally, I'm strong enough to handle all the scrutiny that comes my way, so it's fine with me. I'm aware that some people aren't ready for change, or *weren't* ready for change. They see only someone who is different from them, someone who looks different and was raised differently. Every aspect of what these people see or what they were used to seeing has changed, and that can leave folks who aren't ready a little rattled. Although I have had to deal with a few crazy experiences like booing crowds and criticism from other players, for the most part people have been kind and open to having us in the sport. Our experiences haven't been like those of my idol, Althea Gibson, who won Wimbledon and the US Open in 1957, was named "Female Athlete of the Year" in 1957 *and* 1958 by the Associated Press, and still had to sleep in her car while competing because she wasn't allowed in a room in a hotel.

Now it's more of a norm when I see someone in a locker room who looks like me. Seeing another black woman there makes me feel really good, as if another door has been unlocked. As a black female athlete, I always want to make sure that we are still moving onward and forward as a culture. I am content to be a part of this movement, and I celebrate that.

I am often asked what advice I would give my younger self if I could. My response is always the same: I wouldn't. I *needed* to pass every challenge, to win, lose, and do everything in between. That's what formed me. Every course, every path, every bump, every speedway, every great thing, and every bad thing created me— and I wouldn't trade any of it for the world.

As a black female athlete, I always want to make sure that we are still moving onward and forward as a culture. I am content to be a part of this movement, and I celebrate that.

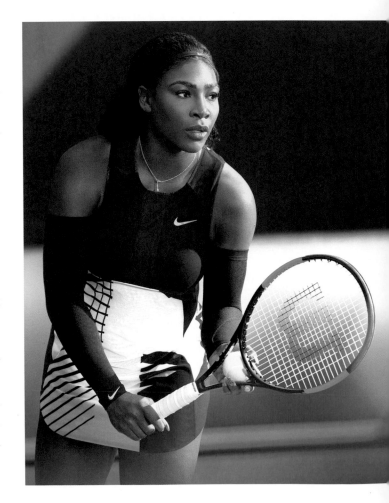

TRACEE ELLIS ROSS

SHE GET IT FROM HER MAMA

Actress, model, comedian, and producer

IT'S A PARTICULAR AND UNIQUE EXPERIENCE BEING THE CHILD OF A superstar; being the offspring of someone so beloved. When I was growing up, there was so much energy focused in my direction, and I knew it was because I was an extension of my mother, a piece of someone people loved. I wanted to know that I deserved any attention I got. So I set out to discover who I was and to become someone.

My story is one of individuation, the story of a daughter emerging into her own light and becoming her own person. People always assume I grew up in my mother's shadow. It never felt that way to me. I feel like I grew up in my mother's embrace.

My mother is a phenomenal woman and a world treasure, but first and foremost she is an incredible mom. She created space for all of her children before we were born so that we could explore our own existence. She encouraged me to have a voice and taught me to be my own compass. She also taught me what family means, what being there for another person means, and how to show up for somebody. She taught by example. I never heard her complain. I never heard her say, "I don't have time. Not now. Don't bother me."

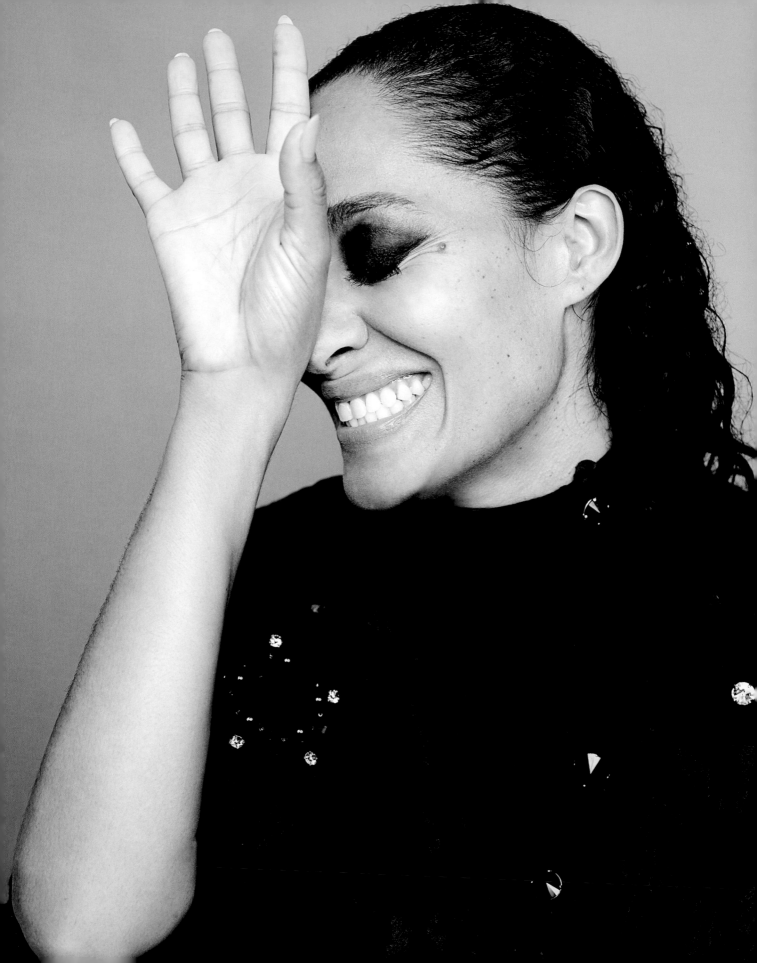

The "Diana Ross" who belongs to the world doesn't even hold a candle to the woman I get to call "Mom." I did grow up with abundance, but, most important, abundance of pure, unconditional love and safety.

As a result, my personal journey came from an attempt not to make my own space but to discover my own self. What I have discovered is that I'm both courageous and shy, quiet and loud. I am many things—one of which is very silly.

I used humor both as a way to connect to others and as a way to keep people at a distance. As a child, I used humor as a protective tool. It was the way I made sharp things soft. I used it to defend myself from racism and sexism. But what I discovered over time is that I could also use my humor to entertain people. I didn't know it would become a profession for me, but I was certainly drawn to the art of comedy and all its great practitioners. I grew up watching Carol Burnett, Lucille Ball, Lily Tomlin, Gilda Radner's "Roseanne Roseannadanna," and Mary Tyler Moore, just to name a few. I was intrigued, and wondered how they were so free and courageous. I loved seeing women being so multifaceted, glamorous, beautiful, silly, funny, and free. I thought it was magical and fantastic.

My craft as a comedic actor has grown over time. I've logged a lot of hours doing what I do, what I love. I see my job as sharing humanity, and I know that my vulnerability is the key to my humanity. I've learned that the more honest and open I'm willing to be, the more magic I feel.

As artists and as an industry, I think we are meant to share humanity, and with that comes a responsibility to share it with courage, authenticity, and honesty. That is why I am mindful about the stories I choose to tell, because how we are represented in the media has an impact on how we see ourselves and how we are seen.

There is work to be done on the representation of black women on television, and on how women of color are represented in media overall. As black women specifically, we are often objectified, oversexualized, and sassified. So, for my character Bow, on *Black-ish*, to be something other than that on a hit mainstream television show is important. She is still a sitcom wife and could just be "wife wallpaper," a prop in her husband's world, and yet she isn't.

She is joyful—not because she is happy to be cooking dinner, washing the dishes, and loving her husband but because she is embodying the fullness of her own life. I have said this before, but it bears repeating: Women are not defined by who we are in relationship to. We are valuable and powerful and entertaining because we are.

Bow is a representation of that; she is today's woman—she exists in the humanity that surrounds us in communities across America. What is interesting to me about Bow is her selfhood—not just her motherhood or her job-hood or her wife-hood, but that she is a self with all of those parts. She is rare as a sitcom wife, and especially rare as a black woman on television.

To be a part of reshaping what it is to be a modern woman through the face and beingness of a joyful black woman is pretty special.

Because of the courage of the women who paved the way, I know what it feels like to spread my wings as wide as I'd like, to dance, and to live in places that others are afraid to go. And all of that makes me feel like a magic black girl. ⚡

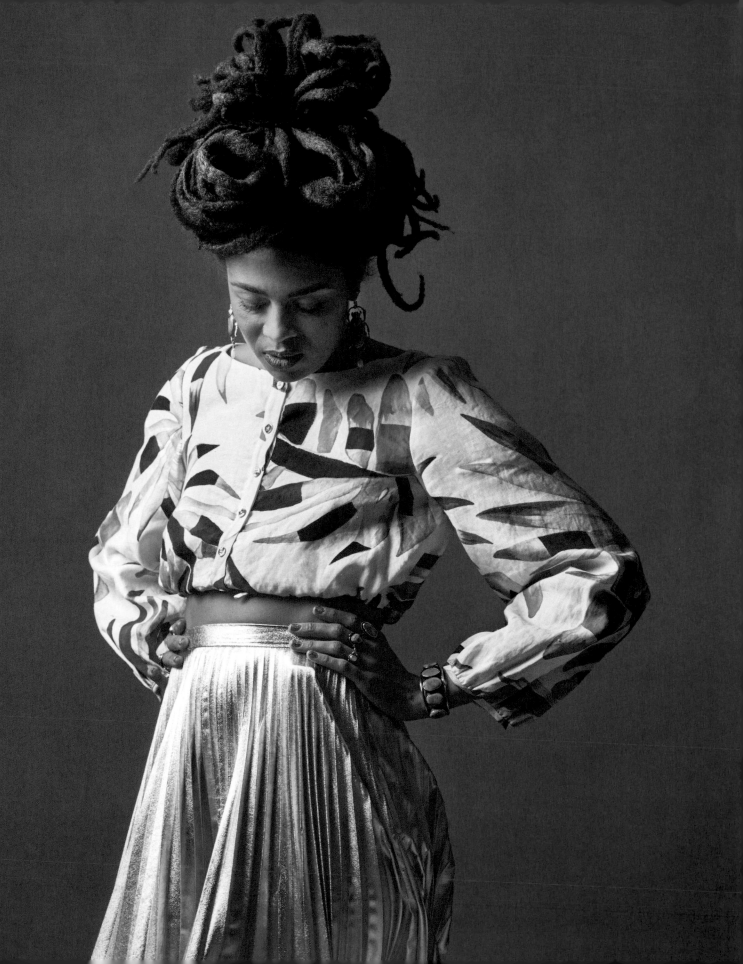

VALERIE JUNE

IRIDESCENT SOUL

Singer, songwriter

MY MAGIC IS OTHERWORLDLY AND ETHEREAL. IT IS FORMLESS, VERY turquoise and iridescent. It lives in the magical moments in my mind, my spirit, and the world I'm creating in my music. It's very dreamy.

I was raised singing in church. However, the church I went to didn't use instruments and didn't have any kind of choir. People usually think that because I'm from the South and because I'm a black woman who sings that I must have attended one of those big southern gospel churches, like the kind you see in a Tyler Perry film. They imagine that I was raised in a church like that. I really wish that I had been, but my church was way more reserved. There weren't any instruments, only voices. Everybody just sat together in the pews singing.

There were about five hundred people at the church, and there was only one song leader. He or she who would get up and tell us which page to turn to, and everyone would sing together, whether they felt they could sing or not. It was part of the religion; you had to sing. I loved experiencing those voices and being in a room every week for eighteen years with five hundred people singing with all their hearts. Lifting our voices to God and using our voices as instruments—that's what we did, and those are my roots.

I call my sound "organic moonshine roots" music because it's eclectic. Sometimes it's rock and roll, sometimes it's country; sometimes it's gospel, sometimes it's blues; it's bluegrass, it's soul. I'm influenced by all forms of American music, and I mix them all together to make my sound go into a magical place. All my songs are different, and they're

different because of how I receive them. I just hear all these voices—they sing the songs to me, and I gift them to you. Sometimes it's like a child's voice, sometimes it's like an old man's voice, but I just try to reinterpret what I'm hearing in my head. I channel it from wherever it comes from, out there in the ether, and I give it to you.

People are often taken aback when they see me onstage: a multi-instrumentalist black girl with a head full of dreadlocks singing and playing a banjo in front of multicultural audiences. But I'm fortunate to be able to maintain my originality despite the industry's tendency to box black artists into small sound spaces. It would be really stifling for me as an artist to be boxed into a genre versus being allowed to move freely in my creative headspace.

It feels really amazing to bring my Black Girl Magic to our collective awesomeness by representing us in a lane that we don't usually occupy. When I read all the incredible and positive reviews on my artistry in *Rolling Stone* calling me "unstoppable" and hear NPR calling me "an elemental talent"—it makes me think about the honor and blessing of representing us through my gift. My presence in this space may open doors for other black girls and encourage them to pursue their dreams, even if they don't see people who look like them on their particular path.

Life is not about the accolades, awards, and reviews. Life is about being able to be authentically you. I rock because I came here to shine my light. I'm going to do it fearlessly, regardless of whether I "fit in"; I have to live for what's in my spirit. My advice to other creators, artists, and human beings trying to walk their true path is to dive deep inside yourself and stay really, really close to your inner light. Connecting with the heart of who you are is the greatest reward on earth. So, be true to yourself and believe in yourself. That's the best way to rock. ⚡

Life is about being able to be authentically you. I rock because I came here to shine my light. I'm going to do it fearlessly, regardless of whether I "fit in"; I have to live for what's in my spirit.

DANAI GURIRA

I SLAY

Zimbabwean-American producer, actress, playwright

WITH EVERY PLAY I WRITE AND PUT INTO MAINSTREAM INSTITUTIONS, whether on or Off-Broadway, I put a black woman in the leading role of the story. By doing this I am demonstrating that there is no reason black women should not be there. Our stories are just as important. I reject the notion that black women cannot be at the forefront. I could never understand the marginalization of our rich narratives in media. It made no sense to me that you didn't see more black women acting leads and more black women's stories; that you didn't see us in all our power and complexity. There is *absolutely* nothing that we lack.

While reading an article in the *New York Times* about a very vicious African war zone, and how women dealt with various components of that war, it struck me that even though I grew up on the continent, I'd never heard about the struggles of women in the midst of war in Africa. You hear about the "warlords," but you don't hear about the women. Women stopped the Liberian civil war. A woman, Ellen Johnson Sirleaf, became the first female president of Liberia and the first female African head of state after that war. Yet I knew nothing about it. I was absolutely shocked that I hadn't been exposed to it. There was no real exposure to those experiences. This was something that just burned in my soul.

I often create from outrage—outrage that there's so little attention given to the experiences of women of African descent, their stories and their complexities. So, after learning about the Liberian situation, it became very clear that I had to try to tell this story, and that became my play *Eclipsed*.

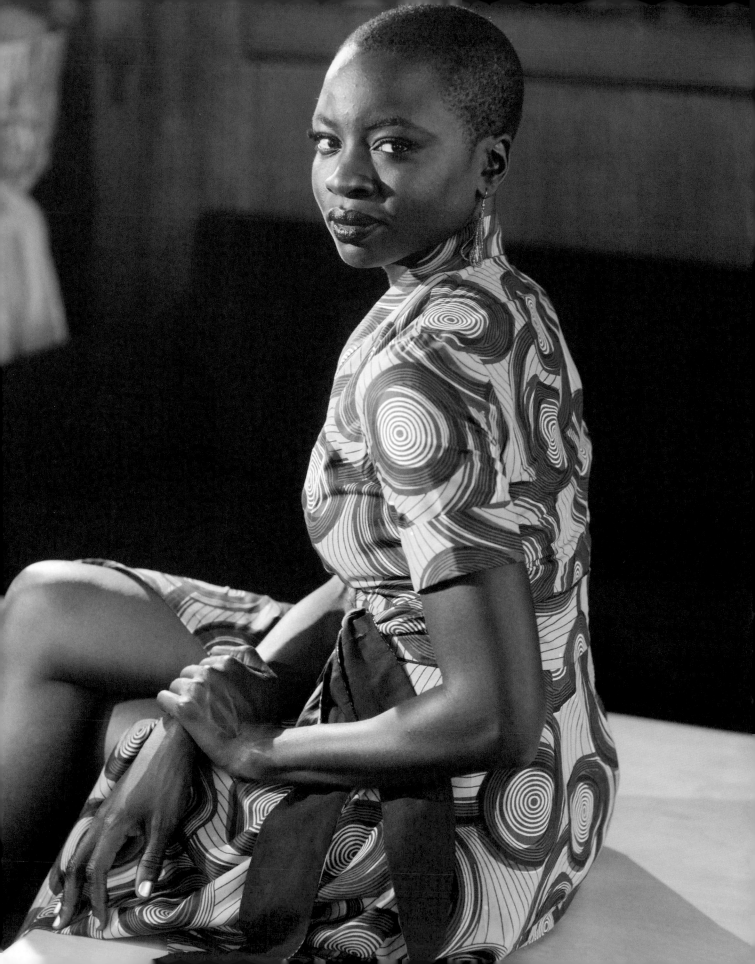

It's been pretty clear to me that a big part of my calling or my purpose is to give a voice to women who are often marginalized and never heard from in the global realm or on the global stage. I've recently been researching and paying close attention to Miriam Makeba for a project I'm working on. I was watching a clip of her appearance on the *Ed Sullivan Show* in the 1960s. I wept as I watched this pioneer perform on American television in Xhosa, her native tongue. It couldn't have been easy performing in the 1960s, while America was grappling with its own version of a civil war, a civil rights war. Yet there she was, coming from apartheid South Africa and singing in Xhosa on American television. That's what inspired me.

If there is any black woman out there—young or old, a writer, an actor, a director—who was inspired by what she saw in *Eclipsed*, then I've really accomplished something. That's the ultimate goal: to be an example for those who have even bigger barriers to break and for those who are destined to break them. That's why I create art.

It has always infuriated me that our volume seemed to be lower in the global realm, lower than others'. Now to see Shonda, Ava, Issa, and all types of stories and storytellers break through is so much of what I've kind of always known in my soul. We are excellent, and our voices and our ideas should be at full volume. Now it's just about building on that.

The fact that I get to play a heroine on one of the most popular shows on television really shows that there is a change happening. There is a more diverse palate, not just in Hollywood but also among the audience that is consuming media. My character, Michonne, on *The Walking Dead* inspires a spirit of fearlessness, and she shows that leadership can come in any package. It's amazing to see how much influence this black female powerhouse has had not just on black girls but on all girls.

All types of women and girls have expressed that they find Michonne empowering. That's important, because it takes away the misconception that one's skin color dictates what type of role one can play. It eradicates the idea that my Blackness relegates me

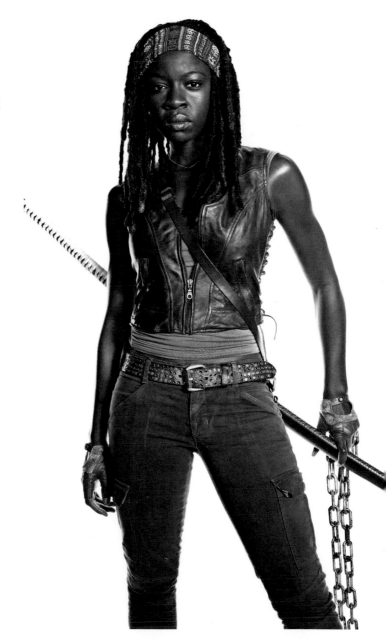

to being a sidekick or a nonheroic character in film or television. And it shows that race isn't a barrier to audiences connecting with a story. Girls of all different colors see a female character that they look up to, appreciate, and admire.

I'm a big advocate of empowering young girls and having them understand their worth and their purpose and the importance of their voices in the world. They need to know that we need their voices! I am happy to help nurture those components in girls through my work, whether it be a role I'm playing or a production I'm producing. We are in a world that can still be largely hostile and discouraging, with messages telling girls they are not as worthy as we know them to be. So if there is anything I can do that encourages or brings out some sort of inspiration in young girls so they can feel a sense of self-pride and know that they can walk out into the world and be who they are with confidence, then that to me is a great blessing.

I do truly want to contribute to that. I feel like the foremothers, from Harriet Tubman to Miriam Makeba to Maya Angelou, guide me into my own sense of purpose. Stepping into that purpose allows me to feel my magic. Despite all the odds we've been up against, we will continue to conquer, progress, and break through. And I find that a really, really exciting aspect of being a Black girl—that there is just more. . . . We will make a new way and we will continue to do as our foremothers did before us, and it will be against all the odds, but it will be. And that to me is magical.

NINA SIMONE

I PUT A SPELL ON YOU

Nina Simone was a singer-songwriter and civil rights activist who was outspoken about celebrating black beauty and black brilliance. She embraced her own natural aesthetic and opposed aspects of racism that were manifested in Eurocentric beauty standards. She also challenged self-hatred and colorism in the black community with her music, as seen in her recording of the traditional folk song "Black Is the Color of My True Love's Hair," her testament to the divine beauty and natural strength in the black race.

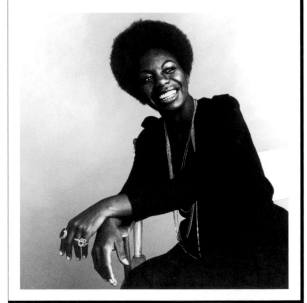

SOLANGE KNOWLES-FERGUSON

BLACK GIRL MAGIC: FOR US

Singer, songwriter, music producer, and model

WHEN I WAS GROWING UP, MY MOTHER OWNED A HAIR SALON, AND I SPENT a lot of time there. It was like my second home. I met every kind of black woman in my mother's shop, from lawyers to teachers to dancers to preachers' wives. They all shared a common denominator that wasn't just about their hair or the beautification experience— it was also about having a safe space where black women could talk about their issues with work, relationships, or their children. The hair salon was a haven for bonding among sisters. Seeing the transformative process of women stepping in feeling one way and stepping out feeling another gave me insight into the role of the salon as a sacred space for us.

Black women's hair is such a spiritual part of who we are, regardless of how we decide to wear it. Our hair is symbolic of our journey and our cultural identity. It's our crown. When I was writing "Don't Touch My Hair," I wanted to break down our unique relationship with hair as much as it was broken down for me as a kid. I was thinking about the importance of our hair as a political statement, but hair is only one very small piece of the song. It's really about pride and strength and grace and having a voice much more than about hair itself.

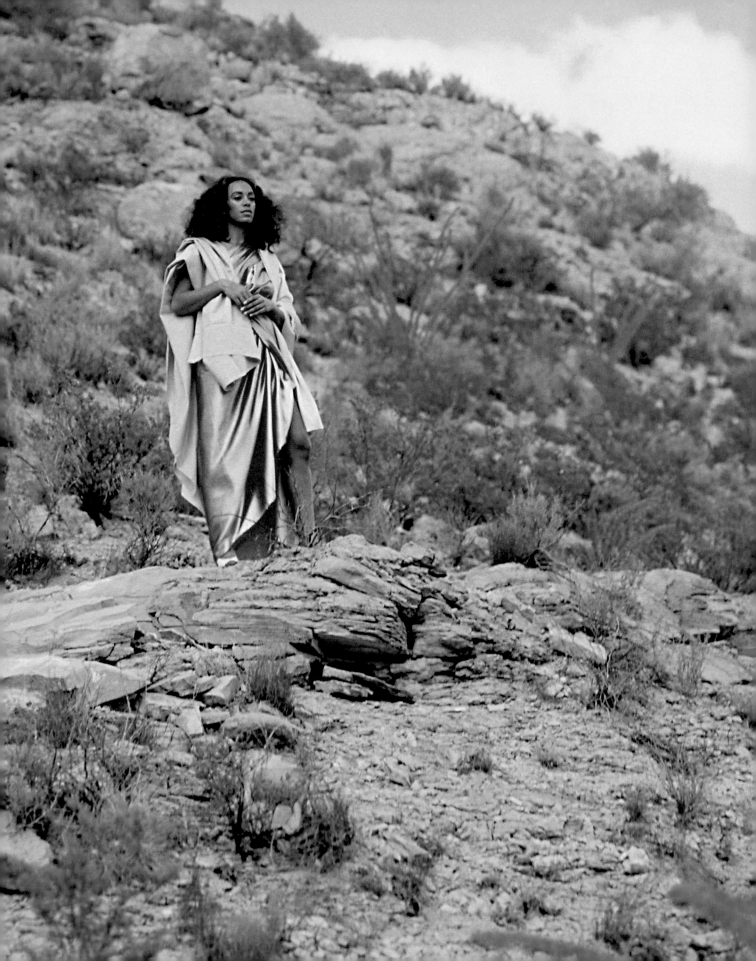

I was reacting to what I was witnessing in society. As we started to claim our beauty and our magic, and as we began to embrace our natural aesthetic more, there was this pop-cultural appropriation of our style and our essence. When we go out into the world and see the appropriation of hairstyles we've worn for our entire lives, it's really frustrating. Our hairstyles are not just trends; they have personal and political significance that should not ever be undermined. The sisterhood, the womanism, and the storytelling that go into our hair can never be replaced, redone, or remade.

I often think about black women and all that we have endured throughout history. Since the beginning of our time, here in this country, we have been told that our space belongs to everybody else. We have had to share our bodies and space so often throughout our entire existence. And I felt so empowered by saying, "No—this space, this album, is for us." And that's okay, because we should have our own platforms to be celebrated for our unique aesthetic, accomplishments, and experiences.

When I was writing *A Seat at the Table*, I felt a yearning to show black women being minimal and stately, which is an opportunity we are rarely given. So often we are asked to be bold, courageous, loud, funny, big personalities. I wanted to show us as understated, vulnerable, sensitive women to illustrate that we can be all of those things. During the creative process, there were absolutely moments of doubt when I worried that I was taking the messages too far, that I was being too honest or not writing poetically enough. When you set out to create something with purpose, it's easy to get lost in the process, especially when there are so many layers and evolutions to the project; but I knew exactly what needed to be said. I felt like black women needed to be told that we're not crazy, we're not losing our minds, and we're not super-emotional. We aren't drama queens when we're experiencing these microaggressions every day.

It feels right that this is our time to love ourselves and each other. It's so exciting to think about my niece and her friends getting to grow up in a time when all the negative ideas of black womanhood are being broken down and disassembled right in front of us. We are not looking for anyone to give us validation; we have manifested it for ourselves. We are now saying that we rock, we matter, we are magic, and we are poppin', but not as an expression of arrogance. It's an expression of sisterhood and self-love. Our affirmations are beautiful reflections of our power, and no one can take them away from us.

We all have a power that's uniquely our own, and there's so much freedom in knowing we have light and magic in us. Since I was a young girl, I've known my power. I felt it inside me. Even when a lot of other people didn't see it or understand it, I never let them deter me. I always stuck to my guns and made sure that what I put into the world matched what I felt inside. At times it was very scary, and at times it was very hurtful when people didn't understand me—when people criticized me or called me weird or said I was just seeking attention—but there was always a voice in me that said, "Stay steady and be you." It's exciting to know who you are and to maintain a sense of self, even when the future is unknown. Even now I feel like the Universe and God—through all the love that I've received throughout my journey as a mother, a wife, an artist, and a businesswoman—are calling me to another place, perhaps another journey that might be even deeper.

I think my Black Girl Magic is my authenticity. I feel authentically me, and I am very grateful that being myself has done right by me. I am so thankful that people are receiving me, my music, and my message so graciously, and I am honored that I have the opportunity to play my little, small, minuscule part in doing the thing that so many black women have done for me. ⚡

III.

BOSS UP

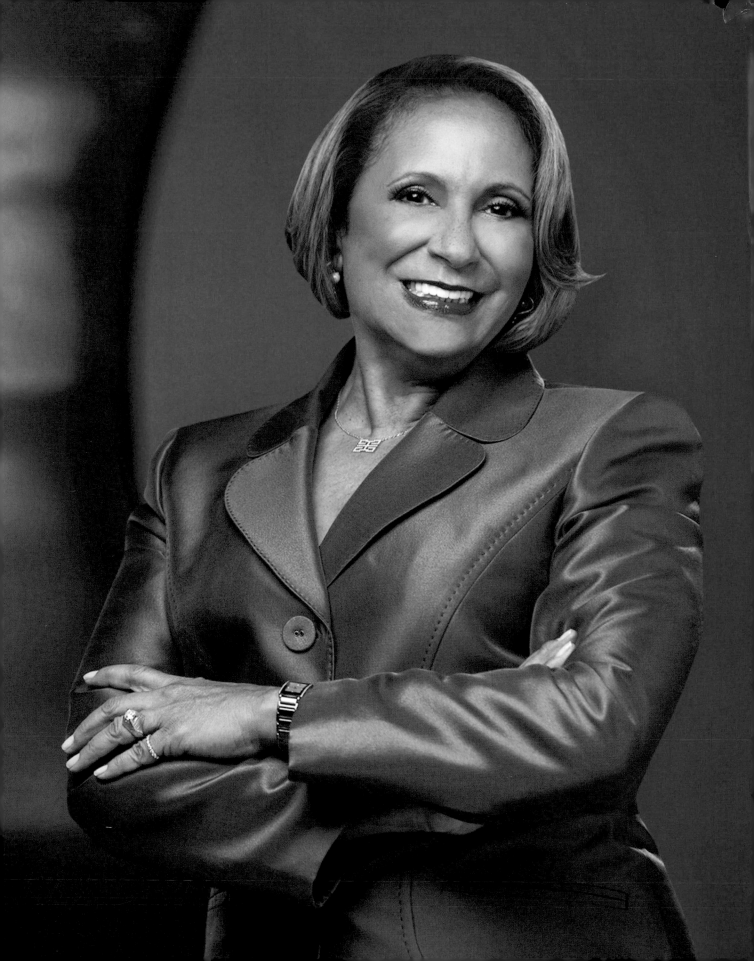

CATHY HUGHES

KNOW THE LEDGE

Media mogul, entrepreneur, and founder of Radio One Inc. and TV One

BLACK WOMANHOOD GIVES ME GREAT JOY. I LOVE THE SISTERHOOD. I love the affirmation from other black women that I get. It's in their eyes, in their actions, and in their missions. I have never felt anything other than love and support from my sisterhood.

My goal as a businesswoman has always been to provide opportunities in my industry for people of color and opportunities for women to be in decision-making positions. I'm the first African American woman to chair a publicly held corporation. The expectation for publicly traded companies is always to enhance our shareholders' value first and foremost. However, it has been my mission to open doors for people of color and for women. That remains my priority.

One of the most important things I always emphasize is black ownership. We have to own our own companies, especially in the communications and media industries. I am living proof that it can be done. I've grown Radio One and TV One into the largest African American–owned broadcasting companies in the United States.

We can't depend on the *Washington Post* to tell our stories. I cannot say that enough. We should not expect any other culture to get the story right or to assume the responsibility for telling it. No other group does that, so why would we depend on a culture that enslaved us to accurately portray us?

Just look at the film *Hidden Figures*. When I was a kid, John Glenn was bigger than life, and now, as an adult, I find out that not one, not two, but three sisters made it possible

for him to be "the Great John Glenn." No one ever once put it into the *Congressional Record*? He never once opened his mouth and gave these black women credit for what they did? I have to wait until I get to be this age, in 2016, to learn about these hidden figures? These three brilliant black women's work was so instrumental to NASA and the US space program, and yet their stories are just coming to light now. Even those of us who, like me, pride ourselves on knowing our history and culture knew nothing about these women.

That's why it is critical to have black ownership in the communications industry and to tell our stories from our perspective. When we don't own the means of communication, we hinder our ability to create change for our communities; our businesses don't grow or they grow too slowly, and we don't generate wealth. Ultimately, we limit our collective power and influence, and a whole lot of other people and cultures benefit from us.

When TV One started, it was just us and BET featuring black content on a regular basis. Now it's almost impossible to turn the television to any station without seeing a show with black people. I think this increase in demand for black content is interesting. I'm thrilled our stories are being put at the forefront. I'm thrilled that black folks are getting these jobs, I even welcome the competition. But I still think we need to be mindful about ownership, because our cultural capital should also transfer to financial capital for us.

I love the essence of my African roots; it colors who I am, and that acceptance of who I am is what has empowered me to do the things I've been blessed with doing in business and in my community. The more you build, the more you can be of assistance to other individuals. I've always had this philosophy of lifting my community as I climb. It's the reason for my existence.

Two powerful things have happened in my life to affirm my work. One was when Howard's School of Communications changed its name to the Cathy Hughes School of Communications at Howard University. (What an honor for Howard to move its own brand aside and replace it with mine.) The other was creating the "Quiet Storm," which became the most successful music format in radio history.

I have tried with every ounce of my existence to give back as abundantly as God allows me to. When they give my eulogy, all I ask is that I be credited with leaving my community in a little better shape as a result of my work and passion. ➤

SUZANNE SHANK

ALL THE WAY UP

Municipal investment banker, entrepreneur, and financial strategist; chairman and CEO, Siebert Cisneros Shank & Co., LLC

I AM A PROUD PART OF A SACRED TRADITION OF PROGRESS AMONG BLACK people in this country. Black people have continuously found ways to make a way out of no way. It is embedded in our culture to be resilient, to be prepared, and to knock on doors in pursuit of opportunities when there are no Welcome signs. That tradition, and the support of my family, have laid the path for my life.

My family is from the Deep South. They were of a time when society stripped us of our names, individual talents, and the significance of our achievements. On my birth certificate, my father's identity was reduced to "Negro laborer." That designation hides the fact that he sacrificed his own college education to support his family and his siblings. It hides the extraordinary work ethic that he taught me by example. It hides the dignity of his character. It sheds no light on the pride he took in his work that enabled him to become the first African American director of transportation for our local transit authority.

My mother was an equally powerful example of the dignity of work and the importance of fortitude. She was adopted and had to find love in a family that wasn't her own. She thrived in another component of the black tradition—that the family is the village. Fueled by that love and support, she graduated from Spelman College and got a graduate degree while taking care of me and our household. She began her career as a schoolteacher and rose through the ranks to become an assistant superintendent in the local public school system.

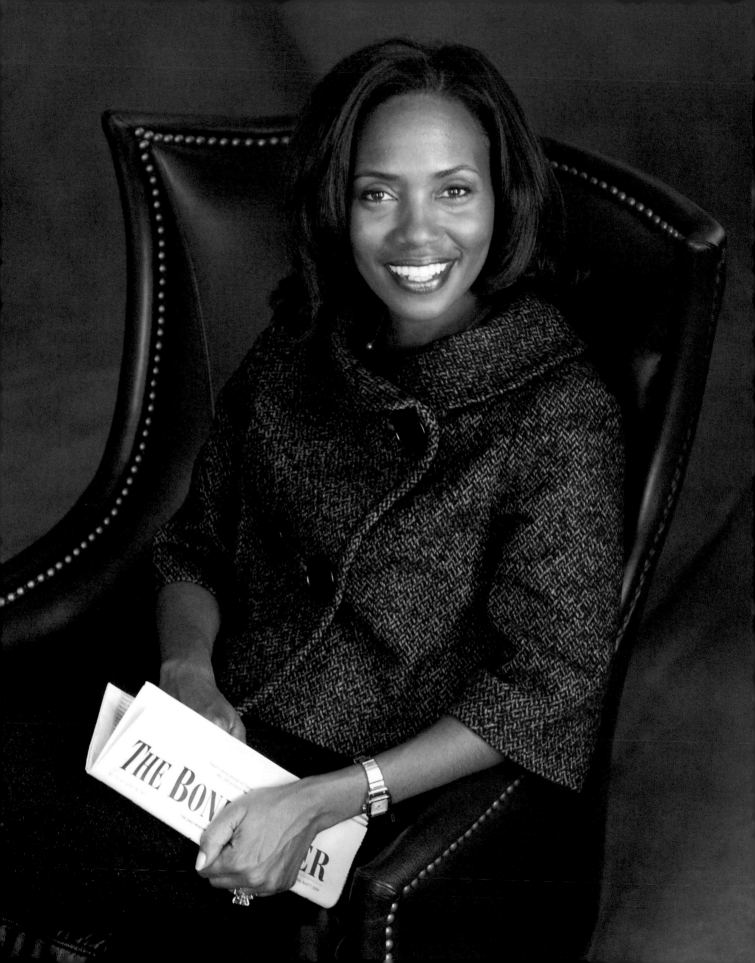

My parents were the epitome of an upwardly mobile family that rose into the middle class despite the labels and barriers they faced. I stand on their backs and on the backs of all those who labored with quiet dignity to lay the path for me. As such, I feel a responsibility and a duty to do all that I can to be as successful as I can and to contribute as much as I can because of what they instilled in me.

I am an investment banker. Wealth and the investment of funds into new ventures is what drives the modern economy; therefore, it is important that people understand, at least conceptually, what investment bankers do. We bring together entities that have capital to invest with those who need investment. In essence, we serve as intermediaries. My firm brokers those deals. We assess the merit and utility of potential projects to assure investors that their capital will be put to good use and help them fully evaluate the risks to ensure their returns will be secure.

My firm has participated in over two trillion dollars' worth of financing for corporations and municipalities. We started as a public finance firm in 1996 and, in 2014, acquired a capital market group. Since our inception, the scope of our work and our ability to contribute to the improvement of people's lives have been extraordinary. I have spent most of my career financing municipal projects. We fund the construction of schools, roads, water and sewer systems, transit systems, and airport expansion. These are projects that impact everyone. For every service the government provides, we work on finding the best funding solutions to enable it. Through my work, I have been able to support communities that I care about in very tangible ways.

Succeeding in this section of American industry is not easy, and it is especially difficult for black women. I have had to overcome preconceived notions about my smarts as a black person and my toughness as a woman. That doesn't worry me anymore. I studied civil engineering at Georgia Tech. My first job was at General Dynamics, where I worked on nuclear submarines. Having that kind of technical training and experience allowed me to develop confidence in my abilities. The logical and analytical skills taught in engineering training force you to seek solutions that are sound and verifiable. The persistence required to seek solutions to complex problems also helps you develop extraordinary mental toughness. I'd like to credit two tough courses in particular for my confidence—Mechanics of Deformable Bodies and Differential Equations. I keep the books from those two classes on my shelf to remind me that if I can master these subjects, I can overcome any hardship.

I left engineering to go to business school with an aspiration to advance into a management position. The management courses were too touchy-feely for me, and I gravitated toward statistics and finance. I felt more at home with the certainty that comes with logic and numerical order. Ultimately, that is what led me to the world of finance. But access to that world was not handed to me.

As a woman, you cannot be quiet and reserved and expect that because you're competent, doors will automatically open. With my shy demeanor, I had to make a way for myself. While I was at the Wharton School of Business, I realized that being quiet was not going to cut it, however competent and well-educated I was. One day, I literally took a New York subway map, went to Wall Street, and knocked on door after door, trying to convince someone to hire me. That is how I got my first Wall Street job. I had to knock on doors and make a way when there was no Welcome sign for me.

While the numbers are still low, more women are beginning to occupy influential roles in both public and corporate finance. Our presence is slowly chang-

ing the culture of these industries. I have found these women to be my biggest advocates, supporters, and clients. They intimately understand the difficulty of the journey we have all undertaken to get to our respective positions. They have given me the benefit of the doubt and assumed my competence in ways that didn't happen for me when I started out. The assumption of competence is a privilege that men have long held in this field. Women put more emphasis on actual merit.

It is always difficult being a woman in a male-dominated field. Merely because we're women, we are often not given the easy path or the respect we're due based on the substance of our work, experience, and education. As black women, we are always in a position of having to prove ourselves. Unfortunately, it is a responsibility that comes with our identity. The battle is an uphill one, and achievement is not easy. Still, because I am competitive, I am always ready for the challenge. I think most leaders are: we want to succeed; we want to be the best.

For the many accolades I have received, from being listed as one of the top women in finance by *American Banker* or one of the top black women on Wall Street by *Black Enterprise* to being named one of the top twenty-five of one hundred thousand Wharton graduates to watch, I am grateful. Being recognized by Wharton was noteworthy because my classmates were so dynamic. I have also been fortunate to receive recognition from the public finance industry, receiving the Private Sector Freda Johnson Award and the Austin Koenen Career Achievement Award, both of which are pinnacle awards in my field. It's always great to be recognized, but especially so by your peers with whom you've worked and clients who have hired you because they believe in you. My

success is a part of God's plan, so I don't spend a lot of time thinking about how great I am or what I've accomplished. But I am appreciative of my successes. While I never aspired to be a CEO, I do believe that my appreciation of the sacrifices made by my parents and others before me armed me with a work ethic that helped me get here. ⚡

VENUS WILLIAMS

VENUS RISING

Top tennis player, Olympic gold medalist, fashion and interior designer, and philanthropist

I DEFINE A CHAMPION AS SOMEONE WHO GIVES HER ALL AND WHO HAS NO regrets. It's someone who can look back and say "I gave this everything. I was my best."

When you are chasing your dream, you take huge risks and you have to make many sacrifices. You can do all this work and never get the outcomes you expected. So, in order to pursue the top tier of your endeavor, I think you have to love what you do. When there is an element of love in the mix, you pursue your vision and your goals relentlessly and fearlessly. That doesn't mean you won't be afraid sometimes, but it means you are not too afraid to go for it.

Serena and I always say "You gotta pay the price," which is a mantra we got from Billie Jean King. We use it as a way to push ourselves to our next level. Paying the price is putting in the work. When you pay the price, you are able to step forward with conviction. When you know that you've practiced hard and paid your dues, you're confident. I don't believe you can be self-confident when you know you haven't put in the work.

I've worked hard to be on top in my sports career and my business endeavors. I never get complacent, because I know the next loss could be right around the corner, but I also use every loss as a lesson or an opportunity to strengthen myself. I always say, "Lose, but learn!" The biggest loss in losing is not learning from it.

Part of going to my next level has been about venturing into uncharted territory. I was motivated to start my own design company because I love design and am inspired by the challenge of being an entrepreneur. Running a business has taught me so much. For one,

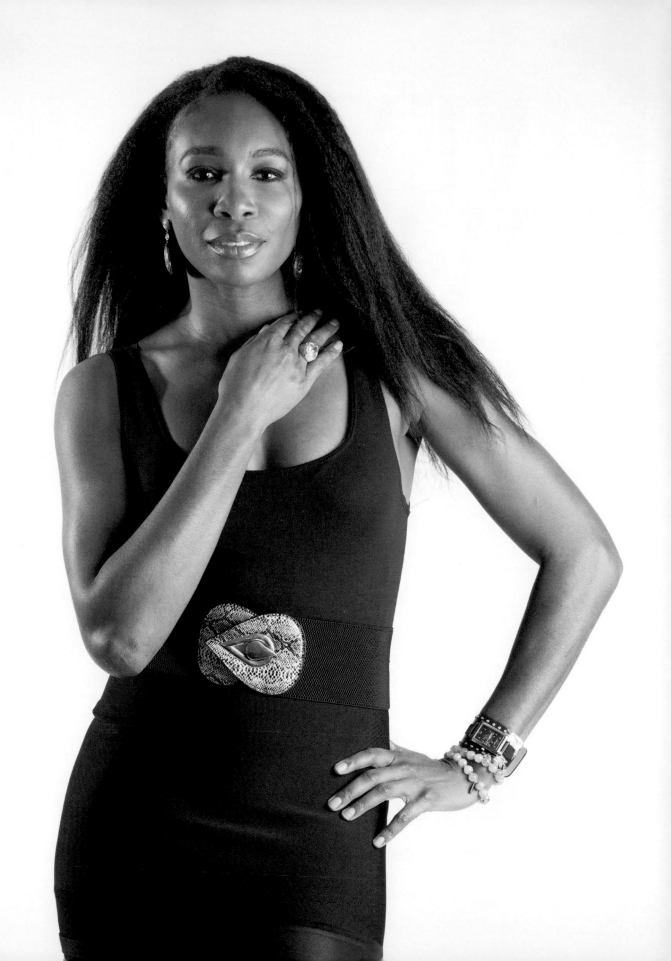

it has taught me how to manage different personalities. Part of being a good team leader is figuring out how to get your staff to be their best. What motivates me may not motivate others on my team, so my challenge is to find out what will inspire them to do their best work. I thrive on that. It has also taught me how to think 360 degrees about any project. As an athlete, I'm always in control of my own faculties. That's my job: to control my mind, my body, and my spirit. All those things need to happen in order for me to be an amazing player every time I walk out onto the court. But as a business owner, I find that there are so many things that are out of my control. The market could crash, or the market segment you specialize in can become irrelevant or obsolete. The question is: How are you going to react to that? What do you do?

As an entrepreneur, I get to oversee every element of the job, even the "not-so-sexy work," like paperwork or accounting. I find that exhilarating. What I love most about being an entrepreneur is being the boss. Not only is it self-empowering but it also gives me an opportunity to help other people live out their dreams. As they help me with my dream, I help guide them in some way. When you're running a business, you get to pass down your knowledge to others and watch them grow. I find that deeply fulfilling.

It's difficult to balance being an athlete and an entrepreneur. Balance is great, but discomfort is great, too. If I'm too comfortable, that means I'm coasting. I'm not pushing myself.

The key to maintaining my life has been striving to have a level of spiritual balance. That's crucial to me because it creates equilibrium with everything else. When you have spiritual balance, you can put your whole life in perspective and accomplish anything. ⚡

> The key to maintaining my life has been striving to have a level of spiritual balance. That's crucial to me because it creates equilibrium with everything else.

DONNA BYRD

STRICTLY ROOTS

Digital media maven and founding publisher of *The Root*

IT IS IMPORTANT FOR ME TO DO WORK THAT MATTERS. I'VE HELPED LAUNCH four companies now, and two of them have been in the black media space. I've dedicated a good portion of my career to this work because I believe it is important for us to share our stories. If we are not highlighting the stories that are happening within the black community, they will go unheard. I am passionate about making sure that our people and our nation hear and understand what is going on in our neighborhoods, in our schools, and on our streets. This is something that's driven me every day, and was the driving force and passion behind launching *The Root*.

The Root came to be when Don Graham, who was the head of the *Washington Post* at the time, was having a conversation with Henry Louis Gates Jr. about black media. Graham asked Gates, "Is there a smart black daily news online site?" Gates replied, "No, there isn't." And Don said, "Well, if you can find the right people, go ahead and create it, and we will support it." That's when they began searching for the right team to create this platform. They found Lynette Clemetson, who was at the *New York Times* at the time, and they found me at a marketing company that I co-owned in Atlanta called Kickoff, and the two of us started *The Root*.

We launched *The Root* in 2008, eight days before Super Tuesday. We dedicated ourselves to educating, engaging, and celebrating black America. It was revolutionary. When you looked at the traditional news sources for black media at the time, none of them were daily, and none of them offered a perspective from black Generation X or

budding millennials. During that time, Barack Obama was running for president, and mainstream news outlets were clamoring to find African Americans who actually believed that he could win, and they didn't know who to go to. Quite frankly, if you look back at the history, right around the beginning of 2008, there were only about three go-to people that mainstream media relied on to speak about the black perspective. At that time, all of those individuals were either in Hillary Clinton's camp or on the fence. They didn't believe, or they were not publicly saying they believed, that Barack Obama could win. But when we looked around at our own generation, there were people everywhere who believed Barack Obama could become our forty-fourth president. We knew what we were offering was a new perspective.

We provided a platform for extremely talented and thoughtful writers to provide a different lens from that of the generation before them. We were able to showcase some of the most talented black writers, like Ta-Nehisi Coates, Melissa Harris-Perry, Marc Lamont Hill, and others. We really saw *The Root* as a platform for a new generation of African American voices—a group of individuals who saw the world and this country differently than their parents did.

One of the most unanticipated things that we found in growing *The Root* was that it is not only black people who want to read and understand what's going on in our community. There are a lot of white people who read *The Root* because they're also interested in understanding what's happening in our country and getting it from a different perspective. It's been surprising to me the number of diverse readers we have.

History has demonstrated that we cannot solely rely on others to recognize the brilliance and talent that exist within our people. I feel that it's incredibly important for us to celebrate what's going on in our communities, not just to highlight issues around injus-

tice or areas where we need to focus on improvement. I think it is also important to celebrate those who are contributing. If we look at what has happened in our country over the last few years, we've seen activists and everyday people taking to the streets to protest injustice. They've raised awareness of the issues plaguing our nation. They've made it clear that we're not going to stand idly by while injustice continues around us. At *The Root*, we felt it was important to support those voices so that they could continue. So we created *The Root 100*, a yearly list of one hundred influential black Americans between twenty-five and forty-five years old who were doing work that mattered.

Building *The Root* and being a serial entrepreneur has been a labor of love in many respects. It has been a lot of work, and it is not always easy for me to achieve balance, but I try. Yes—I believe that you can have everything you want in life, but you have to prioritize different things at different points. I've made many sacrifices to build the businesses I have. The way I've tried to maintain a level of balance has been my focused, strong, spiritual practice of meditation and prayer. I also think that when you can find a way to use your skills and your talent to do something good in this world, you can make magic. That's how I have lived my life thus far, and how I want to continue to live my life. I want to live it on purpose, I want to live it with passion, and I want to continue to use the talents I know I have to make a difference. ◄

DR. KNATOKIE FORD

FLY-SCI

Biomedical scientist, creative science communicator, media game-changer, and former senior policy advisor, White House Office of Science and Technology Policy

AMONG THE FASTEST-GROWING JOBS, 80 PERCENT REQUIRE SCIENCE, technology, engineering, and mathematics (STEM) skills. STEM fields have driven American economic growth and global competitiveness, yet the United States is not keeping pace with the growing demand for STEM talent to fill the jobs of the twenty-first century. Historically, women and minorities have been consistently underrepresented in STEM fields, but in black communities in particular, it is especially alarming. In 2013, African Americans were nearly 12 percent of the US population over age twenty-one, but comprised less than 5 percent of STEM workers. The share of black women in the science and engineering workforce has been stagnant for decades, and the proportion of black women holding the highest degrees in STEM fields is actually less today than it was in 1993—the only ethnic minority group to experience a decline. STEM is a critical element of social and economic justice. If black children are not equipped with these skills, they will continue to be locked out and locked into a vicious cycle of underachievement that is historic, systemic, and racist. That cycle reinforces the perpetual American image and perception that black intellect is innately incapable of excelling in mathematics and science. Dispelling this notion in order to disrupt the cycle is the driving force behind my work.

My own love for science began early on and arose from an unfortunate circumstance. At the age of three, I was in an accident that left me blind in one eye. The incident

sparked a profound curiosity about the world that surrounded me, and I had this deep interest in vision and the physiology of the eye.

I also really loved math and was fortunate enough to have parents, teachers, and mentors who affirmed me in my intellectual capabilities. As staunch advocates for the importance of an education, my parents instilled in me the belief that I could accomplish anything I set my mind to if I was willing to work hard. In high school, I had great teachers who exposed me to the exciting aspects of scientific discovery through courses like AP chemistry, where I did some really fun lab experiments. I also had a geometry teacher who bolstered my mathematical confidence by letting me teach the class in her absence; she trusted me more than she did a substitute teacher, and I took great pleasure in that responsibility. Those early experiences provided a strong foundation for my interest in math and science, and they also gave me a great sense of confidence in my academic prowess as I went on to pursue higher education.

I knew I wanted to major in a STEM field, so I began an accelerated five-year Bachelor of Science and Master of Science program in chemistry at Clark Atlanta University, a historically black university in Atlanta, Georgia. My original plan was to use a chemistry background to go on to medical school and eventually become an ophthalmologist, a doctor who specializes in the physiology and diseases of the eye. However, I ended up shifting gears to focus on research on diseases of the eye, which brought me to Harvard University for a PhD program in biological and biomedical sciences. Harvard was a turning point for me. The transition from a predominantly black institution in the South to an Ivy League school in New England was difficult; not only was the academic work extremely challenging but also the lack of people who looked like me made me feel isolated.

It dawned on me that this was essentially the first time that I became acutely aware of my otherness. In spite of all my previous academic success through college, it wasn't until this experience when I had the thought *I'm a woman and I'm a black person, so maybe I'm not supposed to be good at science after all.* It never occurred to me up until that point that my race or gender could be a factor in my academic success, and so I had this extreme identity crisis during which I didn't feel smart anymore.

I lived with perpetual anxiety about making mistakes and the feeling that I didn't deserve to be at Harvard, constantly thinking to myself, *What if they find out they admitted me by accident? If I mess up, am I going to make black people or women look bad?* Little did I know that I was experiencing imposter syndrome, the inability to internalize accomplishments, combined with stereotype threat, the fear of conforming to a stereotype about one's group. The extreme amount of pressure that I was putting on myself on top of the rigor of the program ultimately prompted me to take time off after just one semester. I needed to take a step back so that I could determine whether a PhD and a career in science were really for me.

At that point, I was only twenty-three. I decided to move to Los Angeles to pursue other interests that did not involve science. I had always been in the performing arts as a kid, so I really wanted to try my hand at acting. I started out working as a background artist in a couple of television shows, and I was even an extra in the film *Dream Girls.* My days as an "extra" were fun and exciting, but I was earning only minimum wage. I quickly discovered that when it boiled down to becoming a starving actor, I was not "'bout that life!" (Especially since I already had my master's degree in chemistry at that point.) In order to make ends meet, I finally decided to take a job as a substitute teacher in the Los Angeles Unified School District, which

helped me put my life into perspective. I would often get placed at this one school in South Central, which was no joke. The challenges this school faced were intense, a middle-school version of the movie *Lean on Me*. It was by far one of the hardest jobs I've ever had, including my job in the Obama White House. But it was also very rewarding.

Whenever I began long-term teaching assignments, I would always give a presentation about my life in which I was transparent about growing up poor with limited resources in Ohio. It was my way of showing the students that we could relate, and in spite of difficult circumstances, I still managed to achieve. It didn't register to me until that point how transformative and affirming it probably was for those kids to meet this black woman scientist with natural hair who looked like them and could talk like them, but was also on a "break" from a place like Harvard. The notion that my "image" and presence was potentially reshaping their own aspirations and perceptions of possibility was incredibly inspiring.

Working with these students also brought a great sense of accountability about the opportunity that awaited me at Harvard. I had been on leave for more than a year, and one student in particular was not shy about reminding me. Each time we periodically crossed paths in the hallway, he would ask, "Ms. Ford, what are you still doing here? I thought you were going back to Harvard." Truthfully, I didn't know whether I was going to go back, but a major turning point in my decision process actually occurred in a somewhat unlikely place: a movie theater. I was watching the film *Akeelah and the Bee* when I heard for the first time a very powerful quote by Marianne Williamson: "Our deepest fear is not that we are inadequate but that we are powerful beyond measure. It is our light, not our darkness, that most frightens us. We ask ourselves, 'Who am I to be brilliant, gorgeous,

talented, fabulous?' Actually, who are you not to be?" This quote spoke to me because it tapped into how much my fear was promoting self-sabotage, and yet there was so much potential within me waiting to be unleashed. It was almost as if a lightbulb went on in my head, and I knew in that moment that I had to return to Harvard. I had to go back and finish what I had started, not only because I legitimately missed science and needed to prove to myself that I could do it but also because there were kids waiting for me to show them that they could do it too and that they had permission to go after their wildest dreams. To this day, those children in that South Central Los Angeles middle school remain a reminder to stay committed to my journey even when I am afraid, and of the importance of acting on behalf of the countless children (and adults) who might be unknowingly hindered by stereotype threat or imposter syndrome. I was fortunate to not encounter extreme self-doubt until graduate school, but I often wonder how many dreams of children are deferred because they feel incapable or unworthy of achieving the things they desire.

I'm so grateful that I took that time off, because if I had just tried to suffer through the program at Harvard, I don't think I would be where I am today. The combination of my experience at Harvard and serving as an educator reinforced the importance of encouraging and inspiring our kids to feel confident and to believe in themselves, especially in the context of STEM participation and achievement. This, in conjunction with my time dabbling in the entertainment industry, has transferred over into my more current work as a STEM education and inclusion advocate in the policy world.

After finishing my PhD and completing a short postdoctoral fellowship, I had the opportunity of a lifetime to serve as a staffer for the President's Council of Advisors on Science and Technology (PCAST) in the Obama White House. PCAST is an advisory group

of the nation's leading scientists and engineers that directly advises the president and the Executive Office of the President on a range of science and technology policy issues. President Obama's PCAST produced seminal reports on K–12 and postsecondary STEM education, elevating its importance as a national priority. President Obama prioritized improving STEM education and fostering inclusion from the outset of his administration. He also proudly admitted to being a science nerd and was probably our most science-savvy president since Thomas Jefferson.

After completing my two-year fellowship with PCAST, I later went on to serve as a senior policy advisor and designed and led what became known as the "Image of STEM" project. The goal of the work was to leverage the power of storytelling to improve public perception of STEM in order to promote diversity in STEM careers. Popular entertainment media is powerful because it can shape or reinforce the "cultural meanings" of STEM fields and careers, yet research at the Geena Davis Institute on Gender in Media has shown that men outpace women by five to one when it comes to portrayals of STEM professionals. What kind of message are we sending our little girls when we rarely show them in scientific careers? Given the statistics on stagnant and declining participation of African American women in the science and engineering fields, black women and girls especially need to be able to see images of themselves in technical roles in all forms of media. For children who don't have access to adults who work as scientists or engineers, media may be their only exposure. It has been underestimated how powerful negative stereotypes are in excluding people or prompting folks to opt out of the STEM world. Our challenge as a community and as a country is to liberate ourselves from these images and perceptions that have suggested, for centuries, that black people are not intelligent and do not excel in math or science.

In reality, quite the opposite is true, and an impactful first step in the right direction is unearthing the obscured history of black excellence in STEM. NASA mathematician Katherine Johnson, who was awarded the Medal of Freedom at the age of ninety-seven by President Obama in 2015, is a powerful example of this and of why stories matter. During the ceremony, tears welled up in my eyes as I listened to the president describe this amazing black woman who was so critical to our nation's history and yet had not been duly celebrated.

Katherine's story is the inspiration for the critically acclaimed, award-winning film *Hidden Figures*. As a part of my Image of STEM project, I co-organized a White House screening of *Hidden Figures* and also moderated a panel with the cast and creative team of the film, and First Lady Michelle Obama provided closing remarks. It was an amazing experience, and the absolute highest note on which to end my tenure in the Obama Administration. This event and the honor I had as a black woman leading such a project illustrated the unique platform the Obama White House afforded in promoting and uplifting positive messages and stories of black women in STEM fields. The success of the movie demonstrates the appetite for reimagining the image of black people, especially black women, in STEM fields. A challenge remains in capitalizing on the momentum of *Hidden Figures* as a part of the national effort to rebuild the image of STEM. This work is my passion.

I am unapologetically black and a woman. I am unapologetically a scientist. I usually rock my natural hair in a funky, pompadour updo, and I love bright lipstick. I have a silent *K* at the beginning of my first name, but if Knatokie is too difficult to pronounce, you can call me "Dr. Ford." I am building a new image of STEM by being it. ⚡

LUVVIE AJAYI

KNOW YOUR WORTH

Blogger, digital strategist, and *New York Times* bestselling author

ALLOW ME TO INTRODUCE MYSELF. MY NAME IS LUV, L TO THE U V. Okay, lemme stop. But really, I'm the writer and professional troublemaker who says what you think but dared not say, and I do it unapologetically. I'm the best friend in your head who speaks the truth. Truth is one of my major core values (and so is shea butter). Everything I do stems from that.

I'm known for my humor and my unique approach to writing and commentary. The humor I would use with my friends is the same humor I insert into my writing, and that's the key. Wit is so important, especially when talking about difficult issues, because it makes everything a bit more digestible. I've been blogging since 2003, and the responses I've gotten from readers have shown me how powerful humor can be in helping people deal with daily difficulties. Someone once messaged me to say, "I'm reading your blog, and this is the first time I've laughed in six months, since I've been going through a depressive episode." That (once) little blog of mine (AwesomelyLuvvie.com) eventually led to a book—*I'm Judging You: The Do-Better Manual*—which became a *New York Times* bestseller.

I got started by being funny, and I might be goofy AF sometimes, but one thing I'm serious about is my business.

My background is in marketing and communications. I was working as a full-time marketing coordinator back in 2010. That year, I got laid off, and people would constantly contact me to figure out how to do social media marketing for their businesses. That is when I started consulting for entrepreneurs, and that is the year I started working for myself full-time. Since

then, I've learned a hell of a lot about race, business, and monetization.

It takes a lot of time and courage to forge an entrepreneurial path, and when you are a black woman, it adds layers to it. Black women always have to quadruple-prove our worth: we always have to be four times as good to get half as far. It comes with constantly having to prove that you belong in the rooms you end up in. It comes with having to justify over and over again why you charge whatever you charge. A lot of times, we're expected to do luxury work for dollar-store pay, and it is beyond frustrating.

One of the lessons I've learned over the years is that sometimes you have to walk away from some money to make more money. When you feel personally cheated from doing good work, that feeling propels you. It motivates you to want to ensure you aren't being taken advantage of and that you are being paid your worth. A favorite quote of mine is from Nicki Minaj, who said, "Had I accepted the pickle juice, I would be drinking pickle juice right now." The point being: When you accept less than you're worth, that's what people will keep offering you. As women, we need to learn to ask for 100 percent of what we're worth, even when we are afraid to do it.

A passion point of mine is to figure out how to get us black women to work less and earn more. If this world were a true meritocracy, based on the elevation of the people who work the hardest, we would be the majority of the folks on the "richest" list. We work our asses off, and too often have little to show for it. Black women have this huge spirit of hustle, and we cannot work harder than we already are. Yes, some of us are making a lot of money, but we're working ourselves to the bone as teams and empires of one. That must stop. The one thing that is finite: our time. So I encourage us to buy time instead of always selling ours. We cannot do everything by ourselves.

Black women are my patronus, and surrounding myself with villages of black women has been my biggest form of self-care. As we live, work, and brunch in the City of Noir Pixie Dust, we also need to make sure we aren't burning out. The fastest-growing group of entrepreneurs in the United States is black women. It's time that more of us see our pockets filled as we do the great work we are known to do. It's time more of us have champagne bottles on our desks instead of jars of pickle juice. We've paid our dues, and now we should be paid our fair share. ⚡

LISA JACKSON

GREEN IS THE NEW BLACK

Chemical engineer, former administrator of the US Environmental Protection Agency, and vice president of Environment, Policy, and Social Initiatives at Apple Inc.

I GREW UP IN NEW ORLEANS, WHERE EDUCATION WASN'T ALWAYS EASILY accessible to black people. Education was important in my family, but there was only one other person who had been to college, my godmother. My parents never went to college, so there was a lot of expectation for me to pick up the torch. Like many black girls growing up, I was surrounded by strong black women who instilled in me the value of education, working hard, and never giving up. The matriarchs of my family dispensed "tough love." They'd say things like, "There is no doubt that you are going to school, there is no doubt that you are keeping your legs closed, and if you mess up, we will slap some sense into you!" From the beginning, there was a "no excuses" policy. My family's tough love was the bedrock of my expectations for myself and remains my foundation to this day.

From the beginning, I was a good student. I was the valedictorian of my high school class. I excelled in math and science. In those days, when you were good in math and science, teachers and counselors would tell you "You should be a doctor." I listened and grew up thinking that I was going to be a doctor. When I was a junior in high school, Tulane University offered a program sponsored by the National Consortium for Minorities in Engineering. There were very few black students going into engineering at that time, and they were trying to make us more aware of the opportunities. This program changed my view of what I wanted for myself in education.

It was a six-week summer program in which we took calculus and physics courses

and learned what engineers did. Through that program I fell in love with engineering. I didn't like the popular disciplines—electrical, mechanical, and civil engineering; I loved chemistry and decided that I wanted to be a chemical engineer. Once I made the decision, I went home and excitedly told my grandmother. "I don't know, Granny, I might want to be an engineer instead of a doctor." Her only reference to engineering was a train conductor. Her response made me laugh: "Honey, I support whatever you want to do, but how come you want to work on the train?" Her response was funny, but in hindsight it made me understand some of the challenges black students face when their parents can support them with love but not experience.

The summer program worked, and I decided to go to Tulane University to study chemical engineering. It was at Tulane, while studying engineering, where I first began to learn about the environment. The big news stories of horrendous environmental disasters at the time also captured my attention. I learned about the Love Canal in Niagara, New York, which was a hazardous waste site that made hundreds of people sick. I learned about the studies done on the water from the Mississippi that provided the drinking water in my hometown of New Orleans. The water had more than one hundred different identified carcinogens in it because of all the chemical waste being dumped into the river. I began to understand that our treatment of the environment was a manifestation of justice.

I felt conflicted. I wanted to become a chemical engineer, but began to think that I would be contributing to polluting the environment. Although I was interested in chemical engineering, I didn't want to be a part of the problem, creating toxins that harmed people. I wanted to help people. Then it occurred to me that if a chemical engineer knows how to make waste, then a chemical engineer ought to know how to clean it up. That's what I should be doing. That revelation was when the environmentalist in me was born.

I went on from Tulane to Princeton and earned a master's degree in chemical engineering with a focus on the environment. I went to work for a nonprofit, and then in 1987 I joined the Environmental Protection Agency in Washington, DC. It was literally my second job after college. I knew that if I wanted to help the environment and to have a long-term impact, the EPA was where I ought to be. I didn't know at the time that I would invited back many years later to lead the effort for environmental justice in one of the most important government agencies.

Being asked to lead the EPA during the tenure of the first African American president of the United States was beyond my wildest imagination. The tough love of my family and the concern of my grandmother were still with me as I was asked to be the first African American to lead the EPA. The expectations of the matriarchs who surrounded me when I was young and the tradition of passing the torch all rang out when I was asked to lead. It was one of the biggest honors of my life. It is so surreal and humbling to hold this place in history.

With my appointment also came a tremendous responsibility. I felt that I had to act on behalf of the countless people of color and communities that are marginalized, voiceless, and powerless in the face of environmental injustice and abuse. To be the first black head of the EPA meant personifying the idea that environmental protection should apply to all.

Seeking environmental justice is as complicated as the environment itself. Why does waste always tend to end up on the other side of the proverbial tracks? Everything from coal tar to oil spills to toxic water tends to affect poorer and unprotected commu-

nities. This is generally a result of the idea that the people who live "on the other side of the tracks" do not matter as much. It is not a coincidence that Flint, Michigan, is a poor community and their tap water is poisonous. Poor and disenfranchised people have fewer resources to advocate for their environmental protection. They are as vulnerable to environmental assault as they are to so many other assaults like substandard education and health care.

This is what I see as a critical role of the government. There are some things that government has to do for people. It has to protect people in the cases where market interests fail to do so. Our laws have to be designed to protect all of us. Not everyone has the money, time, or access to power to protect themselves, especially on environmental issues, which are big and complicated. Poor communities can't test their own water. That is the government's responsibility. The provision of clean water for children to drink, to bathe in, and to have food prepared with is something the government has to do for people. In the case of Flint, the water coming to people's homes was poisonous. That was an environmental crime that the people, who were mostly poor and black, could not protect themselves against.

I get mad when I think about corporations' roles in all of this. Many of them are practicing the worst kind of short-termism. They are driven by financial objectives at the expense of people's well-being. They are concerned about maximizing the next quarter's profit by lobbying for limiting regulations that cost money but protect people. Many executives of these firms make a moral choice. They choose to negatively affect unprotected communities by attempting to undo environmental regulations while living in protected areas where the air is good and they don't worry about their children drinking poisonous water. I don't know if there is anything more unjust than that.

It angers me when small groups of politicians team up with corporations and make plans to lift EPA protections in order to allow companies to make more money but that harm people and our environment in the process. Over 75 percent of all Americans believe that climate change is real. More than that, they believe human activity is the primary cause. Despite that, certain politicians and corporations continue to refute the science and resist the effort to address this global challenge.

We can all remember just one or two generations ago when catastrophic floods happened only once in a lifetime. Now we experience them with regularity. We are experiencing devastating droughts that are affecting food production here in the United States and around the world. The real issue with forging sustainable change in environmental justice is that there is a tendency for the people who can buy their way out of a problem to do just that. In many instances, the limited group of politicians and corporate leaders who are contributing to the problem are not yet feeling the effects of the problem. If it's a corporation whose whole business model and profits depend on burning fossil fuel, maintaining the status quo is in their best interest.

This is why environmental crises reoccur. When I think back, every decade had a huge environmental crisis that alarmed the general public about the importance of being proactive about environmental protection, but our elected officials have not always addressed these cases with transparency or urgency. In the 1960s there was lead and bacteria in pipes. In 1969, the Cuyahoga River in Ohio caught fire due to pollutants. There was a huge oil spill in Santa Barbara, California. The EPA responded with the Clean Water Act, which said we needed our water to be swimmable, fishable, and drinkable. In the 1970s there were cities like Los Angeles and Pittsburgh

where you literally couldn't see the sun at noon-time on many days because of the smog. The EPA responded with smog regulations for particulate matter and air pollution.

This is why the EPA is so important. The federal Environmental Protection Agency and the state-level EPAs were founded on the idea that the government must help to protect the air we breathe; the water we drink, swim in, and catch fish from; and the land we live on. I think the EPA is as important as the military. Just as we are prepared to protect our country with armed forces, we should be prepared to protect the environment that gives us the ability to live in this country. We should be passionate about that work, because we all can play a part in it and we all benefit from it. And if we want to see what happens when we don't do that, we don't have to look very far. There are a couple of countries and corporations that have made that choice, who have decided to go whole-hog for economic growth without any concern for air and water, and it's not sustainable.

Despite shouldering this tremendous national responsibility as the head of the EPA, I also had to shoulder the burden of doing it as a black woman. When I was head of the EPA, politicians—most of them white, male, and conservative—made it a point of pride to call me in for hearings. It was their opportunity to sit in public judgment of my work and to publicly scrutinize my authority and my decision-making. I was called for more public hearings than any other cabinet member. During the longest war in American history, in Afghanistan, I was called to testify more than the secretary of defense. The person controlling the military and the nuclear codes and the people controlling the treasury and the budget did not get questioned as much as I did. None of the other senior agency heads or cabinet members were questioned as much as I was. Not even close. The person they thought should come up and testify the most was me, the head of the EPA. A black woman.

They didn't even want my picture on the wall of the EPA. Every white person, male and female, who has run the EPA has a portrait on the wall. If you walk the halls of Congress, there are portraits of white people looking at you from every angle. If you chair a committee, there are portraits. If you go to the Pentagon, there are so many portraits of people there that you don't even know who they are—all paid for with public money. But when I had my portrait done, that was a feat! There was so much protest and pushback. They were opposed to documenting my history, and they were hypercritical of every move I made.

They change the rules. It was similar with the president—whether he went golfing or not, how many days of vacation he took—and the First Lady—what she wore, whether her arms were out, and whether arms and other body parts being out are okay. They change the rules on us, and if you are not surrounded by people to help make sure that you are seeing clearly, you will start to believe that the something wrong is you. That's the whole game. My mother's and grandmother's training gave me strength. When I could have been defeated spiritually and emotionally, I was not. I was propped up by the tradition of black women who have been battling forever. I was an extension of their tradition, and my portrait is on that wall.

The end of the Obama Administration was a transition for so many people. I'm so fortunate that I now work for Apple Inc. because it's a great company that is intentional about building a clean environmental footprint. Apple is probably the only place I would have gone after working for Barack Obama, and that's because when I met my boss, CEO Tim Cook, I knew I was dealing with somebody who agreed that you don't have to choose between making money and

doing the right thing by the planet and by the people who live on it. In 2017, we just announced that we are 96 percent renewable around the world. We just announced a huge goal to try to stop any connection between our products and mining for raw materials, because we know that those mines are doing devastating damage in places like Africa, Asia, and India, and even in our own country.

When I think about where I've been and what I've done, I'm overjoyed that I have been able to make a difference during my lifetime. I think I rock because I have a pretty good brain. I've ridden my talent for good, not just for me but for the overall good of humanity. I'm still on my journey, but I know what makes me happy has always been giving back. I feel like philanthropy is our shared purpose in life, regardless of one's career choice. It's that story from the Bible, the Parable of Talents, in which you learn that if you take your talent, dig a hole, and put it under the ground to protect it or preserve it, you'll still have it, but if it's not being utilized it will never grow in interest. I believe our purpose is to use our gifts to create progress in the world. We do not gain anything from burying our talents. And I think what black women have done so well for such a long time, whether in our own families and communities or in politics, in corporate America, or in academia, is to take our talents and use them. Ain't nothing gonna stop us. That is our magic. That is why we rock.

BRIDGET "BIDDY" MASON

FAITH AND FORTUNE

Born a slave in Georgia, Bridget "Biddy" Mason made history as an emancipated entrepreneur in Los Angeles. Upon earning her freedom, Biddy earned a living as a nurse and midwife. She carefully saved her money and accumulated three hundred thousand dollars. She then made history as the first black woman landowner in Los Angeles, ultimately propelling her to a life as a real estate mogul. "Grandma Mason" or "Auntie Mason," as she was affectionately called, embraced a philanthropic passion and shared her wealth with the poor, visited with prisoners, and invested in children's education. Biddy donated the land for and financed the First African Methodist Episcopal Church in Los Angeles, the city's first black church.

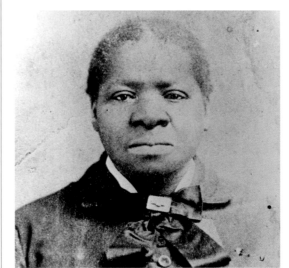

JESSICA O. MATTHEWS

POWER PLAY

Renewable energy inventor and entrepreneur

I HAVE BEEN FORTUNATE ENOUGH TO HAVE TEN PATENTS AND PATENTS pending in a world where only 13 percent of patent holders are women. As a result, one of the questions I'm most often asked in interviews is, "Who is your favorite inventor?" The interviewer might expect me to say someone well-known like Marie Curie or Madam C. J. Walker (two badass female inventors I truly do revere), but the truth is that my favorite inventor is my mother, Florence Matthews. She's not a professional scientist or a patent holder, but she's had more impressive MacGyver moments than anyone else I know. Growing up, I didn't see a lot of black girls or women portrayed as inventors or scientists in the media, even though they were out there (a là *Hidden Figures*). It can be a struggle when no one looks like you in the space in which you yearn to exist, but my mother taught me to transform my obstacles into strengths. She taught me to ask myself again and again: What does it really mean to be black, to be female, and to be an inventor—all at the same time? What does it mean to love everything that makes me different and to embrace the opportunity to show myself what I can really do? The shorthand answer to these questions: It means I need look nowhere but within myself for the motivation to build the world from my own perspective. I need to continuously set my own standards for success and view my authenticity as a compass that guides my every move. And after twenty-nine years of life, I can confidently say that my authenticity compass can best be described as a perfect balance between Bill Nye the Science

Guy and Beyoncé. This is my own unique brand of Black Girl Magic.

When I was nineteen and a rising junior in college, I invented the SOCCKET, an energy-generating soccer ball that provides off-grid power for the developing world. Just sixty minutes of play can provide up to three hours of light. The idea for the SOCCKET came from my lived experience. Every summer, my family would travel from our home in Poughkeepsie, New York, to visit relatives in Nigeria, where everyone—no matter their socioeconomic status—had to contend with dirty, unreliable energy from diesel generators and kerosene lamps. These devices are horrible for the environment, and their fumes cause lung damage equivalent to smoking two packs of cigarettes a day. However, during my visits, I noticed that what was as ubiquitous as poor energy access in Nigeria was soccer. Soccer brought unrestrained joy that inspired passion and hope in people young and old. It did not occur to me that something people enjoyed as much as soccer could be used to address a problem as serious as energy access until I took a class called Idea Translation: Effecting Change Through Art and Science, in which we had to identify a problem and then, through science or art, try to find a solution. I did not consider myself at the time to be a pure scientist or artist. However, I did have my unique experiences in Nigeria to draw from when considering both the problem (i.e., a lack of access to clean electricity) and a potential way to address it (i.e., through a sport full of "artistic" athletic display loved around the world). I very quickly earned a PhD in Google as I researched everything I could find on the mechanical, electrical, and physical properties of energy generation. This was how my obsession with the power of movement and social invention began.

The first SOCCKET prototype was full of Mac-Gyver moments inspired by my upbringing. I never had the "Well, I can't make this because I'm not a mechanical engineer" moment. Instead, I used what was available to me at the time and sourced many of my initial research and design materials from the local convenience store! The engineering students scoffed at the idea at first, telling me it was impossible. But they did not have the advantage of my experiences in Nigeria and my understanding of the market for which the invention was intended. Eventually, the SOCCKET—and my experiences in emerging and developing markets—would become the seed for Uncharted Play, the company I founded when I was twenty-two.

Uncharted Play is a renewable-energy company that creates microgenerator energy systems that can be scaled to power large infrastructure systems such as streetlights, Wi-Fi hotspots, and off-grid electricity power packs. Starting first with an energy-generating soccer ball, I built a company that would provide a platform for energy innovations both large and small. But in order to start the company, I had to be a leader in addition to being a dreamer. That meant making a solid business plan, building a team, and raising money from venture capitalists in a world I barely understood. I walked into rooms filled with people who looked nothing like me. The world I was entering was white, straight, and male. At first, I worried that these investors would never understand me. We don't even laugh at the same things. Like it or not, these kinds of nuances are critically important when you are thinking about giving your money to someone, and investors often invest in people who look and sound like them. That is not good news for black women or anyone else who does not match the classic "Silicon Valley pattern." Digital Undivided did a groundbreaking

study titled "Project Diane" that showed that out of 10,238 venture deals closed between 2012 and 2014, only 24 were closed with a black female founder or cofounder. In addition, only eleven start-ups founded by black women have raised more than one million dollars in venture capital. Eleven! As Project Diane puts it, black women are the real tech unicorns.

So how did I raise the money I needed in that environment? At first, I felt pressure to change myself—to change how I spoke and existed in an attempt to blend into this world: to code-switch permanently. However, I understood from the beginning that I couldn't pretend I was just like the VC guys—not even for a minute. Successful start-ups need investment partners who will stand by them and what they represent. Companies have ups and downs, so when you are thinking about your investors, as a black woman you might wonder, "How can I ensure they'll support me during those lows when they don't fully understand where I come from and how I plan to deal with those lows?" My aha moment came in realizing that while investors trend toward the familiar, what they are looking for in these familiar places is something that is impactful and authentic. Impact and authenticity are at the core of Uncharted Play. So yes, we could code-switch and try to play down the things that make us different, but the investors that were truly fit to help us scale would want us to double down on the things that define and differentiate us. Raising money is rarely easy, especially for minority groups, but it is possible to do it effectively if you remind yourself that you are enough—in fact, you are more than they could have ever dreamed.

Uncharted Play started in Manhattan's Wall Street area, but I moved our headquarters to a beautiful brownstone in Harlem. I'm intentionally not in Silicon Valley. After a successful venture capital raise, I faced pressure to move my company to the West Coast, where "all the talent is" for tech. But the West Coast didn't feel authentic to us, and I wondered how much we'd have to code-switch to fit into the culture there. If we didn't fit in at the table in Silicon Valley, was there another way? What if we doubled down on what makes us great and created our own table—in Harlem? I already knew that good ideas and talent could come from anywhere. My mother showed me that long ago. So we followed our instincts and have been successful not only in terms of profit and growth but also in terms of giving back to the community in ways that create opportunity right here. We're doing everything from hiring local vendors to encouraging new start-ups to providing students in Harlem with our social inventor curriculum, "Think Out of Bounds," which aims to inspire future social innovators to embrace their differences and communities to create impactful and meaningful inventions. The typewriter, the paintbrush, and the pen—those were some of the most important tools of the Harlem Renaissance. The next renaissance is going to be about the soldering iron, the laptop, the microgenerator, and the 3-D printer. Everything we are building and sharing here at Uncharted Play is infused with culture, art, and science, and in a way brings me right back to that Idea Translation class. Uncharted Play is effecting change through art and science in Harlem and around the world.

My perspective as a black woman has been my greatest asset as an inventor and an entrepreneur. It can be hard, but when we view our unique perspective as a competitive advantage instead of an obstacle, the world notices and follows suit. Do not be afraid to be

different, to be authentic, to be black, or to be female. Own it. Relish it. Doubling down on everything that makes me different from others in this space is what has opened the most doors for me. Never underestimate Black Girl Magic. ⚡

her story
—
SYLVIA ROBINSON

COLD CRUSH SISTA

Cofounder of hip-hop's first record label, Sylvia Robinson was the queen of Sugar Hill Records. Robinson's R&B roots from the sixties and seventies included singing, penning, and producing chart-topping singles, all of which prepared her to help pioneer and usher in the new era of hip-hop. She signed legends such as the Furious Five and Grandmaster Flash and produced Flash's classic, socially aware rap track "The Message." The year was 1982, and Robinson was introducing the world not only to the genre but also to the business of hip-hop.

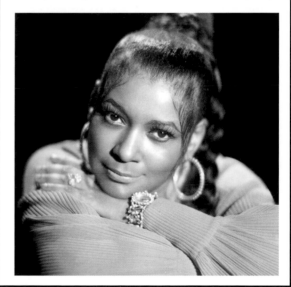

IV.

LIFT EVERY VOICE

her story

THE RBGS:
SOJOURNER TRUTH,
HARRIET TUBMAN,
NANA YAA ASANTEWAA

These three women warriors were "revolutionary but gangsta" in their fight for truth, justice, and humanity.

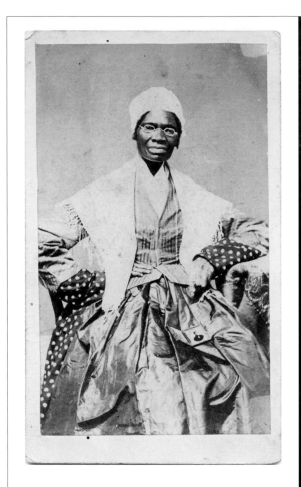

SOJOURNER TRUTH

THE TRUTH

"Truth is powerful and it prevails."

At the 1851 Women's Rights Convention held in Akron, Ohio, Sojourner Truth delivered one of the most famous abolitionist and women's rights speeches in American history, "Ain't I a Woman?" Her question called out the hypocrisy of the first-wave feminist movement, which overlooked the human rights struggles of black women and other women of color.

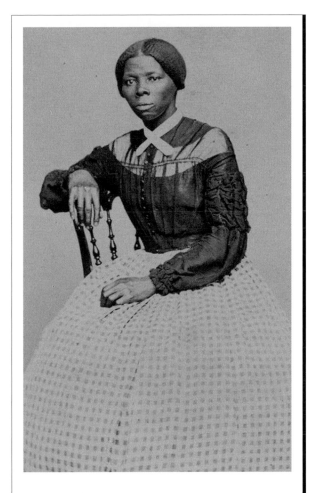

HARRIET TUBMAN

THE ORIGINAL GANGSTA

"Every great dream begins with a dreamer. Always remember, you have within you the strength, the patience, and the passion to reach for the stars to change the world."

Harriet Tubman was a fierce freedom fighter and a leading abolitionist. Not only did Tubman escape slavery but she also returned to the South nineteen times to liberate enslaved men, women, and children, leading them to freedom along the Underground Railroad.

NANA YAA ASANTEWAA

THE ILL NANA

"I must say this, if you the men of Ashanti will not go forward, then we will. We the women will. I shall call upon my fellow women. We will fight till the last of us falls in the battlefields."

Yaa Asantewaa was a queen, an intellectual, a politician, a human rights activist, and a dynamic leader. She became famous for leading the Ashanti rebellion against British colonialism to defend the Golden Stool of the Ashanti people. She is also known for her prominent role in promoting women's emancipation and gender equality.

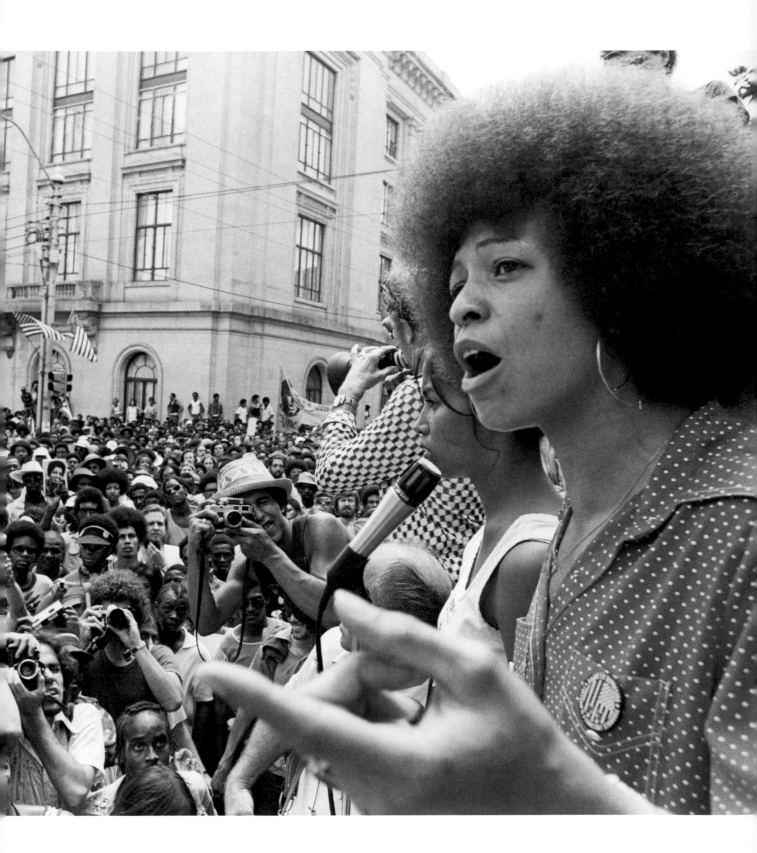

ANGELA DAVIS

ALL POWER TO THE PEOPLE

Educator, activist, intellectual, and author

I DIDN'T MAKE A DELIBERATE DECISION TO DEVOTE MY LIFE TO SOCIAL justice. I don't think there was a single epiphany or moment of realization. Rather, I grew up under conditions that required that kind of resistance. The forces of racism were all around us. My mother and father taught us that the only way we could preserve our own integrity and self-confidence was to struggle against those forces. All the messages around us were telling us that we were inferior and that we didn't deserve to live decent human lives; that we didn't deserve education, that we didn't deserve to live the life of free citizens. Therefore, from a very young age, I was involved in collective campaigns of resistance, and for me it became a way of life. I cannot imagine my past or future life in another way.

Most people are aware of who I am today because, in the very first place, there was a vast movement around demanding my freedom. I more than likely would still be in prison had it not been for the fact that millions and millions of people in the country and all over the world joined together to conduct a struggle that was assumed to be unwinnable at that time. Richard Nixon was the president; Ronald Reagan was the governor of California, where I was in jail; J. Edgar Hoover was the head of the FBI—and all three of them had dedicated themselves to guaranteeing that I would be sent to the death chamber or spend my life in prison. Although people recognized that I was not guilty of the murder, kidnapping, and criminal conspiracy charges, many people at that time assumed it was impossible to counter the strongest forces in the world—the most powerful forces on this planet.

I remind not only myself but also those who tend to see me as a legend or icon that if I am important, it is only because of the message my presence carries. I think my presence conveys the importance of people coming together. That we can be victorious even when we're up against seemingly insurmountable odds, and that's a message that we need even more today.

I think we've completely underestimated the power of white supremacy and racism in this country. The 2016 election was a wake-up call. We didn't do the work we should have done to present a more complex analysis of what was at stake. About a quarter of eligible voters voted for Donald Trump, and we should remember that. Vast numbers of people who would have voted against him simply chose not to vote, and that, I think, has to do with the fact that our movements, while growing, aren't as powerful as they should be. Had the young people who chose not to vote been given an urgent message regarding what was at stake, perhaps they would have gone to the polls.

One of the reasons it was so important to use our right to vote has to do with the impact on the Supreme Court and how Supreme Court decisions can affect people for many generations to come. Given that analysis, we should have viewed the 2016 election not so much as one that would pick the more perfect candidate to lead us, but as an election that was about creating the space for more radical organizing. It's critical for us to be strategic. One can analyze the recent overt rise of racism, patriarchy, and white supremacy as a vicious response to having a black president and black First Family in the White House, and to the presence of the Black Lives Matter movement, which represents to some the resurgence of militant, radical activism.

Regardless of the outcome of any election, we must continue to organize at the grassroots level in order to counter the forces threatening our humanity. I remember when Richard Nixon was elected, which was a major defeat in 1968: our response was not so much to mourn the outcome but, rather, to recognize that we had to accelerate our political efforts in grassroots movements. That is precisely what we need to do today.

I'm hoping that this period is going to witness not so much the resurgence of radical activism, but the emergence of a *new* kind of activism. I always think about the June Jordan line in her "Poem for South African Women": "we are the ones we've been waiting for." We have to create that resistance. We know so much more than we knew during the Civil Rights era, and can do so much more. This is going to have to be a period of unceasing resistance to the current political climate.

It's going to be increasingly important to develop the kinds of strategies that allow people in black communities to recognize that there is no hope for black people if we cannot push back against all challenges to social justice and human rights. It's going to be important for black people, in particular, to be sensitive to the emergence of new forms of racism, including the current climate of violent Islamophobia and anti-immigrant sentiment. We have to stand together with immigrants regardless of their country of origin. We also have to centralize the climate issue because, of course, climate justice is ground zero for social justice. If we have no planet in the future, it will make no sense at all to have won victories in areas of racial or gender justice.

Within the arena of private prisons, it is the immigrant detention centers that are now most likely to generate a huge profit for corporations, and this is why private prison companies have been supporters of anti-immigrant legislation, the most destructive

anti-immigrant legislation of this era. And let me say this: racism, of course, is a fuel for all this. If one looks at who's in prison, not only in the United States but all over the world, it's people of color. It's people from the global south, it's immigrants, it's refugees. So, we must address the role that prisons are playing in compelling us to look away from the problem, to think about crime rather than education, and to think about crime in a very narrow sense, considering that the vast majority of people in prison have never committed a violent act but only property crimes.

Prison abolition is one of the chief human rights issues of this time. Prison represents ways of refusing to address the most important social problems of our era under the pressure of capitalism. Rather than providing people with adequate housing, education, mental health care, and all the other services they need to live decently as human beings, the strategy that emanates from the United States and the era of global capitalism has been to lock up those people who have problems so that you can forget the problems or needs exist. Prisons have become such an integral part of the general economy that corporations one would think would have little stake in large prison populations are now very much involved in the effort to continue to retain these populations because they have contracts with prisons. From telecommunications companies to food production and medical care—it is all outsourced to these companies, which now seek prisons as a source of profit.

We must call upon the feminist notion of intersectionality and the deep relationality that animates all social justice questions. Black feminism, in particular, is a feminism that emanates from radical women of color—it is a feminism focused not only on gender, but also on the interconnectedness of all the social disparities women and people of color face. Black feminism has revealed new paradigms of leadership.

It's not simply replacing black men with black women but, rather, it is an emergence of a new kind of collective leadership that Ella Baker argued for many decades ago during the civil rights movement. Not only have black women recognized that it's important to take credit and seize leadership, but black men have begun to follow our lead, particularly younger black men, who are much more aware of the importance of accepting the leadership of black women. It's very important that we recognize that black women, more accurately and more fundamentally, represent the interests of all.

I have always recognized that the fate of black people is interconnected with the fate of the planet and the fate of the universe, because of our history: Our history has been a constant struggle for freedom, and black women are the backbone of that struggle—not only today, but historically. From the antislavery movement to the civil rights movement, black women have always been freedom fighters on the front lines for our families and community, even when we weren't given the credit for our courageous leadership and social justice work. And that is why we rock. ⚡

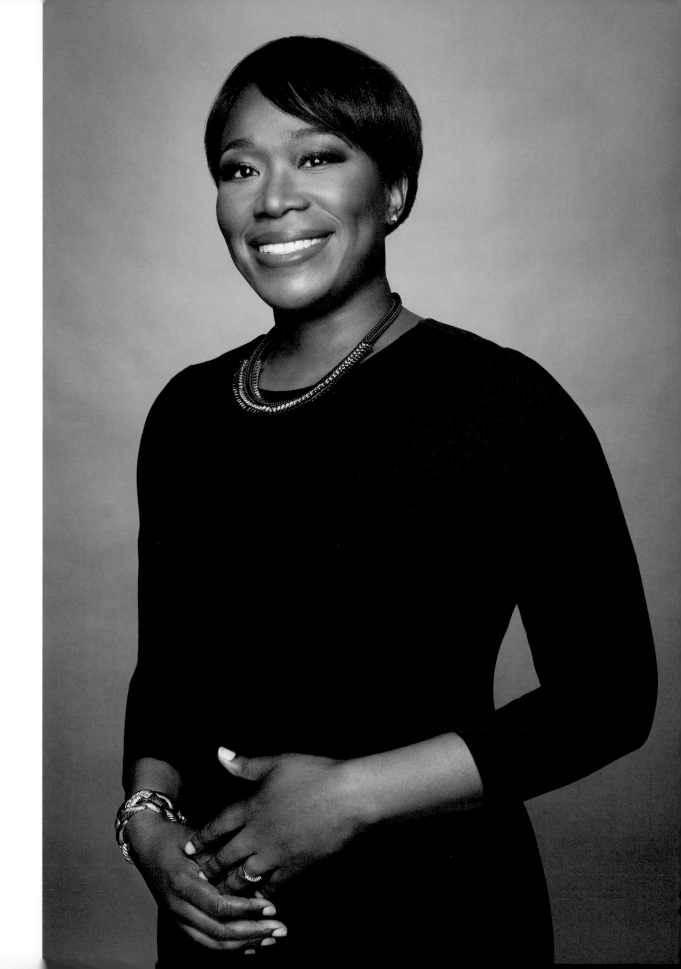

JOY-ANN REID

I AM JOY

Journalist, political commentator, and host of *AM Joy*

WHEN A WEST INDIAN CHILD SAYS, "I WOULD LIKE TO BE A DOCTOR," their whole family pretty much converges around the *certainty* that she will, in fact, become a doctor. Such was the case for me. I enrolled at Harvard University as a pre-med student, but my mother passed away about thirty days before I started school. I lost all faith in medicine and developed a complete phobia of even walking into hospitals. I literally couldn't see the idea of entering a profession that I thought failed me, my mom, and my family. So, I entered Harvard feeling very depressed.

After freshman year, I decided to take a year off from school. I went to New York and moved in with my aunt in Brooklyn while I figured out what I was going to do with the rest of my life. I wound up getting a series of temporary jobs, one of which was at Columbia Pictures. I eventually got my own place in Fort Greene right down the street from Spike Lee's 40 Acres and A Mule offices. There were always productions and creative things going on in the neighborhood. The area was kind of a black Bohemia at the time, and that creative energy really motivated me.

The following year, I went back to Harvard inspired to do something creative. I changed my concentration to visual environmental studies, with a concentration in documentary filmmaking. After I graduated, I went knocking around for jobs in New York. I got a job in the production office at the School of Visual Arts, which is where I met my husband. When I got pregnant, my husband and I moved to Florida, where I landed a job at a Fox News affiliate in Miami working as a writer on the morning show. It was

fascinating, because it combined the things I had always loved the most: politics, news, and writing. I just loved it. So I fully immersed myself in it. I also started my own tiny political blog on the side. Eventually, I landed at the NBC affiliate in Miami and wrote a column for the *Miami Herald*.

My very first column got me into trouble because it was in opposition to invading Iraq. I was very much against war and very unsettled by the way we were covering it and the way I felt the news business was not directly in touch with the people who were the most impacted: the families and the people who were going off to fight this war, which was billed falsely as vengeance for 9/11. I just found that unacceptable.

My own personal views on the war led me to go into politics and political journalism. I felt that mainstream journalism had morphed into this middle-of-the-road safe space, and that wasn't for me. I still had the need to have my own voice and not this regurgitated voice of the news corporation for which I was working. I also wanted to be directly responsible to the public, to provide them with accurate, thorough, informed, and truthful reporting.

Journalism has definitely tried to restrict its voice over the years because of this perception of bias. The fear of *appearing* biased has caused journalism to back away from telling definitive truths in favor of more neutral reporting. I don't think it's a malicious thing. News organizations are sensitive to the audience's perception that they are on one side of the cultural divide and opposed to the other side. This has evolved for a lot of reasons, but mostly because of race, to be quite frank. If you look back to the turn of the century, when journalism was trying to pull back from the jingoistic, pro-war, Pulitzer-driven tabloid wars, you had the kind of aesthetic journalism in which people would see a lynching and just report on it without any emotion. It was sort of bloodless reporting of horror

that generally had to do with race-related incidents.

There were a lot of black journalists who demanded change. When black newspapers and black journalists demanded that the moral dimension be brought back into reporting, it was because they were fighting against the extrajudicial murdering of black people, and that sort of required that journalists take an absolute stand. That really bled into civil rights coverage: things like bussing and lynching. But this really exacerbated the sense among *some* Americans that journalism was liberal, was leaning toward people of color's point of view, was leaning toward women in this battle over birth control and abortion—and away from traditional America, which is largely "white America." Journalists sort of internalized this criticism and decided that they should just be neutral when reporting, rather than take a stand even when something was wrong. And now that people have said journalism is biased, you have an explosion of niche media that fits whatever ideology makes you feel the most comfortable. If you are a right-wing conservative, you can just imbibe that; if you are a conspiracy theorist, you can just imbibe that. I think that polarization has caused a crisis of confidence in mainstream journalism.

When journalists refrain from fact-checking or do not use their platform to investigate implicit dangers because they want to appear neutral, they do the public a disservice. Journalism has an obligation to have more integrity than that. Culturally, we have to decide whether we truly value "free press" as a form of checks and balances; and we journalists have to reclaim our voices and our responsibility to tell hard truths. We try to do that on *AM Joy* every week.

Look at what happened in the 2016 presidential election and its aftermath. There was a heightened level of absurdity in the media coverage during the campaign—from the rise in fake news to the refusal

to really examine outrageous behaviors, exclusionary ideologies, and the mental state of a leading presidential candidate. There wasn't enough *matter-of-fact* reporting on the questionable people who had been appointed to the new administration, or real investigative reporting on Russia's interference with the campaign.

When media covered the 2016 campaign, Donald Trump's reprehensible behavior was often justified and normalized to a certain extent. The media attempted to balance both sides rather than appear to be biased, even when the truth was glaring. This resulted in a deeply ingrained public belief that the presidential candidates were two equally and identically flawed people. I think this media narrative had a tremendous influence on young people in particular. They grabbed onto the idea that there wasn't a *real* difference between the candidates; they were both evil, so a lot of them did not bother to exercise their right to vote or voted for the third-party candidate as some form of protest or rebellion.

These presidential candidates were absolutely not the same. Trump said things like, "I can go out and shoot someone today and I would still win"; he subtly suggested that Hillary should be "handled" by anti-gun-control lobbyists; he suggested that it was appropriate to "grab women by the p—y"; he would not show his tax returns; and he has constantly threatened marginalized people around the world. But the media treated this ridiculously sexist, racist, Islamophobic, and xenophobic behavior as if it were just one side of the argument. I think Trump's campaign counted on this fallacy in modern journalism in which mainstream media backs off from being investigative or hypercritical. I'm proud to say we didn't take that tack on my show. We tried to meet Trump and his campaign head-on.

It's unfortunate that the same young people who marched, protested, and organized on grassroots levels were also partially swayed by this media narrative regarding the two "undesirable" presidential candidates. Once Bernie Sanders was no longer an option, they failed to use their right to vote for the best candidate available or to use their platform to mobilize others to vote. They dropped the ball.

History has lanes—and I think that's the thing that some young people missed in their quest for a charismatic presidential candidate. The president of the United States is not a civil rights activist. You are not voting for a civil rights leader. They were trying to vote for a charismatic leader like a Martin Luther King Jr. figure, but King was not the president of the United States. He negotiated with the president of the United States. And King would rather have negotiated with Lyndon B. Johnson, with all of his flaws, than with the alternative. That reality must be learned, so people who try to reenact the sixties understand the need to do the full reenactment. In the fifties when Emmett Till was lynched, Dwight Eisenhower had to eventually send in the FBI, make the arrest, and make a federal investigation out of it. There would be a civil rights department, after the civil rights bill, that would investigate civil rights cases. The murder of Medgar Evers got federal attention. The National Guard came in to *stop* the local police officers from beating African Americans. In the sixties when John Lewis was violently assaulted in Selma, Alabama, the cavalry was sent in by Robert Kennedy and the Justice Department. Members of the white nationalist "Alt Right" have served inside the White House, and the Justice Department is led by an inversion of Robert Kennedy. If Jefferson Sessions is responsible for sending in the cavalry, guess what? The cavalry isn't coming!

As a political commentator, I am fortunate that I am in the position to use my voice and my platform to report hard facts that can inform public opinion. I

am fortunate enough to be in a position on my show to challenge untruths, to question the status quo, and to use media to elevate the voices of marginalized people. There aren't a lot of people of color in this media business who get to give our opinion and have this platform. Consequently, I feel a huge obligation to be informed, to be intelligent, and to be coherent while representing myself and people who look like me. I do my very best to take on the important but difficult topics that concern people of color. When others scratch the surface, I take a deep dive and give in-depth analysis on issues like race in politics, police brutality, and immigration.

I've spoken about the racial hysteria regarding the reactionary responses to the Obamas—especially to Michelle Obama, who received racist taunts until the very end of her husband's term. It's impossible to overstate how incredibly threatening she was to a certain subset of white America. She was challenging everything that they believed a woman and a First Lady should be. She was bearing her arms, literally, and she's strong as well as beautiful, confident, and accomplished. The more successful she was, the more angry people became.

When there were these racist portrayals of her and her daughters as apes and beasts, I thought it was important to remind people that this repulsive narrative was quintessentially American. This is part of our country's story. Black women have always been bestialized and reduced to kinds of animals, workhorses with no value and no beauty and no grace. And that is a part of America that Americans do not like to see. Our history is that America was born a slave republic, and even now, that legacy is with us. A powerful black woman is still threatening.

When I went Florida to cover the Trayvon Martin case, that was actually the first time I had that level of national exposure. At that time, I realized how huge my responsibility as a reporter was. So many young people, teenagers, elderly people, and black women would come up to me—sometimes teary-eyed—saying how important it was to have someone who looked like them doing what I did and having *that* voice. It is a tremendous honor to represent us, and one I take seriously. I want to make my family proud. I would love to make my late mother proud, and, of course, I want to make African Americans, black people—the Diaspora—proud.

I think you'll find that while we've made tremendous progress, we still have a long way to go to get the voices of people of color, women of color, people of alternate religions, and people of different sexual orientations to the front of the line. In my little corner of the media, we're certainly working on it. ⚡

PATRISSE CULLORS

BLACK LIVES MATTER

Activist and cofounder of Black Lives Matter

I AM AN ORGANIZER AND AN ADVOCATE FOR BLACK LIBERATION. COMMUNITY organizing has been my life's work. I'm committed to service. I grew up in a poor working-class neighborhood outside Los Angeles. Never did I imagine that my community organizing work would take me from a small suburb of Los Angeles and catapult me to a national and international stage. It feels jarring, and it can be challenging at times. There's a lot of pressure when people are watching you and trusting you to lead them somewhere. I try to remind people that I'm not their light. They are their own light. That's the Ella Baker model. Baker would go into communities and remind people that *they* had the power to create and sustain change! It's an incredible responsibility to be present in this current time, but despite the pressure, I do feel honored and humbled that I get to be a part of history in this way and hope to continue contributing to the liberation of black people.

When Alicia Garza, Opal Tometi, and I first imagined the development of Black Lives Matter, we wanted to create something that could resonate with black people around the world. Black Lives Matter is not just an affirmation for us, and it is not just about black people living inside the United States. It is about blackness as a philosophy, as a way of life across the diaspora. We've seen blackness being picked apart, abused, destroyed, and humiliated all over the world historically and presently. So, we wanted to use Black Lives Matter as a way to uplift, to rebuild, to respond, and to really put the flag in the ground — to say that we matter as black people and we deserve life and we deserve dignity.

I think Black Lives Matter has resonated so deeply because when black women create

things, we don't put boundaries around them. We offer them to the world. Sometimes this sharing so freely can be our blessing, and sometimes it's our curse, but we offer it to the world anyway. So, Black Lives Matter was an offering, one that people really needed at the time. People needed it desperately, and they needed to feel like it belonged to *them* just as much as it belonged to us. When folks first heard the words "Black Lives Matter" (or when they hear the words now), I think they reverberated in people's bodies; it's such a strong, affirming, and unified declaration. It's our powerful declaration of our humanity—similar to what "Black Power" was in the 1960s and '70s.

Building this movement with two other black women has been very special. Black Lives Matter has been such an important opportunity for the three of us to transform as women, leaders, and organizers. Black women are often pitted against one another, so the symbolism and action behind three women coming together to build such a tremendous platform is also very powerful. When I go to places around the world to talk, it's black women who come up to me the most and who express gratitude. "Thank you for making us more visible," "Thank you for reminding people how much we do and how much we carry this country!"

That doesn't mean we have not had our detractors. What we have seen over the last three years is this deep need to discredit us as women leaders, this idea that we are not deserving of where the movement is at right now. Clearly, we don't believe we did everything on our own, but we do believe that we laid the foundation for this groundswell. We didn't just put out a hashtag. We built, curated, and developed this thing—just like you do with any garden or art piece. It's okay for us to take credit for having built the foundation of what is now the Black Lives Matter movement! If we were black men, people wouldn't be as upset with the credit we get. But some are upset because it's still so hard for people to celebrate black women and our successes. I don't think people even understand why, but it's what I call "misogyn-noir." I observe it, but I've learned not to let it make me feel jaded or prevent me from doing the work.

A lot of people have told me, "You are so humble"—considering the accolades and tremendous visibility of Black Lives Matter. I always think, "What else am I supposed to be?" It doesn't matter how many awards I get or how many times I appear in a magazine. If that isn't translating to black folks getting freer, then that's not success to me. Success is in the collective! ⚡

EUNIQUE JONES GIBSON

BECAUSE OF THEM WE CAN

Artist and founder of Because of Them We Can™

IN 2013, AS WE APPROACHED BLACK HISTORY MONTH AND THE ONE-YEAR anniversary of Trayvon Martin's murder, I started to think about the negativity surrounding African Americans in the media. I worried about how those images and narratives would impact my own children, and I wanted to play an active role in changing the messages that were being conveyed about us. I thought that one great way to refute the negative stereotypes and false narratives would be to place our young people in the shoes of history makers. So, in February 2013, we started Because of Them We Can™, a month-long community engagement campaign that depicted children as famous black historical figures. The campaign started small, featuring my kids in our home, but soon it grew beyond the confines of our house and spread across the country. We initially planned for the project to last twenty-eight days, but when we saw how Because of Them We Can™ was shifting the culture as it pertained to black history and black excellence, we knew it needed to be bigger.

Because the visuals the campaign used featured children, people were able to lower

the barriers they might otherwise have put up when being taught about black history. For example, some may view a photo of Malcolm X and jump to conclusions based on their preconceived notions about his ideology or his religion. However, with Malcolm X depicted as a seven-year-old, it was easier for people to let their guard down and open their minds. We've had people of all different races, including white people, Latinos, and Asian Americans, reach out and share how these photographs touched their hearts and challenged their thinking. The campaign pushed everyone to confront his or her own biases and misconceptions.

Nina Simone once said, "It is an artist's duty to reflect the times." While that may be true in a lot of ways, I also did not want to succumb to the negativity of our current political and social atmosphere. I wanted to take the opposite approach, and not just reflect these times of struggle but also demonstrate that, in the midst of the struggle, in the midst of the hardships that we constantly endure as a people, we continue to make amazing things happen.

It is important for me that we still remember our strength, our resilience, and our greatness. We have to remember these things so we can move toward brighter days. We are the evidence of the progress of our ancestors, and it is important not only to reflect the times as an artist but also to communicate our accomplishments. ⚡

> We are the evidence of the progress of our ancestors, and it is important not only to reflect the times as an artist but also to communicate our accomplishments.

TAMIKA D. MALLORY

WHY WE MARCH

Organizer, activist, and marketing strategist

I WAS RAISED AS A MOVEMENT BABY. MY PARENTS ARE ACTIVE IN THE CIVIL rights struggle. My siblings and I were young when they introduced us to it. But at twenty, when my son's father was shot, killed, and left in a ditch for two weeks before his body was discovered, my life changed. This was no longer my parents' civil rights movement. It had become my own.

My son was two when his father, Jason, was killed. After losing him, I was extremely depressed, frustrated, and embarrassed about the way he died. Jason's mother and father both struggled with drugs and incarceration throughout his life, but he lived with his grandparents in a good, middle-class household, and I didn't want people to know he was engaged in illegal activity. It was embarrassing. As I began to peel back the onion, though, I realized that he wasn't alone. As far as how his life ended, many young men have had the same story. It was becoming a trend. I'd joined a club that so many women were part of: the single-baby-mama-of-a-child-whose-father-has-been-killed club.

At the time, I didn't see the link between fighting police brutality and issues of inequity and poverty. Lack of education, housing, mental health services, other resources, and overall hope is directly connected to the number of young men being shot and killed on our streets. I began to look at the system and how it was set up so that young black men are led to either try to get a scholarship to play ball or end up in prison or dead like my son's father. I realized that being depressed about what happened to him wasn't enough. I wanted to be more proactive. I needed to be a participant in the fight against the ills in our

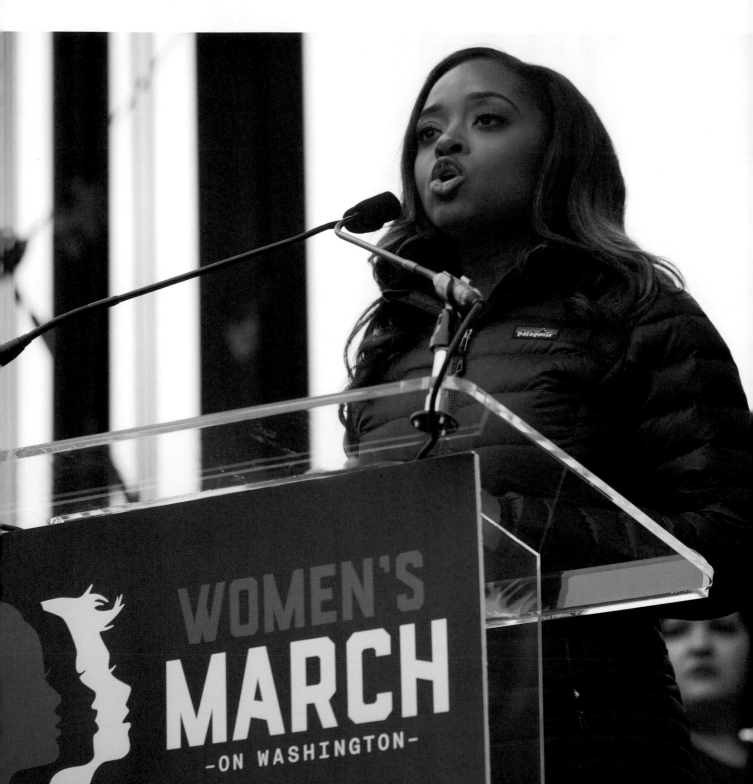

community that make this negative narrative a reality for so many black families.

Cases like Amadou Diallo's also influenced me. He was a young man aspiring to be a success, fighting against the odds. When he was shot forty-one times by police in 1999, the city never acknowledged that the cops had made a mistake. Nor did it acknowledge that the entire community was suffering and outraged as a result of this inhumane treatment. Rudolph Giuliani was mayor of New York at the time. His tongue was so disrespectful. Meanwhile, much of the city went on with business as usual, as if Amadou's life did not matter. He had been dehumanized and criminalized—and that was too much for me to handle. When some people feel down or discouraged, they sort of live in that space. But what I had learned as a very young child in the movement was that when there's a problem, there's always something we can do about it.

In order for us to be able to address gun violence, we have to be able to love both the victim and the shooter, to have the same compassion for both. There is something gravely wrong with our community, and with society in general, when young people of sixteen, fifteen, or even younger are killing one another. It's not just the fact that they're actually shooting but that they have access to guns and might find themselves in a situation where they feel the need to pull the trigger. We have to ask ourselves, "Where have we failed as a society?" If we continue to look at the shooter as some object unconnected to us, we will continue to find ourselves in this situation. As soon as we own the shooter as our family, as part of us, as part of our community, then we will want to find ways to ensure that he or she does not feel the need to pick up a gun. This is what I fight for.

My work led me to become cochair of the 2017 Women's March on Washington. It began with a white woman, Teresa Shook, a retired grandmother living in Hawaii. The day after Donald Trump won the election, Teresa sent an invitation to forty of her friends, asking them to get together in Washington, DC, to march on January 21. That invitation went viral and ended up receiving ten thousand RSVPs overnight, so Teresa named the event the Million Women's March. She immediately experienced pushback on social media from black women who objected to the title because it was the name of a historic march organized by black women in 1997. Fifty-two hours later, Carmen Perez (my partner with Harry Belafonte's Justice League NYC) and I received a call from my colleague Michael Skolnik, who connected me to people involved in the march's planning. They asked whether we would consider engaging. Carmen, Linda Sarsour (a young Palestinian-Muslim sister from Brooklyn), and I had successfully executed a march from New York City to Washington, DC, walking almost 250 miles with a mission to highlight criminal-justice issues with three justice-reform bills. After fifty or sixty hours of seeing posts about the planned event online, we joined and became part of the Women's March on Washington's national organizing team.

By the time we got involved, more than one hundred thousand people had signed up to be a part of the march. The list of names was very diverse. Many people from different races had signed up through our Facebook page to say that they were coming, mostly white women. Right after the election, polls showed that 53 percent of white women had voted for Donald Trump. That became a really difficult fact for us when organizing the march, because many in the community felt betrayed by white women and, as a result, didn't want to participate with them. Still, we felt we could not afford to have any convening in this country where issues of women were being defined without women of color being a part of it. We had to

ensure that we were in front of the charge, leading the discussion as far as our needs were concerned, and ensuring that our issues, specifically, were not just a part of the agenda but really infused in every area. Sitting around criticizing the march via Twitter and writing beautiful diss opinions wasn't going to achieve that. We believed that a much more productive and effective way to ensure that women of color were centered was to be involved, not just by being at the table but by sitting in the middle of the table—and showing that every time someone brought up an issue, we would find ways to make sure it intersected with the needs of women of color and the specific challenges we face.

There were more than one hundred people on our organizing committee. Carmen Perez, to her credit, had the job of working with the more than six hundred partners who came on board. We focused on the intersectionality of issues, race, and gender. We tried to find ways to help people see themselves in their solidarity with others, strategizing how to get the climate-justice folks to sit down and hear from the reproductive-rights folks and the racial-justice community. We worked to find ways for them to be able to support one another's issues. That was the secret sauce of how we were able to get millions of people together.

I'm confident that I was part of a very historic moment. I am also confident that because of my involvement, the story cannot be told that *white* women came together in Washington over sexism, reproductive rights, misogyny, and equal pay, and then went home. The story that will be told is that from that stage in Washington, the names of Trayvon Martin, Michael Brown, Sandra Bland, and the nine people shot at Emanuel African Methodist Episcopal Church in Charleston, South Carolina, were spoken to millions. Their stories were told. There was a woman who spoke that day who had been incarcerated for more than twenty-seven years.

I'm grateful to God that I had the opportunity to be a part of something so historic. Some of the organizers, white women, had to sit with the uncomfortable feeling of having women of color, particularly black women, bring up issues they had been trying to avoid at every turn, every planning meeting, every conversation. In fact, during those meetings, we black women often shared books and other educational tools with the others to ensure that the white folks on our national organizing team would understand what white privilege looked like. That wouldn't have happened if we hadn't been involved in the march.

I don't believe that anything happens without it being in God's hands. Divine order, and I answered the call.

More black people have to feel that this movement is something in which they must be involved. We must have a seat at every table. More of us have to be prepared to give up something in order to have more later. The resistance struggle is waiting on us. There are no other people on the face of this earth who have experience challenging the system like black folks do. We are the leaders in terms of how to fight the system. This is what we do. So we need to employ that.

Groups have been organized. People are moving together, unified in challenging what's referred to as the Muslim ban. The undocumented community is standing together to push back against discrimination and deportation. White women are gathering their resources to fight back against the repeal of women's rights. We as black people have to ask ourselves: Where are we? Yes, we've been fighting since we were brought to America, but what is our renewed commitment? What is going to be our renewed tactic for *our* liberation struggle?

Outside this work, I'm still trying to figure out how to balance my personal life. Fighting on behalf of a people, the people, becomes your life. And sometimes that's a detriment to your family and yourself. I certainly have an awesome family and a great support system. I do turn to Don Coleman, my partner, as someone who gets it. When you're in this work, you have to be linked up with people who understand that your calling is not something you can just turn off and on. You've got to have family members and others who support the idea that this calling is from God and it's never-ending. When you feel that your own life, your family, and your children's lives depend on the work you do, you get up every day and do it.

The most authentic people come with flaws and previous challenges. They are ready to jump in and lead from a place of personal experience. I don't believe that being a part of the movement means you can't be cool, sexy, or fun. It doesn't mean you have to dress, look, or speak in a certain way. It gives you the flexibility to be whoever you are. And I don't feel that just because we're in the movement, we have to live without. I think we should work hard to be able to live an abundant life and to have the things we need and want, as long as those things are not compromising the community in any way. ⚡

The most authentic people come with flaws and previous challenges. They are ready to jump in and lead from a place of personal experience. I don't believe that being a part of the movement means you can't be cool, sexy, or fun. It doesn't mean you have to dress, look, or speak in a certain way. It gives you the flexibility to be whoever you are.

TOSHI REAGON

FREEDOM SONG

Singer, songwriter, producer, creative curator, and multi-instrumentalist

AS A CHILD, I BELIEVED IT WHEN PEOPLE TOLD ME THAT I WAS BEAUTIFUL, I was amazing, and that I deserved everything I wanted. I internalized that, and because of those early affirmations, I believed in myself.

Growing up, I was always regarded as strange. I was not *regular*, so hearing those affirmations were really important to my self-confidence, my development, and my existence. Having people give me that positive reinforcement, and actually believing it, is probably the only reason I'm alive. I've always felt that I belonged exactly where I was, and I am thankful for that. I tell people all the time, "Tell your kids how beautiful and incredible they are before they can even understand your words perfectly. Tell them those things. Don't measure them against anyone else. Measure them based on who they are." My mother did that for me when I was growing up, and as a result I never have doubted myself or felt I didn't belong.

My mom is a special human being. I think we've been traveling through lifetimes together for a long time, and this is one of the best ones. I always say, "Thank you, universe, for bringing me here through Bernice Johnson Reagon." She's an extremely brilliant person, and she has taken the most amazing path, on the highest level. She grew up in southwestern Georgia during the time of legalized segregation. She was already on the path to freedom, so when organizers from SNCC, the Student Nonviolent Coordinating Committee, came to Albany, Georgia, she helped lead one of the first marches for civil rights there. One of the SNCC members who came to Albany was my father,

Cordell Reagon. My mother was a single parent with two kids, but went on to have a wide-ranging career as a singer, composer, curator, and scholar. She was a touring musician who ran an all-women black a cappella group, Sweet Honey in the Rock, for thirty years, when no one thought it would last for more than a minute. Her journey is fascinating because she fluidly united her paths of academics, frontline activism, innovation, education, composition, and performance.

We as artists have the power to change everything. If we are good artists, if we are generous with one another, and if we are willing to be congregational, we can thrive, and transform the emotional color of our communities.

I loved being a part of her musical world. My mother could see that music was holding me and anchoring my life and resonating with my spirit. Once she saw that I was actually serious about it, that I watched and followed everything she was doing, she created access for me. I loved going to rehearsals; I loved being in the theater; I loved being in the recording studio. I also appreciate Nona Hendryx and June Millington, who became like second moms to me.

When I decided that I was going to be a professional musician, my mother gave me two pieces of advice. The first was "Don't do drugs. If you do drugs, no matter how good you get, no matter how famous you get, you're going to fall and something terrible is going to happen. The most important thing in your life will be getting your drugs. It's never going to be about your art." The second was "Learn to produce. If you become a producer, you never have to wait for someone to decide you're good enough to take the space you want."

Her advice and overall influence have been instrumental in my being able to be carve out my own path in the music industry. I was already writing and recording by the time I was a teenager—I produced my own show at seventeen, and started touring. In my early twenties I moved to New York City, where I could be a working musician and take some night classes at Fordham. That lasted for about a semester, and then I was offered the opening slot for Lenny Kravitz's first tour. I never looked back from there.

Growing up in an environment surrounded by artist-activists from all walks of life helped me understand the meaning and the purpose of art. It empowered me to push my creative boundaries and made me unafraid to be different. Musically and aesthetically, I never fit into any box. I never fit into anything that was established, but because I was already rooted in my identity as an artist and as a human being, I never felt pressured to conform.

The music industry has had a tendency to box black artists into a very narrow space. For those few who do break through with an out-of-the-box style and sound, they end up becoming the only one who can have this sound or this look. Every era has the one black woman with a guitar who is allowed to be a star. In the sixties, it was Odetta; in the late seventies, it was Joan Armatrading; and in the late eighties it was Tracy Chapman. Then every other black woman doing anything remotely similar gets compared to whoever "that one" is. Today, the music industry and the overall cultural climate are a much more accepting environment for me—a butch, GNC, bald-headed lesbian who voices her activism and politics in her music.

I have always felt what I do is not about a genre; it is about speaking to the wholeness of my body. People break my music and songs down into multiple genres and use five or six words to describe my music, but when I'm asked what kind of music I do, I just say, "Good music. I do good music." Sometimes it sounds like a heavy metal tune, sometimes it sounds like a

blues song, and sometimes it sounds like folk, rock, or spiritual music. The thing that is always fluid and present in my sound is truth. It is impossible for me to lie from the position of using my voice to make sound. I often perform solo, but I am never alone, and as much as possible I curate events like my festival Word, Rock & Sword: A Festival Exploration of Women's Lives. All are welcome as a way to expand the voice of the community I am part of.

I was taught that we black people used our sonic vibrations as a system of communication in order to survive in a world that was literally trying to kill us. The line of survival for our people has always been connected to our freedom music. Our ancestors developed a keen sonic awareness, which we have clearly held on to today. When you look at our art, our music, and our poetry you see they all have a message. There is a vibration. Our Negro spirituals, our jazz, our blues, our protest music, our call and response— it all has a frequency that resonates with our spirit. As an artist, I try to channel the magic of our people's sonic vibrations in my music. I draw upon the pain, the protest, the beauty, and the grit to express the rich tapestry of emotion that illustrates the shared experience of black people. And that sound is not monotone. Just like our life experiences, it is multilayered and too dynamic to fit into one box.

When you look at our art, our music, and our poetry you see they all have a message. There is a vibration. Our Negro spirituals, our jazz, our blues, our protest music, our call and response—it all has a frequency that resonates with our spirit. As an artist, I try to channel the magic of our people's sonic vibrations in my music.

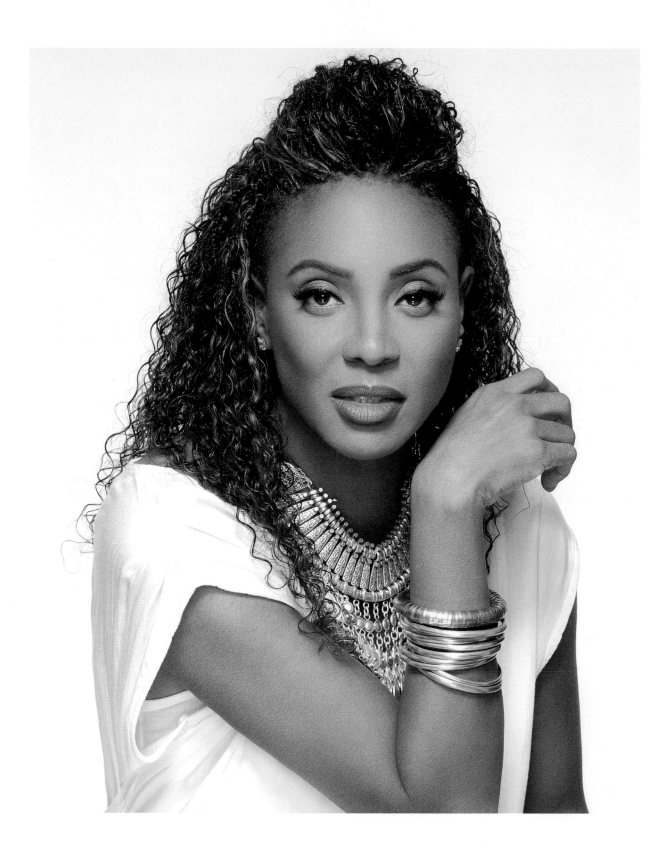

MC LYTE

LYTE AS A ROCK

MC, Hip-hop legend, education advocate, and philanthropist

I THINK BEING RECOGNIZED AS A HIP-HOP LEGEND IS AWESOME, BUT I WAS never aiming for that. I've been rapping since I was seven or eight years old. As a kid, I rehearsed for hours and spent time enunciating so I could be heard clearly. I paid attention to the greats before me, and I respected the art. I've simply been doing what I love all along. It wasn't intentional. I was not thinking, *Let me aim for a status*. I was just thinking, *Let me create good music*.

A lot of ingredients go in the pot in order to make a legend. I don't think anyone who's been dubbed "legendary" is mediocre or just coming on the scene. They're either doing something that hasn't been done before or they're doing something in a new way. It takes a lifetime of dedicating yourself to your work.

It also has to do with caring about the art, craft, or discipline you participate in and giving back to the culture in a meaningful way. And I definitely think I have done that. Still, it's taken me a while to really own my legacy. There's a funny story about my journey toward appreciating "my legendary status."

When I had to perform at the White House, I remember getting a call from Queen Latifah, who was going to introduce me at the event. She shared over the phone that she had some concerns with the introduction that they asked her to read about me, and was like, "We need to talk about this one." When she came to my hotel room later that day, we discussed the introduction, particularly the line that referred to me as the "godmother of hip-hop."

She asked, "You want me to say that, Lyte?" I really wasn't sure. It sounded so old. I was thinking to myself, "The godfather of soul is James Brown, and we're from two different eras. How can I already be the godmother of anything?" In all honesty, I was also wondering if I was deserving of that title. When I talked to my chief operations officer, Lynn Richardson, about it, she said, "What, are you kidding? You don't get to choose when you get a title like that. You get it now or you may never get it. Take your blessing when you can."

It's been a process, but I've learned to receive praise graciously and to accept the titles or celebrations of my achievements despite my modesty. I really appreciate all the accolades I've received over the years, but I am most proud of the fact that I was the first recipient of the BLACK GIRLS ROCK! Award.

Being a hip-hop artist has not been easy. I've had to navigate a hypermasculine and oftentimes misogynist industry. Sexism is something I've experienced firsthand coming up in this business, and it exists in every medium of entertainment. Women just have to face it. One of the things that keeps me grounded and motivated despite the many barriers I've encountered is that I've carefully carved out who I am. I'm very clear about my voice, my identity, and my purpose as an artist and activist.

I believe artists have a responsibility to their communities. Like Nina Simone once said, "It's an artist's duty to reflect the times." And this was always important in hip-hop. I don't think there's ever been a period when "conscious content" wasn't necessary for our culture and our community. It's always been necessary because there's always something going on that we need to address. If hip-hop is going to continue being the platform it set out to be in the beginning—a way for the streets not only to convey their stories but also to get their news—then we need a resurgence of MCs who care about our people and the integrity of the art and culture.

There is a new generation of MCs, and their level of success comes to them rather quickly when they are rapping about nothing. Their hearts and minds are almost unable to be where those of hip-hop's forefathers were. Many of us who came from the old-school culture came from nothing, so we built this art together to attain something. That meant we were collectively accountable to and responsible for this culture and community. We protected it. But the way society is flowing right now, there are a lot of new artists who are out for themselves. There isn't a valuing of community, or any desire to make society better as a whole.

It's important to teach young people how to process what's being presented to them in our culture. They must figure out how they fit into the matrix of lies being presented to them through music and media. Will they become the truth tellers or the oppressors? Even though we all have a role in guiding them to make the right decision, they ultimately decide.

I rock because I love my people and I use my gifts, talents, and blessings to give back to my community. I've learned that it's my duty to take it back to the old school. So, I am dedicated to empowering the next generation with knowledge, philanthropy, music, and my voice as an artist and activist.

MAXINE WATERS

RECLAIMING MY TIME

US representative for California's Forty-Third Congressional District and advocate for women, children, people of color, and the poor

I AM A TRUE BELIEVER IN JUSTICE, IN FAIRNESS, IN EQUALITY. I BELIEVE IN people and the right for every human being to pursue a good quality of life.

From the time I first started my career in politics when I was younger up until today, women come up to me and say things like "I'm praying for you" and "Keep on doing what you are doing." They say things like "You are motivated by the spirit!" They encourage me. They tell me who I am. They tell me what they see in me. They tell me that my strength comes from a higher power, and they say they see it. Sometimes they'll just stop me and embrace me. I believe that is an indication that I chose the right path.

It's difficult to be a change-maker if you are too afraid to speak up or unwilling to ruffle some feathers. I think that I have become the forthright, outspoken leader I am today because of the support and direction of great black teachers and strong black women mentors in my life. I came from a large family with a very strong mother who was very outspoken. She was very clear about what she liked and what she disliked, and she led by example. And I'm sure that I acquired some of those attributes through her.

Our society socializes people to be too protective and precautionary regarding our willingness to stand in opposition of the things that stifle us or are unjust and don't serve humanity. People are too protective of their image and too afraid to challenge the status quo. From the time when we are young, we are taught to be protective and cautious and not to do anything that would generate criticism, that would have us identified as a troublemaker,

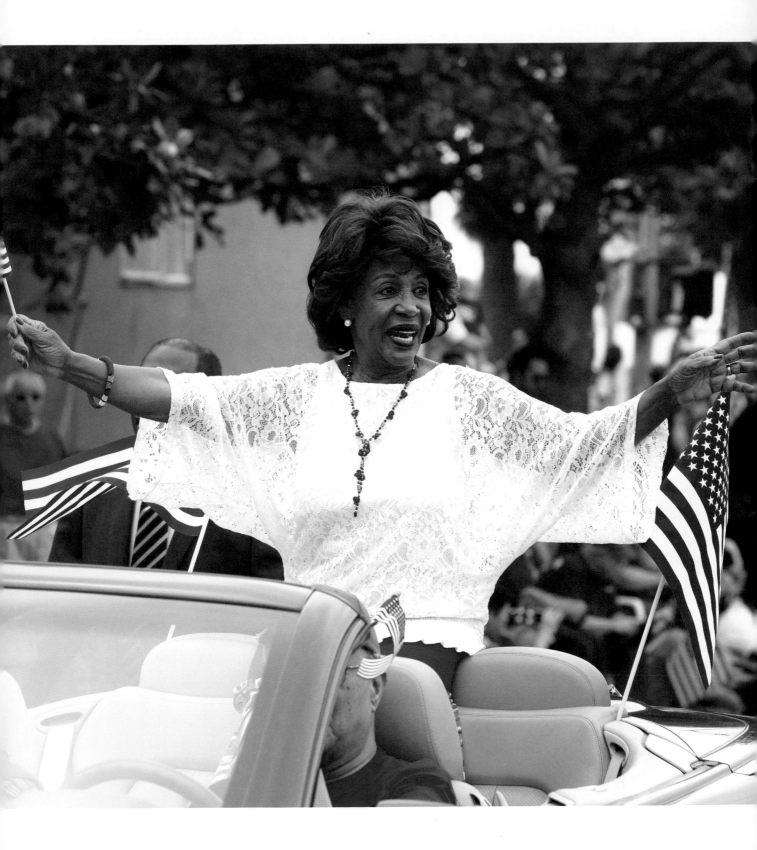

or that would be considered confrontational, because that is not acceptable in our society. But to become who we want to be, who we are designed to be, this conformity almost has to be unlearned. We have to learn how to use our voice and our power to fight for justice even when it's risky or unpopular.

Early in my career, I was fortunate enough to be around and witness people who decided to step outside the box to challenge the system and fight for justice in their communities. I had the wonderful experiences of living and working with and getting to know some extraordinary people, and many of them were African American women leaders in the community. Their names will never be known because they weren't famous, but they did incredible work that totally transformed the lives of people in their neighborhoods. They challenged and confronted the system, and they took the licks that came along with it.

There was one woman in Los Angeles who was the head of welfare rights. She spoke and fought for women who were on welfare and who were being treated badly by the establishment simply because they had to depend on public assistance to survive. During that time, the system was set up so that social workers had the authority to cut welfare recipients off if they saw fit. Sometimes the social workers would reprimand the public-aid recipients, ridicule them, belittle them, and treat them with unwarranted disrespect. People in the community were being stigmatized just because they were on welfare and just because they were poor. But this woman fought for their rights and stood up for their humanity. She challenged the system, and she strengthened the will of welfare mothers so that they could learn to stand up for themselves.

Another woman who inspired me was an education advocate who went to the board of education meetings religiously. She would sit in and demand access to education for children who were denied

real, equal, high-quality access. There was another woman who, during the War on Poverty, took up leadership and worked with all the agencies, including Head Start, the neighborhood adult participation project, and all the programs that were put together when our government decided that they were going to give a real helping hand to poor people.

I witnessed these women's work. I learned from all of these women and followed in their footsteps. Because I saw them in action, I had a reference. I wanted to be like them and have that type of impact on my community. Those kinds of role models influenced me and prepared me to step outside the box and get involved.

I started my advocacy work when I went to work for the Los Angeles Head Start program. I believe that Head Start was one of the most exciting things that the government did under the "War on Poverty." This program gave poor children and children of working-class parents who may not have been able to afford preschool otherwise opportunities to have a tremendous preschool experience that would prepare them to go into kindergarten and give them the foundational tools to have a better, more successful education in the future.

When I started working with Head Start as an assistant teacher, not only did we do work in the classroom but we also organized in the community. We helped to connect parents with their elected officials, their city council people, and members of congress so that they could lobby for more funding. In doing that organizing work, I could really help poor families. We were offering lifesaving medical support by giving physical examinations to every child. We discovered the kinds of common problems that children may have but that often go unrecognized and untreated if the families don't have resources or money. We found eye problems; we found that some children were dyslexic; we discovered autism in children and caught it early

enough to support the child. The experience of working there and seeing the benefit of community organizers, politicians, and other community figures working together to solve social problems really stuck with me and piqued my interest in running for office.

After working and organizing in the community, getting to know the elected officials, and understanding how labor unions worked, I really started to see the power in politics and social action. While I was still at Head Start and at the height of organizing for the Women's Movement, there was a member of the California State Assembly who decided to retire. I had been getting to know other women who were leaders in different sectors through my work organizing in the community, and they all said, "Why don't you run? Why don't you run for office?" Although I'd never strongly considered it before, I decided to take them up on it. I had community-organizing experience, I had a sea of support from women in the movement, and I had mentors who were already elected officials. It was the perfect climate in which to take a risk and try something new.

At the time, the secretary of state in California had to make a special ruling in order for me to run, because the assemblyman who was retiring had already chosen his administrative assistant to run. He had not told anybody that he was not going to run, and so his administrative assistant was the only one who had been timely in filing the paperwork to run for the seat. We challenged it, and the secretary of state opened it back up for five more days. The rest is history. Because it was the height of the Women's Movement, I got all of these newly organized women, including the National Organization for Women, to come together around that campaign. We fought hard. We fought the establishment and we fought other elected officials, but we used our organizing skills and we won.

By the time I went to the California State Assembly, I had already been organizing with prominent leaders in the Women's Movement like Gloria Steinem, Bella Abzug, Patsy Mink, and others, so I came into the Assembly fired up and feeling empowered. After I was elected and people referred to me as an assemblyman, I kept thinking, *Why are they calling women assemblymen?* That's just the way that it was back then, and one of my first thoughts was to change it. I'd just come off the Women's Movement; I was not going to be called "assemblyman." So I spoke up and I caught hell, but I wouldn't let it go until it was changed. These men fought back, declaring, "How dare you try to change this? It's tradition," but I pointed out that it was a tradition rooted in sexism, and they did, in fact, end up changing the title for women.

That was one of the moments when I kind of discovered my strength and uncovered the importance of not having any fear and speaking my mind. My conviction came only because of the years of experience I had on the front lines of the Women's Movement and organizing in my community. When the moment presented itself, I simply had the courage and fire to step up and lead. And that's when I learned that I could do this: I could take any beating that I may get and withstand criticism or whatever kinds of attempts to undermine me.

There have been so many transformative moments in my career that really solidify who I am and what work I am called to do. I became the leader of the antiapartheid movement in California, and I created legislation to divest pension funds from companies that were doing business in South Africa. That was a defining moment in my life. I ran a job-training and employment program in the housing projects to get gang members honest work and to help them find decent employment. Today, I continue to fight for the rights of people against the wealthy, conservative politicians who think it's okay to infringe on the rights and welfare of the American people.

I think we all have to embrace the word *resist*. We can't just go along and think that we don't have the power to fight back against injustice. Part of the reason why young people and millennials are connecting to me and have named me "Auntie Maxine" is because they think that I am somehow the epitome of resistance. They've said that I am authentic and fearless in my fight for justice and liberation. I think I have become an example, or a symbol, for them that they can also step outside the box, they can become change leaders, they can be involved in challenging patriarchy and oppression, and they can use their tremendous intellect in order to lead this country.

Sometimes having an example of bold leadership is all it takes to really inspire another generation to be unafraid and unshakable in their pursuit of justice. I'm proud to say that I have played a unique role in motivating others, as so many have done for me.

This is a special moment in history for black women. We are emerging, and we will provide the leadership this country needs. It has all come together in some interesting ways. Our creativity is so amazing, and so it has to be recognized. We are flourishing in corporate America, in entertainment, in journalism, and in politics. I see it in the way we dress, I see it in the way we write, I see it in the way we speak, I see it in the way we create products, and it is absolutely amazing. Also, the average black woman now is a part of this powerful number of black voting women. When you take a look at the rate at which black women are voting, percentagewise, we are outpacing everyone else, which means that black women understand the importance of voting, and they want to make sure that they are helping to influence the decisions that are made in government and public policy.

Black women are at the forefront of the black community's movements, and we have always been doing this work. However, the visibility and spotlight of our leadership is now being recognized in ways that have never been acknowledged before; I feel like this next wave of feminism is Black Girl Magic.

PAULINE MURRAY

HIGH PRIESTESS

Armed with the hypervigilance of a quadruple consciousness to be black, American, woman, and gender nonconforming, Pauline "Pauli" Murray shed light on the particular effects of racial and sexual discrimination of African American women, coining the term "Jane Crow." As a woman, she was denied entry to Columbia and Harvard Universities in the 1940s, which fueled her passion for Negro and women's equality. Murray cofounded the National Organization for Women (NOW) in 1966, and became the first black woman ordained an Episcopal priest in 1977.

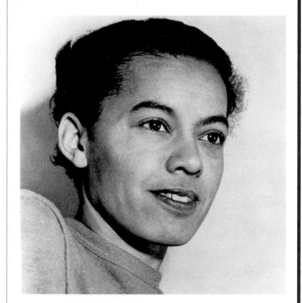

V.

MORE BLACK MORE BEAUTIFUL

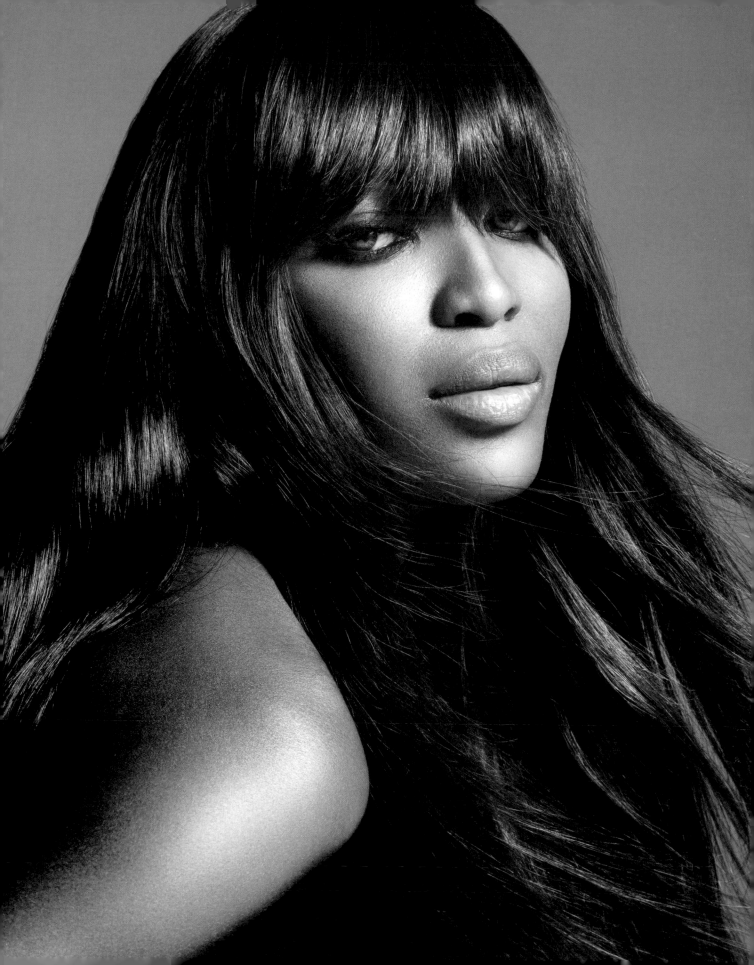

NAOMI CAMPBELL

FLAWLESS

Supermodel, actress, and icon

I'M JUST DOING WHAT I LOVE. I DON'T THINK OF IT AS "CHANGING THE GAME" or being a "history maker." I don't see myself in that way. If I inspire someone by doing what I'm doing, that makes me feel good. That's important. If I've touched one person, then that makes me happy.

The keys to longevity really come down to being honest with yourself and not letting your ego take over. I entered the modeling industry as a teenager. I've made my mistakes like everyone else. That's no excuse, but it is a reminder that I grew up quickly, unconventionally, and in the public eye. I didn't always know how to act. I've had to deal with that and take responsibility and own that. I was taught by my mother at an early age to not take things personally in my profession, to not buy into the hype, and to know that there is always something more to learn. I've always embraced and faced my challenges. I looked for a solution to every challenge, and I made it through them; then I would think, *Okay, what's next? Let's go.* When it comes to my portrayal in the media, I've learned over time that my pitfalls do not have to define me. At the end of the day, I'm still here after three decades, and I continue to work with amazing photographers—photographers I've known since I was sixteen. And they still ask to book me.

Early in my career, I was fortunate enough to be mentored by model and fashion industry icon Bethann Hardison. Bethann is like a second mother to me. I've known her since I was fourteen years old. She was the first person I met in New York in the modeling business, and she's someone I turn to personally and professionally. I trust her, her wisdom,

her guidance, her truth, and her honesty. And that's why she's still in my life! She is the type of person I like to listen to. I don't want yes-people around me, because at the end of the day, if I had only yes-people around me, I wouldn't know to look in the mirror and face truth. And I think that's important. We all need to know how to do that. When Bethann started the Black Girls Coalition, a platform to empower black models to speak up about the issues we face in the industry, I thought it was the most amazing thing, and I was so proud to be a part of it. What I loved most was that when we were all together in the room, it wasn't just about race. It wasn't like that. It was a feeling of female empowerment and not having to even say a word because we were all going through similar challenges in the industry.

People don't always see it, but I'm nervous all the time when I'm in public. However, I never want to be 100 percent sure of myself. I try to use my fear in a positive way, to get me over that hump.

My career as a top model and entrepreneur brings demands that are often taxing, so I have to be intentional about creating harmony in my life. There are times when I'm burning out and I need to stop, decompress, and press restart. I have to know when to say no and when to choose my spiritual or emotional well-being over the demands of my career, my friends, or even my family. When I'm overworked or overwhelmed, I take a step back to center myself. I'm very good at disappearing from the world for introspective moments and taking time out for myself. Whether it's going to India alone for a month to learn yoga, going to Kathmandu for a week to do a meditation course, or going to ancient countries with so much history like Egypt or Burma, I give myself time to travel alone to realign my spirit. I just unplug—no computer, no phones, no nothing—and I've learned how to do that without feeling guilty.

My advice to young women is, don't ever let anyone tell you that you cannot do something. Always go with your gut. If you've envisioned it, make it manifest. I wouldn't be who I am or where I am without believing in a power higher than myself. I praise God every day because I'm so grateful to have such an amazingly colorful life. I've been up, down, through it, in and out—just like everybody else. In that regard, I'm no different from anyone else. But the lesson for me is that if you can come through it and be honest and speak about it, there is always somebody you can help. That's what matters most to me today, and that is why I rock. ⚡

MICHAELA ANGELA DAVIS

NAPPY ROOTS

Writer, creative director, and image activist

OUR HAIR IS A METAPHOR FOR OUR HOLINESS. I ALWAYS SAY, "OUR HAIR IS happy because it reaches up to God!" We are the only people on this planet whose hair can grow up and out and reach up above us, creating a halo. Our hair literally shapes into the symbol that the Old Master painters would use to identify someone as enlightened or divine.

What is more iconic than an afro? There is no other hairstyle in the history of mankind that can signify a time, a space, a philosophy, and the energy of a people. The silhouette of a black woman with an afro is divine, like depictions of Isis or Mother Mary. It is the Black Madonna. Every deity, particularly in early Christianity, but also in Egyptian culture, before Christ, would be depicted as having this luminous crown around her head. Our hair does that naturally!

An equally powerful truth is that our hair is the thing that connects us. While I'm as light-skinned as I am, I still have definitively black features, such as my coily hair. People may not know how to read a nose and say, "Oh, that's an Igbo nose," but they can see,

recognize, and understand the blackness of my hair. And I can see *their* hair and know elements of their journey. This is not to say that all black people have hair that's kinky, coily, or curly, but a lot of us do. Our hair is the thread that weaves us together, that tethers sisters together. I don't care if you are from Detroit or Dakar, Los Angeles or Lagos—our hair locates us. It locates us to the Motherland. It locates us to the beginning. It centralizes us, and it holds our history.

Our hair can be spun into gold. It touches the sky. It's strong, yet soft and lush at the same time. It feels so good. Like wool, our hair can be woven into art in a way that others' hair cannot. Wool is strong enough to be woven into the most beautiful tapestry or a protective blanket. Literally and quite magically, our hair can shape-shift like clouds! It can go from straight to curly to something in between. It can give in to some water, or it can give in to some heat. Our hair is a metaphor for what we can do. Much like our hair, we are versatile and resilient.

There is no mistake that we are having a civil rights movement and a natural hair movement at the same time. In fact, there is a civil rights movement and a rise in advocacy specifically around black women wearing our natural hair unapologetically. All over the world, black women and girls are embracing their own features and challenging the European beauty standard and oppressive rules (written and unwritten) and dress and appearance codes that prevent us from coming to schools or workplaces just as we are: rocking our naturals, afros, coils, braids, or twists. Why is there so much resistance around our hair? Why does it become hyper-political or an act of aggression for us to wear our hair as it grows out of our heads? Why should we have to assimilate or conform in order to be accepted and respected at school or work?

In the United States, black girls have been suspended or expelled from schools simply for wearing their natural puffs. In South Africa, high school girls have been protesting clauses in their school's code of conduct that bans wide cornrows, braids, dreadlocks, and other natural black hairstyles. The force, excitement, and courage around the natural hair movement is absolutely an outgrowing of BLACK GIRLS ROCK! and Black Lives Matter. There is an unmistakable and indelible feeling of clarity around black women's sense of self, cultural pride, agency, and choice. There is this beautiful groundswell under way now, a movement of self-love in which black women and girls are operating with a fuller understanding and acceptance of their natural aesthetic, where we are finding the courage to speak up, stand up, protest, and fight for the divine right to be all that we are in any and every space we occupy.

What's also interesting about this natural hair movement is that there is money following it. There is an entire industry that has had to respond. Black people, and black women especially, are starting their own businesses around natural hair. It all started off very organically, with black women sharing information in do-it-yourself video tutorials on YouTube. Commerce and entrepreneurialism followed.

The black beauty business is a part of the DNA of the black community. Black women who worked in beauty parlors literally funded the civil rights movement. They were capable and deliberate about giving back to the community because they had the financial resources to do so. Their staff were black women, their clients were black women, their products were made by and for black women. So, these brilliant black beauty shop owners held clandestine NAACP meetings in their shops. Through our beauty, we organized.

There is politics in our hair. There is movement in our hair. It's our root! Our hair is a deeply rooted repository of our history, our hysteria, our happiness, and our glory! ⚡

LUPITA NYONG'O

SOUL GLOW

Academy Award–winning actress and filmmaker

I CAN SAY FROM EXPERIENCE THAT THERE IS POWER IN HAVING THE MEDIA be a mirror. For me, it was the model Alek Wek's visibility that changed my own definition of beauty. As I engage in being a storyteller, I have realized that it's not just about the images we see but also what we see them *do*. Yes, it is very important to know that you are beautiful, and valuable, and worthy of love, but it is also very important to know that you are capable of building a rocket ship, of ruling kingdoms, and of overcoming abuse. I want to be part of sharing with the world that black girls and women can be and do absolutely anything and everything they put their mind to; that we can be strong and vulnerable, aggressive and timid, sexy and geeky, and even be all these things at once! I think unfortunately the trend in the past has been to limit black women to a stereotype or archetype, and we're seeing a shift in the way black women are portrayed today, in the roles they occupy and the agency they possess.

Shonda Rhimes, Oprah Winfrey, Ava DuVernay, and many others are giving us powerful stories both in front of and behind the cameras, and that is extremely important. (I am still desperate to get my hands on an Ava DuVernay Barbie!). I love the movement of displaying black female writers and directors and producers and media moguls, because this is how we change the personal and global consciousness of who a black woman is and what she is capable of. If we're going to change the way we are presented, we need to have a serious and prolonged conversation about action toward who is telling the stories and why.

I think pride in yourself, in your history, and in your culture is not only powerful but it can also be incredibly healing. Black women have endured centuries of being valued as less than by systems of oppression that would use their bodies as tools and not much more. The psychic wounds of our ancestors can run very deep, even while there are so many who came before us who have accomplished so much.

I think this is the cultural moment of connectivity and breaking down those old barriers. Many of the ideas that black women and all minorities have been force-fed by those oppressive systems were nothing but toxic, and the medicine we can give ourselves and each other is rooted in love. Sometimes self-love or loving those who mirror you is the most radical form of healing, both for yourself and for a healthy global community.

The first thing I look for in a role is some sort of spark, a connection to the material that delights me and also challenges me as an artist. Ultimately, the parts that do this all have characters with agency and clear motivation. I think that in *12 Years a Slave*, *Queen of Katwe*, and *Eclipsed*, you can make the argument for each character having degrees of agency. Their power is severely inhibited by their circumstances—Patsey's by slavery and abuse, Harriet's by abject poverty and doubt, and the Girl's by war and bondage—but their tenacity to survive those circumstances provides them each with the fuel to fight in their own way, which is what interested me most in these roles. These women each have an incredibly strong inner light, but they are fighting against a system or a society that sees them as less than valuable. In drama, when your character wants something, whether it's respect, agency, power, or freedom, it makes for a compelling story when a stronger force than theirs has denied them this very

thing. We made history with *Eclipsed*, the first-ever Broadway play to feature a director, writer, and cast members who were all black women. Not only did I feel so honored and humbled to be a part of this work but it also just felt necessary for me on personal and public levels. Personally, I loved how Danai wrote these women's lives with such cultural specificity and intimacy. Publicly, a story about women during wartime—African women in this Liberian war—felt rather untouched and ripe for a really potent dialogue, and was an opportunity to reveal the humanity and the complexity of what these women go through. My intention wasn't to make history, but how glad I am that we did! My fervent hope is that it can inspire similar productions highlighting black women in all their diversity and cultural specificity. The theater is such a vital part of cultural dialogue, particularly in times of trouble or political strife. I would love to think that this show might galvanize other producers to make work that represents a variety of black women's stories on the Broadway stage.

Winning the Oscar for Best Supporting Actress for *12 Years a Slave* feels very distant and occasionally like it was just yesterday. Looking back, I see someone who was so new to everything. It was my first film right out of drama school, my first red carpet, my first press tour. It was a real whirlwind. And yet I was determined to live in gratitude and take in every moment as much as I could. I learned firsthand that when so much abundance comes your way, it is crucial to practice gratitude. I try to keep a gratitude journal, especially when things are going at breakneck speed. I will forever be grateful for everything that was given to me through that groundbreaking film. So much of what I have now is thanks to Steve McQueen, who is a visionary and has the biggest heart. He was strong

enough to put an unknown among all those seasoned, powerhouse actors.

In terms of any perceived stardom, I just remember feeling afterward that I wanted to go at my own pace. I hated the idea of getting too swept up in something trendy or of-the-moment, and when I look at actors with careers I admire like Cicely Tyson, Viola Davis, and Sidney Poitier, they have work spanning decades. I wanted to use whatever newfound power I had to be able to choose the parts that scared me and also felt like they might be part of something special. I wanted to begin dipping my toe into producing and creating platforms for stories about black women, however I might be able to. I sometimes move slowly, but I try to always go forward with very clear intentions.

I think it is just as important to see black women playing princesses and aliens and queens and warriors as it is to see them embody historical figures and people from the real world. I've often noticed how rare it is for black women to participate in fantasy roles. Even though there is a rich history of pioneers like Nichelle Nichols playing Uhura in *Star Trek* and Zoe Saldana dominating the sci-fi genre, it seems to me that if a story is fantasy or about the future, it should be populated by all sorts of people of color!

I also like to keep a balance between the real and the imaginary—not only for audiences but for myself. Playing a role like Patsey or the Girl can be extremely draining on many levels, and entering a world like the "galaxy far far away" (*Star Wars*) or Wakanda (*Black Panther*) can provide a completely new opportunity that challenges a different tool-set for me as an actor. I often look to actors' careers that I love like Idris Elba and Benedict Cumberbatch, who often explore multiple genres and platforms and push the limits of what and who they can become. I love how versatile their careers are, and I aspire to that level of versatility, imagination, and fun!

My favorite author, Chimamanda Ngozi Adichie, has spoken very famously about the danger of a single story. I think far too often the continent of Africa is subjected to that single story in the media. It was remarkably healing for me to be a part of telling this story, because the film, *Queen of Katwe*, avoided so many of the clichés we have seen time and time again: the white savior, Africans as victims of poverty and being robbed of their humanity, the "exotic" nature of the location. The film posited the very normal state of being told from the point of view of a young Ugandan girl, Phiona Mutesi, and the struggles she encounters in understanding how powerful and important she truly is. Honestly, when I think about it, this film really encompasses the essence of BLACK GIRLS ROCK!, because it shows how this one girl changed the lives of so many by breaking through her own self-doubt and fears of both failure and success. It demonstrates how her mother could become her champion by letting go of her own fear and embracing hope for her daughter. I love the film so much, and have to say that if it weren't for the passion and perseverance of our dedicated producer Tendo Nagenda and our fearless director, Mira Nair, the movie would never have seen the light of day. Madina Nalwanga brings such singular heart and soul to each moment playing Phiona. It's really a thing of beauty!

Marianne Williamson once said "Our deepest fear is not that we are inadequate. Our deepest fear is that we are powerful beyond measure. It is our light, not our darkness, that most frightens us." I have often turned to this quote when I have struggled with doubts about my own abilities (which happens often!). I think the journey to great personal power lies in acknowledging the ways in which we may be limiting ourselves based on our own lack of self-worth. How often do we stop from even daring to dream of something because we decide too soon it could never be a real-

ity? We must always dare to dream. But we must also confront our fears of success, or a sense that we aren't meant to achieve our dreams, that we aren't worthy of the things we accomplish. I was plagued by impostor syndrome on the set of *12 Years a Slave*, and I often feel like I have to learn how to act all over again on every new film set I'm on. I recently read that Steven Spielberg, of all people, felt this way about directing, and it gave me a moment of relief.

I don't think there is one given path to success. We each have our own lessons to learn and obstacles to overcome. One thing I know is that your dreams cannot be realized without the support of others. And more often than not, people will not believe in you unless you believe in yourself. You have to advocate for you first, love yourself, and love your dream, and the right people will see your vision. Those who cannot see it weren't meant to join you on your journey. And anytime you stumble or feel the sting of rejection, remember that every roadblock can be used as a lesson. Ask yourself, Why did this happen? How can I do better? What can I learn from this experience that will allow me to do better next time? If you start looking at your life as a series of lessons and not through the lens of wins and losses, you can build a life full of growth and expansion, and that will put you on the path toward fulfilling your purpose. ⚡

> I don't think there is one given path to success. We each have our own lessons to learn and obstacles to overcome. One thing I know is that your dreams cannot be realized without the support of others. And more often than not, people will not believe in you unless you believe in yourself.

JAZMINE SULLIVAN

MASTERPIECE

Grammy Award–nominated singer and songwriter

AS A CHILD, I GREW UP WATCHING MY MOTHER'S UNINHIBITED CREATIVITY. She sang, she painted, she wrote songs, she wrote plays, she took photography classes. She was free. She is the definition of Black Girl Magic for me. Watching her express herself in whatever way she felt like doing, with no limitations, made me believe I could do the same. I never had to think outside the box because I never had a box to begin with.

I followed in my mother's footsteps and chose a creative path. I went to a performing arts high school and studied classical music. It was in this creative space that I sharpened my skills and refined my talent further. The kids in my school were really supportive of each other, so I was always poised, confident, and self-assured. I was a big kid growing up, but I never felt insecure about my size, and it never prevented me from achieving my goals. In fact, I was pretty popular as a teen, so it was a bit jarring for me to enter the music industry and suddenly become self-conscious and made to feel as if I were deficient as an artist in some way because I was not the "ideal" size.

There is an absurd amount of attention that is paid to the appearance of women's bodies in society overall, but in the music business this focus is magnified a hundred times more. When I started my career, I was blown away by the emphasis on outward appearance over talent and ability. It was hard for me at first to fathom the notion that how you looked could actually overshadow your talent in an industry that is supposed be based on the strength of your talent. In entertainment, there is this incredible demand on women to be unflawed and have "perfect" bodies. It is very difficult to ignore it as an artist

when that is your job. When I first got signed, I really tried to fit in. I focused a lot of my attention on being skinny. I went on extreme diets to get my body down to a size that was considered "marketable." After a while, I realized that my smallest size was never small enough. Eventually, I had to step back and remind myself that I didn't start writing and singing to have my looks eclipse my gifts. I also had to remember that I've always felt naturally beautiful regardless of my size.

My experiences and challenges really made me examine how our culture impacts the way women see themselves. I started to pay more attention to the harmful messages that the media sends to women and girls that make us feel like beauty comes only in one box and fits only one size. These messages often promote perfection at any cost. The byproduct of this is a culture in which women and girls are dealing with body dysmorphia, poor self-image, and lack of confidence.

Between the media telling us what is and what isn't deemed beautiful and women getting stuck in our own heads about unrealistic goals for our appearance, I thought it was important to write songs about self-love to tell girls that we rock, and our uniqueness should be celebrated. Simple as that! I wrote a song called "Masterpiece" as a declaration and reminder to black girls—and all girls—that we are masterpieces just the way we are.

Shortly after I wrote the song I was asked to shoot a cover story for *Ebony* magazine on body image, featuring me and three other strong, intelligent, successful, and fearless black women showing off our curves. I wanted to be a part of that story because it promoted inclusiveness and showed that curvy and plus-size is also beautiful. Here was my opportunity to show women that we are more than enough, whatever shape and size we are. I wrote songs about loving who you are the way you are, so it was time to put my

money where my mouth was, even if it meant exposing my big ole thighs. Showing images of full-figured, thick, beautiful chocolate bodies on a national magazine cover was necessary and way overdue! I'm glad was able to offer myself as an example that women can look at to gain confidence in self-acceptance. I'm definitely not the poster child for confidence. I have my days when I don't feel so hot, but I think it's about being completely honest with yourself and being able to look at yourself in the mirror and evaluate all of you, the good and the bad. My advice to every woman is to celebrate the hell out of yourself for what is good and fix the things that aren't so good. But the key is to not beat yourself up about what you don't like. Simply work on it. And I don't mean just your body—I mean who you are as a person. I find that when I'm actively working on myself I just feel better.

I'm so thrilled that black girls and black women are finally recognizing ourselves as the queens we've always been. It's so inspiring to see us loving on and encouraging one another. We're so bomb, and the more we realize it in ourselves, the more we can collectively influence the world to give us our due respect.

I rock because I never let anyone dictate who I should be and what I could be. I define who I am and always follow my heart.

AFYA IBOMU

SOUL FOOD

Certified holistic health nutritionist, vegan celebrity chef, and author

AS A CHILD, I WAS TROUBLED WITH PERSISTENT ILLNESSES. I HAD ASTHMA, allergies, irritable bowel syndrome, chronic dehydration, and severe migraines. I was in and out of the hospital all the time. I was on eight different types of medication, but I wasn't getting any better.

When I was fourteen years old, my mom found a doctor who was an allergy specialist. He said my health issues might be attributed to the foods I was eating. At the time, my mother was a single parent working three jobs, so my sister and I were pretty much on our own when it came to feeding ourselves. That means our diets consisted mainly of fast food, soda, and Twinkies. I had never before connected those two things, my food consumption and my health.

Around that same time, KRS-One came out with a song called "Beef," in which he raps about how the food industry uses drugs and hormones that are poisonous to our bodies to literally "beef up" cows so they grow faster. Those hormones were transferred to our bodies when we consumed the meat. That was enough to convince me to stop eating meat.

I became a vegetarian, but I wasn't a *healthy* vegetarian. Although I wasn't eating meat, I was still consuming a lot of starchy, sugary, and salty foods. It wasn't until I started studying the teachings of early holistic health practitioners like Queen Afua that I changed my entire way of life and transitioned to a plant-based vegan diet.

The deeper I dived into living a healthier lifestyle, the more apparent it became that

"you are what you eat." Everything that you put into your body actually breaks down to your cells, your blood, your muscles, and your organs. Everything you eat actually becomes *you*.

I started researching health, nutrition, and healing more thoroughly and began to use my knowledge to heal people in my family. Years later, my mother was diagnosed with multiple sclerosis, and the doctors told her she would have to depend on prescription medication for the rest of her life. As the illness progressed, I saw her health deteriorating. She was nearly wheelchair-bound; the medication was not helping her. The side effects were just as bad as the pharmaceutical commercials describe—extreme weight gain, swollen limbs, depression, fatigue, and more. The drugs were causing more problems instead of actually fighting the disease.

I finally gave my mother an ultimatum. I said, "Look, Mom. You can either live or die. I believe I can help you, but we have to get you off these drugs and try a more natural approach." She agreed to come off the meds and try the holistic alternatives I was offering. I then created for her a regimen of raw foods and herbal supplements, and proposed other dietary changes, such as removing dairy, processed foods, sugars, and artificial ingredients from her diet. Her health started improving immediately, which was shocking because MS is a disease from which people don't usually recover.

At that point, I knew that I had a calling for natural healing and the passion to make a difference by educating my community on how to live their healthiest and best lives. So, I chose to go back to school to become a certified holistic health counselor and to get my bachelor of science degree in nutrition.

Unfortunately, we live in a society that promotes unhealthy living—the consumption of overprocessed and genetically modified foods, as well as a reliance on surgery and medication as primary care for diseases. Too many people, particularly people of color, suffer from high levels of cancer, diabetes, high blood pressure, morbid obesity, high cholesterol, and heart disease. The black community is being plagued by preventable illnesses because it is difficult to make good health choices when you are socially conditioned to do otherwise.

Holistic health practices are especially important for black women because of the issues, pressures, and stresses we deal with daily. We have to navigate racism and sexism. We are often the leaders in our families, our communities, our churches, our jobs, and even on the front lines for social justice in our society. Sometimes we try to do everything for everyone but ourselves. We rarely pause to consider what we need for our own survival or sustainability, and that's dangerous.

Taking care of ourselves and our health should be our priority. We live in a culture that tries to push us to value our external appearance more than our internal wellness, so we are socialized to make investments in clothing, shoes, handbags, or weaves as opposed to our mental, physical, and spiritual health. It is crucial for black women to prioritize our holistic health; to commit to meditating, to drinking enough water, to making healthy food choices, to stretching our bodies, to working out, to breathing deeply, and to refusing to let other people's "stuff" consume us or become our burden. Holistic health encompasses your entire life. A lot of times people think of health as just diet and exercise, but so many things can impact your wellness, ranging from the relationships you have, to your finances, your career, your education, your food and nutrition, your happiness, and your everyday stresses—all contribute to your health. In the words of Audre Lorde, self-care "is not self-indulgence—it is self-preservation!" There is no Black Girl Magic with-

out black girl healing. I want to see us collectively living better, longer, and fuller lives. Actively immersing ourselves in a holistic health lifestyle allows us to preserve all our magic and creative energy so that we can continue to give our light to the world.

I am blessed to have a partner, my husband, Stic, who understands and values the process of fortifying our well-being through fitness, family, and a connection to nature and creation. We are blessed to be able to grow our own food, for our children to be able to garden and touch the earth. And we are blessed to have this powerful passion and deep commitment to living well and to fostering the health and wellness of our greater community!

By choosing to live and exist in my full dimensions, I am breaking boundaries, defying odds, resisting stereotypes about black life and the oppression and marginalization of black people. I am resisting the identities that society puts on us as black women, black children, black relationships, black marriage, and black living. I'm a beautiful mix of native, earthy, natural-living, meat-free, vegetable eating, green-juicing, hip-hop-loving, crocheting granola girl. I'm a naturally fly girl with a little Winnie Mandela. I am a healer, a doula, a creator, and a freedom fighter. That is my magic and that is what makes me ROCK! ⇁

> There is no Black Girl Magic without black girl healing. I want to see us collectively living better, longer, and fuller lives. Actively immersing ourselves in a holistic health lifestyle allows us to preserve all our magic and creative energy so that we can continue to give our light to the world.

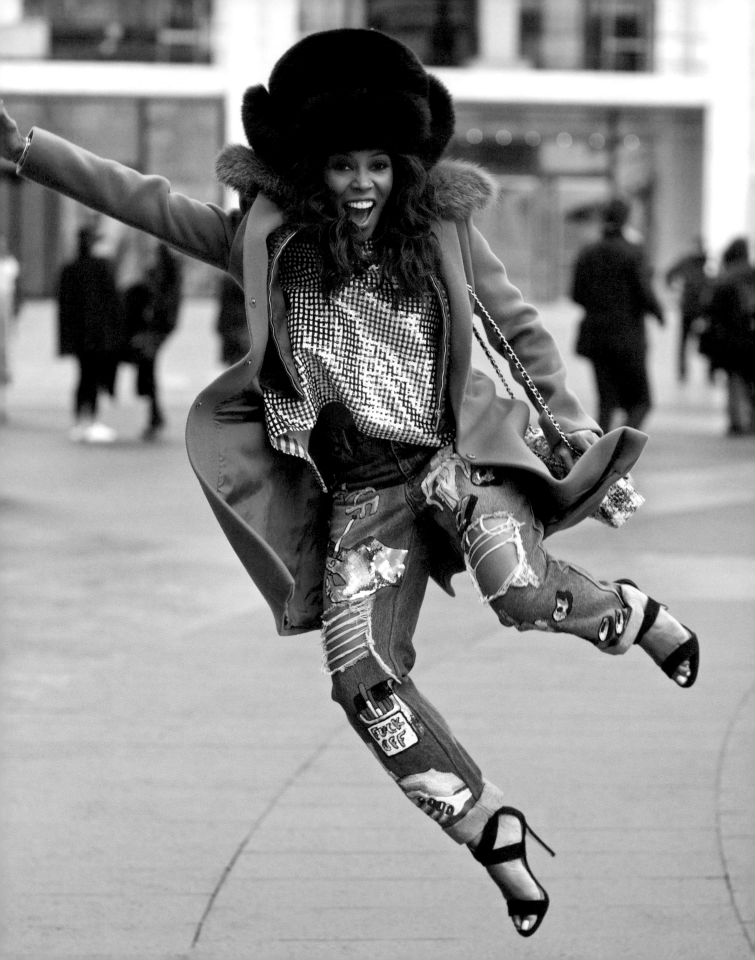

JUNE AMBROSE

SO FRESH AND SO CLEAN

Celebrity stylist, creative director, and costume designer

Style is about self-discovery. Fashion is mute without style. We all have a sense of style, but our power lies in giving it a voice, putting something together and making it our own. The truth is that no particular garment is going to make you feel sexy, coy, or rich. No piece of material will make you feel any of those things. Style is what *you* bring to your boyfriend jeans, your little black dress, your sweats, your heels, and your sneakers. We cannot expect the garment do the work; it's our spirit and our energy that do the work. That's what tells our story when we walk into a room.

As a black woman and designer, it's so glorious to be in a period when we are seeing black girl joy, swag, and style being embraced. It's so delicious. I love how the international community of black women is coming together to celebrate each other. Women are helping each other and we are having authentic conversations about our collective beauty, fashion, and style. I think it's beautiful to witness and participate in this.

We are no longer rationing out our compliments or our love for one another. Today, our cups runneth over. We've come to realize that the sun is big enough to soak into all of us. ⚡

BETHANN HARDISON

MODEL CITIZEN

Pioneering runway model, diversity-in-fashion activist, model manager, industry consultant, founder of Black Girl Coalition, documentarian, and creator and executive producer of *Invisible Beauty*

A LOT OF PEOPLE DON'T KNOW MY STORY BECAUSE I AM A REVOLUTIONARY. When you're a revolutionary, you don't expect to be in a lot of "prestigious" spaces and places. You take whatever recognition you can get, but more important, you stay in your lane and do the work you've been called to do. Revolutionaries are called to focus on their mission.

I started my activism and advocacy work in the fashion industry when I noticed that black models were beginning to get editorial work but were not getting equal opportunities or fair wages. I was deeply concerned with the unfair politics of fashion.

I had a modeling agency that was predominantly white. I had some black, Asian, and Latino models, but there were only a few. Meanwhile, other agencies didn't even have that, so it became the norm for them to send me the black girls who came their way. There I was, trying to keep myself balanced, trying not to take on too many girls, trying to maintain a standard of excellence among the talent I did have, while also battling the racial disparities in an already competitively tough industry.

I eventually said, "Enough! This system is broken, unfair, and needs to change. It can't just be me fighting for balance; the industry needs to adjust, to change from the inside out." That was when I started the Black Girl Coalition to advocate for just practices in the industry and to bring black models together. I thought it was really important to

show them that they could have a network of support in an industry that can be so isolating for women of color.

I created the coalition to educate and mentor girls about the business during a time when black girls were starting to get booked more frequently than ever. The prerequisite to being part of the Black Girl Coalition was that you had to be editorialized. You couldn't just be a catwalk model or someone who sat around. You had to have credibility and respect within the industry.

My vision was multilayered: I wanted to do something that could both celebrate and benefit these models, give back to the community, and generate good press.

I had this idea that I was going to do a gathering to educate models on how they could work together as women of color and also as models, despite the competitiveness of the industry. (When it comes to competition, models are much like athletes: *why her* and *why not me?*)

I thought it would be great to use this moment of strength to raise the consciousness of the industry and to give back—not a common thing in the fashion world. At the time, in the mid-1980s, New York City was hit hard by homelessness, so I thought we could help homeless people, especially children. Originally, it was about all of us throwing a gala to raise money. When I told Iman this, she was all over the idea: "Oh, Bethann, we have to do it." Also helping out were Veronica Webb, Naomi Campbell, Karen Alexander, Roshumba Williams, Cynthia Bailey, Gail O'Neill, and Kersti Bowser, who was often on the cover of *Elle*. Everybody had a little job to do. Veronica would write the letters. Iman and I would lick the stamps. It was funny. Can you imagine Iman sitting there stuffing envelopes? She would say, "How did we get ourselves into this?"

I knew the gathering would bring together people in the industry and give me the opportunity to educate them about the shift in the marketplace.

I'm glad I was able to use my voice to impact the industry and help get black models get more work. I kept the pressure on the industry by speaking up until a change happened.

A lot of people think I started the Black Girl Coalition just to bring attention to racism, but that's not why at all. It started from a place of pure pleasure and celebration. It started from a place of recognizing those women of color who were breaking barriers in a fashion industry that was too fragile to include them completely. My mission has been to empower black models, to make them more visible, and to hold the fashion industry accountable. ⚡

SUSAN L. TAYLOR

IN THE SPIRIT

Editor in chief emerita of *Essence* magazine and founder and CEO of the National CARES Mentoring Movement

BEFORE I BECAME THE EDITOR IN CHIEF OF *ESSENCE* MAGAZINE, I WAS THE fashion and beauty editor. I could have stayed in that position for decades. I absolutely loved it, because it gave me the opportunity each day to explore and elevate the beauty of black women and work toward undoing the negative concepts and beliefs we've been taught about our looks. In my role I could help black women see how exquisitely made we are, offering part of the mental shift needed to own the fullness of our Divine Feminine power.

In 1970, when *Essence* debuted, there were only a handful of modeling agencies, and just a couple representing black models. None of them had the full range of diverse sisters on their roster who mirrored the breadth of black beauty. As fashion and beauty editor of the magazine, I had a unique opportunity—and a responsibility, I felt—to fill the void. And so I made a pledge to our readership and a promise to God: my fashion and beauty team would create a grand stage for black women's beauty that was absent in the world. The narrow standard by which women's beauty is defined is ever so punishing to black women—as well as to our sisters of other races—who fall outside the narrow range of how femininity and beauty are defined. *Ebony* magazine, founded by the heroic John H. Johnson twenty-five years earlier, took African Americans into the lives and homes of the black celebrities who thrilled us. On the pages of *Essence*, we would celebrate every manifestation of the everyday black woman's aesthetic—ebony to ivory, long and lean

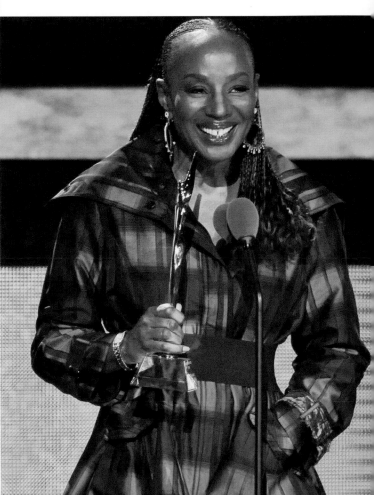

to curvy and lush; hair straightened, braided, beaded, bewigged, and barely there, as I wore my crown.

This was one of the greatest joys in my thirty-seven years at *Essence*—ten years leading the team that produced the covers and style pages, and the next twenty-seven as editor in chief and editorial director. I was twenty-four when editor in chief Ida Lewis hired me as beauty editor; the storied Marcia Ann Gillespie, who soon after became chief editor and fueled the growth of *Essence*, pushed and encouraged the staff to break barriers, to be inventive. She gave me the latitude to explore new ways of representing our women. At just twenty-six years old, Marcia, a history major in college, had a keen awareness of and cared deeply about the suffering black women had endured over the centuries—that our beauty had been negated, our bodies denigrated and desecrated. It was the height of the Black Power Movement, the 1970s, and *Essence* was on!

But it wasn't always easy. Meeting the needs of black women meant meeting myself, confronting my social conditioning about black looks and about my own—my high forehead and skinny legs. Throughout my childhood, every hairdresser who gave me a press and curl also gave me super-long bangs. And the hurtful remarks some Harlem boys would shout about my legs when I ignored their advances led to my seriously considering getting calf implants—imagine! I was fully grown when my friend Joe Mann, head of our city's health and hospital services, insisted that I discuss this with a surgeon he invited to meet with us in his office. When I rolled up my pant leg, the young white doctor exclaimed, "Racehorse legs! My wife would die for them!" Racehorse legs? Hmm . . . I decided then and there to make that my mantra, and over time I came to love my long, lean legs and stepping out proudly in the shortest miniskirts. And blessings to Mommy for always telling me that "a high forehead is a sign of superior intelligence."

One of the greatest joys of my job directing the style pages of *Essence* was scouting for the breadth of beauty beyond the narrow representations available through modeling agencies. And did I ever find our gorgeous women of every hue, size, and shape to photograph! They were walking the New York City streets, on busses and trains, in stores and restaurants. I met the magnificent Mikki Taylor when she was working in the garment center and I was covering the market for an *Essence* shoot. Struck by her compelling presence, I invited Mikki onto the pages of the magazine and then to join our style team. She grew to become our expert cover and beauty editor.

I remember being on the campus of Dillard University in New Orleans to shoot the August Back to College Issue when I happened upon a chocolate dream of a sister. I stopped her in her tracks to tell her how beautiful she was and to invite her to come to a fitting for our beauty pages. She looked behind her, over her shoulder, and all around to see just whom I was speaking to. I said, "It's you!" In utter shock and with tears she couldn't contain, the young woman shared, "No one has ever said that I was beautiful, not even once." All of her life, as the darkest person in her family, she was made fun of, told that her skin was too black, her nose too broad, and that she had liver lips. That unforgettable exchange was an awakening for me and, hopefully, for the black-skinned beauty whose wounds were evident and oozing. Every interaction can be a vehicle for learning and understanding. We had to work ever so gently at getting her to smile during the photo session. It's so easy to become a reflection of what others say to us and about us. Who among us doesn't feel some days that she is not quite right, that there is something about us that needs fixing, polishing; that we are not enough—when it's a fact that we are human and divine, made in the image and likeness of our Creator, and therefore *more* than enough.

Comparing ourselves to others and then judging ourselves harshly is crippling to us women. Even supermodel Iman, a favorite of mine back in the day, had to work toward standing strong in her unique Somalian beauty. While the world was going mad for her, she shared with a little chuckle, "In my village, I'm not even considered one of the pretty girls." When we embark on the most important journey of our life, the journey to self-awareness, the beauty of our being becomes stronger than the conditioning imposed upon us, which holds us captive, divorcing us from our unique self, making us feel inadequate.

And so I began defining beauty more deeply, encouraging us women to discover it within ourselves. Deepening self-awareness deconstructs those boundaries that are the untrue thinking of others. As our true and beautiful self is revealed, honored, and loved, an inner certainty emerges. Unfettered by constructed limitations and false beliefs about who we are, we show up in the world with freedom and authenticity. We see negative portrayals of our hurting black girls on social media and wounded black women—overdone and irreverent—on reality shows. Still today there are too few mirrors for black girls and women to see ourselves clearly. The negative personal beliefs we may host about our skin color and hair, our features and bodies were created by the insidious and oppressive value systems we've absorbed and perpetuated for generations. They are the cataracts clouding many black men's eyes, as well as our own. Unless acknowledged and intentionally purged from our psyche and soul, they will enslave and cause us to dishonor our self, our heritage, and the great miracle of our existence: each of us is one of a kind, each a divine original, perfectly made! Attuning ourselves to this truth and honoring how beautifully and magnificently and uniquely our Creator fashioned each of us

is the way to self-acceptance and healing, fulfillment and joy. Our life's work is opening the way. ⚡

ROBERTA FLACK

I AM LEGEND

"I don't consider myself a soul singer. I'm not a jazz singer. I express myself and I object to categorizing expression. A true artist is a person who is totally devoted to the indulgence of her art form. I am a musician, and I use music to tell stories of my life and my beliefs. Music expresses our lives and crosses all barriers, and we need free expression now more than ever."

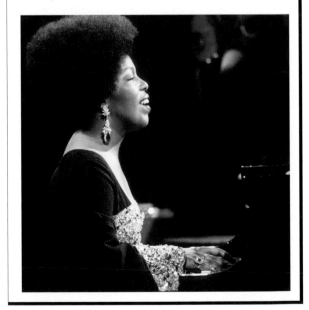

VI.

MOVERS AND SHAKERS

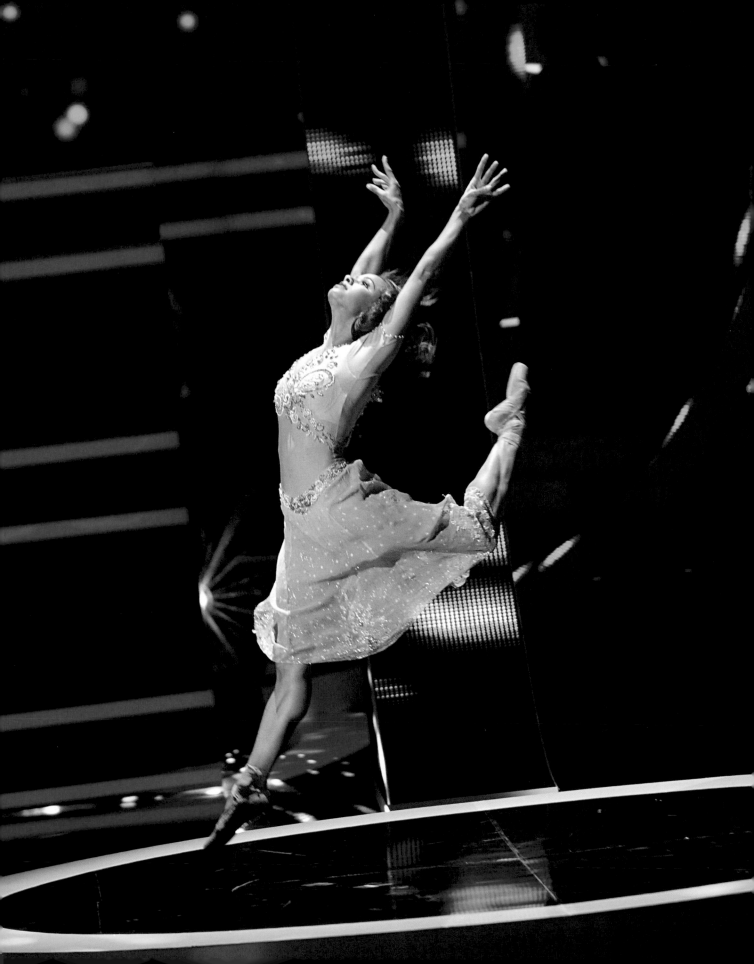

MISTY COPELAND

ON POINTE

Principal dancer at the American Ballet Theatre and philanthropist

THERE IS A KIND OF HIDDEN VOCABULARY IN THE CLASSICAL BALLET WORLD, a language—one that is often tolerated and excused—regarding the ideal body type and aesthetic of a ballerina. *Fragile, pixie, ivory skin,* and *flaxen hair*—all these words cunningly imply that more muscular, athletic, curvaceous female physiques aren't the right body types to succeed in ballet; or that browner skin tones don't convey the right feeling for the art. Although ballet has traditionally required a level of uniformity, when someone like me enters the picture, these words can feel isolating. This coded language is sometimes used intentionally as a way of masking racist thoughts about who belongs in the ballet and who doesn't; it is people's way of avoiding saying straight up: you're black, and you don't belong here.

I struggled with body image and a sense of belonging for some time. I hit puberty really late in life. Just as my career was starting to blossom at the American Ballet Theatre, my body started to change. I started to fill out. Suddenly, my lean, lengthy figure had given way to a stronger, more muscular and womanly body that was quintessentially black. My body no longer fit in with the standard A-symmetrical frames, frail or boyish torsos, or the long lines of other dancers. At first I didn't know how to feel about or respond to my body's sudden changes. There was all this chatter, people encouraging me to lose weight so I could "find my lines" again. I was already petite and lean based on society's standards, even skinny, but in the dance world, I felt like an outcast—like my body was no longer a sound instrument for my craft. The idea that my black girl aesthetic made

me less desirable or less palatable in the ballet world threw me into a depression of sorts. For the first time in my professional career, I had this overwhelming feeling of inadequacy. I became painfully aware that despite my talent, passion, and accomplishments in this field, there were so many who were not ready to receive me or who were ready to dismiss me because of my body and my skin.

Many white ballerinas who are muscular or who have large butts still succeed. They are allowed to succeed. So, to say that black women aren't built for ballet and therefore we cannot succeed in the ballet world doesn't make sense to me. That's just another way of saying, "Your skin color does not fit in."

Once I was more aware of the hidden meaning behind the language used in the ballet world to suggest that I did not belong there, it made me fight that much harder to be the best, to stand up for myself, and to defend my right to be in this space—to live out my dream. I started to appreciate my strong limbs, my fuller breasts, and the curve in my hips. Instead of being crippled by the sting of rejection, I used the aversion to my blackness as an incentive to shift gears, to focus on my love for the craft, and to take my art and athleticism to its next level. I became more aware and attuned. I started to move on the stage more confidently, executing the choreography with grace, strength, technique, rhythm, and precision.

My muscular, curvaceous body gave me an ability to perform more fiercely. And yes, I stood out. I owned it! There comes a point when we just have to affirm ourselves, accept what our bodies are going to be, and remove the stigma that others may place on our appearance. Black girls in particular are constantly being judged by our appearance. Our hair, our skin, and our bodies are always being put under someone's microscope, causing us to wonder if we can ever be enough. I knew going forward that I was

not going to allow the judgments of others cripple me mentally or limit my success. I am enough and I bring my Black Girl Magic to the art form!

I've said this before. I don't know where I would be in ballet if I weren't African American. My path is my path because I am a black woman. Had I been white, with a privileged background, and started dancing when I was three years old, I don't think I would necessarily have had the determination and fire to succeed that I have now. Growing up in poverty and having to make a way out of no way gave me a firsthand look at the incredible resilience and tenacity one must have to reach a level of success in any field, but especially to break barriers as a woman of color in the classical ballet world.

I also don't think I would have had the same intense understanding of music or the same connection to movement if I weren't black. Music, rhythm, and dance are a staple in our collective identity as a people. I've always felt a physical, spiritual, and emotional bond with music, movement, and the black cultural aesthetic. It is a part of my truth.

There are some people, people who aren't black, who say, "I don't know why you always have to talk about being black. You're just a dancer. Why don't you focus on the fact that you are a great dancer?" To me, that's like telling me I should stand down, be quiet, and appreciate being allowed to "sneak in." It's as if they're saying, "We let you in. Shouldn't that be enough?"

Well, it's not enough. They don't understand that I'm fighting for something bigger than me. It's for every dancer who deserved to be on that stage yet was barred or discouraged. I'm not going to remove the label of being the first African American ballerina with the American Ballet Theatre. I won't remove what that means to me, what it holds for me, what I've worked a lifetime for, and what so many other

women from previous generations worked a lifetime for. I will not ignore the collective sacrifice required for me to get to this point.

Being a prima ballerina, in this particular body and this black skin, has given me the platform and responsibility to advocate for the next generation, to bring awareness to the conversation about diversity. It gives me the opportunity to continue the work of those dancers who came before me and who have chipped away at the barriers that black ballerinas face.

I press forward to achieve excellence not just for myself, but for all the brown girls who preceded me and all those who will inevitably follow me. I rock because I am creating a new definition of "what a ballerina looks like." ⚡

My muscular, curvaceous body gave me an ability to perform more fiercely. And yes, I stood out. I owned it! There comes a point when we just have to affirm ourselves, accept what our bodies are going to be, and remove the stigma that others may place on our appearance.

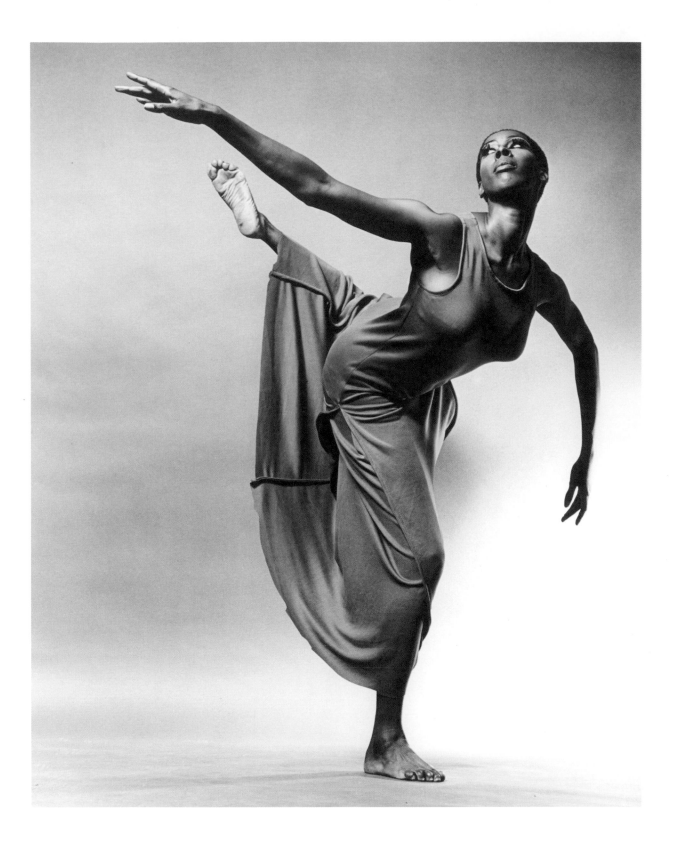

JUDITH JAMISON

DANCING SPIRIT

Award-winning dancer, choreographer, and artistic director of Alvin Ailey American Dance Theater

WE ALWAYS HEAR "BLACK PEOPLE HAVE RHYTHM. THEY CAN DANCE." The truth is all of us can't dance, but we do all have an ancestral heartbeat inside us. That inner heartbeat and rhythm may not always manifest itself through our ability to dance, but it runs in our blood. It expresses itself in the genius of how we walk down the street, in the genius of how we greet one another, in the genius of how we tap a foot or how we extend our graciousness to others. All that is about rhythm. Go to any black neighborhood and you will feel it.

This rhythm is what Alvin Ailey used to call blood memory. You are born with it in your bones. God gave it to you. From the beginning of time it has been ours. You're connected by your ancestors. You're connected by anything and everything that has brought you to this time in your life from the beginning of time. So, it's undeniable that the heartbeat of this black woman is coming from a long time ago. This is why we rock.

Now here we are, transported to today, with four hundred years of history here in the United States, and that connection remains. We're connected to many, many things because we have to walk many paths in order to navigate this life. I love when I see black women and black girls—how we look each other in the eye. Black women own this, and there's nothing that can shake this undeniable connection. Nothing.

For dancers, understanding these connections is key, because for dancers, it is also about how we connect to the dance and the audience. My first time performing onstage,

at six years old, I was scared to death, but when I heard all that applause, somewhere in the back of my six-year-old brain, I went, "Oh, I like this." You want the applause, but the connection is even deeper than the applause.

Back in the old days, the audiences would bring tambourines when they came to the theater to see *Revelations*. It didn't matter if you were performing for a predominantly black audience or not, somebody would have a tambourine. Somebody would also pop up and give you an "Amen." That's that connection, that's the rhythm.

Everyone may not always respond with nineteen curtain calls. They will respond in other ways that let you know they have felt a connection with you and they appreciate you sharing your culture. Our culture extends all around the world. Everyone is trying to imitate us, and there is nothing new about that.

I had been invited to come dance in New York by the great Agnes de Mille. My first gig as a guest artist was at American Ballet Theatre. Soon after, I went to an audition at the Alvin Ailey Dance Company, but I did not get in. I failed miserably. I called my mom at home and said, "I don't know what I'm going to do, but I'm going to stay here." Then, two days later, after seeing me at an audition for another company, Alvin Ailey called me and asked if I would like to join his dance company. I accepted his invitation enthusiastically and joined the Alvin Ailey Dance Company in 1965.

When you're young and making all these decisions and moves, you realize that everything comes the way God wants it to come. You are either overwhelmed by it or you go with the flow. I was twenty-two then, and I've been going with the flow ever since.

On my first day of rehearsal, I just stood there for a second or two, flabbergasted. I was standing in front of my idols, but there were only ten of us in the company, and I knew I was there to do work, not to adore

people. I had to jump right into the rhythm of what was going on in the room.

There was no time to go "ooh" and "awe." There was time only to say, "Okay let us join together and work." I was learning eight pieces in something like two or three weeks, and then was on the road for six weeks. Boom! Just like that, you are in it, dancing in solos and ensemble pieces.

When Alvin created the solo *Cry* for me, I didn't know it was dedicated to all black women until I looked at the program. I didn't know it was a gift to his mother. Alvin would always embed his solos in a larger work, so I was used to him creating solos for me and several other people. The difference with this dance was that it had me out there for fifteen minutes by myself. We hadn't had time to go through it in rehearsal, so the first time I ever danced it from beginning to end was during the first performance. I almost died in the middle of it. I couldn't feel my legs, I couldn't feel anything halfway through the piece. That was quite an experience. It's a brilliant work, and I'm so proud of the fact that I was part of it.

Having performed *Cry* and seeing it passed down to different women in the company over the years has reminded me that the strength of the women in Ailey is just beyond words. Donna Wood, who took over my role, used to do a ballet that Mr. Ailey created for her called *Memorial*, which is a half-hour long. Donna would do one ballet in between, and then she'd have to come on and do *Cry*. The technical and emotional capacity of black women like Donna is just magnificent. It feels as if we're carrying the weight of the world on our shoulders, because we are. You have to be diligent and strong and of a single mind when you get on that stage to do that dance. You are representing all black women, especially our mothers.

For a long time, black dancers couldn't get into

spaces, weren't even allowed to take certain classes, and this problem still exists in some ways. But you have to keep going. You have to be extraordinary in your craft no matter what.

This starts by looking at yourself and loving what you see. Many times, when we see ourselves, we see our flaws. You have to understand that you are not perfect, you are human. There are things for you to work on—and yes, you have to be diligent about it—but you still have to love yourself. When you achieve this in yourself, it frees you and allows you to see it in others. If you don't have that, then you're not going to connect with anybody else.

It has to start with love, because love then encompasses your excellence. In performance, I call it spiritual reciprocity. It's based on hard work, tenacity, a sense of humor, dedication. When you're a dancer, you have to practice until the day you die. You never stop taking class, ever. I still get up in the morning and go down on my knees and pray and then get down on the floor and do a floor barre. It's your life.

It doesn't matter what kind of work you're doing, it is important that you are a person who is conscious, who is present, who has empathy, and who understands what it is to love herself first. It's like when you're on a plane and they tell you to put that oxygen mask over your face first and then on your baby, because what good are you to the child if you're dead? We all need that oxygen.

Regardless of what's going on in the world, if you want something, you're going to have to work hard for it. If you want in somewhere, you are going to have to make your own door: *you* make the frame, *you* put the knob on it. There's no way on God's earth we would get anything done if we waited for "the Man" to open doors for us. And when that door opens for you, you shine brighter than anyone else has ever shone. All the while, you have to understand this: none of us got here alone. Your ancestors are your battery. A lot of sacrificing and resourcefulness went into making sure that the doors got open, and if nobody is opening doors for you, you'd better create your own. ⚡

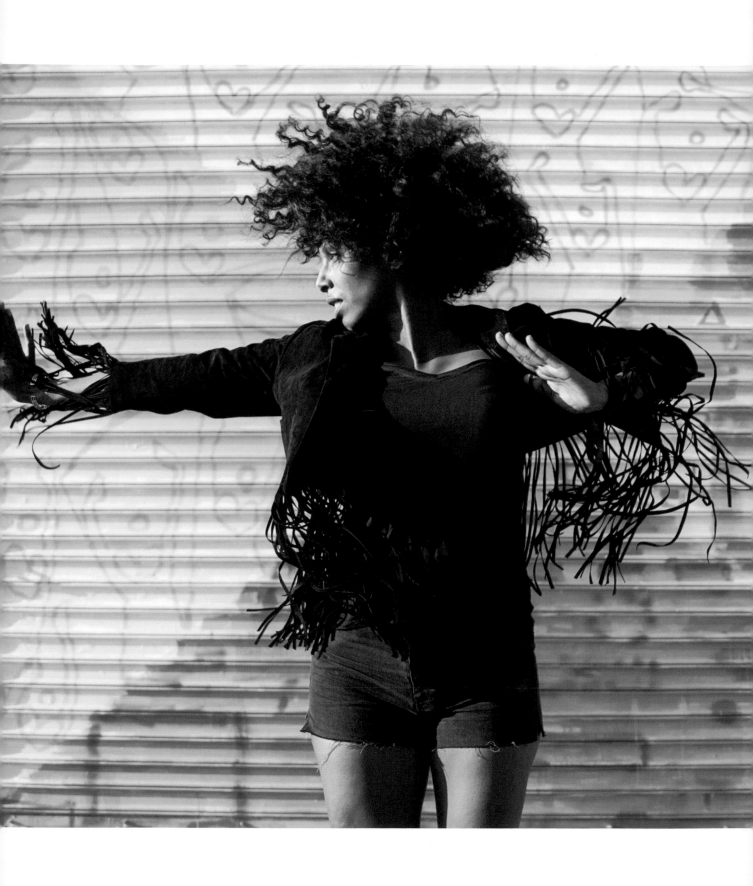

LUAM KEFLEZGY

THE BEAT OF OUR DRUM

Award-nominated dancer, artistic director, and choreographer

DANCE PROVIDES A SACRED SPACE FOR BLACK WOMEN, ONE WHERE WE CAN be totally free, where we can be completely uninhibited. We live in a society where black girls' bodies are constantly judged, objectified, commodified, violated, and even policed. So, it's really important to have a space where black women can explore and own the freedom in our movement. Our dance holds our truth: our cool, our power, our sensuality, and our fierceness. Dance is a part of our magic! Our Black Girl Magic works on so many levels, but definitely with movement, rhythm, and dance. The magic in our dance allows us to lock into something very old in the world. It's very special.

There is something magical about the way black girls move, something gripping and compelling. When you witness it, you are not merely watching, you're experiencing something. You don't just see it, you feel it. There is an implicit rhythmic connectivity shared by black women all over the world. It's a mysterious yet divine energy that we possess, and it manifests itself in the way we move, not just to music, but in the way we walk, the way we hold conversations, the way we sing, and the way we emote. It is in everything we do and in all the ways we move through the world.

I have witnessed this all over the world no matter where I go; whether it's a remote village or a major metropolitan city; from Finland to Ghana it is the same energy and the same electrifying magic. I recently visited a rural village in Ghana, to participate in a program building schools with a charity. When we arrived, the women formed a dance circle, and, of course, I jumped into the center. Being in the middle of that circle,

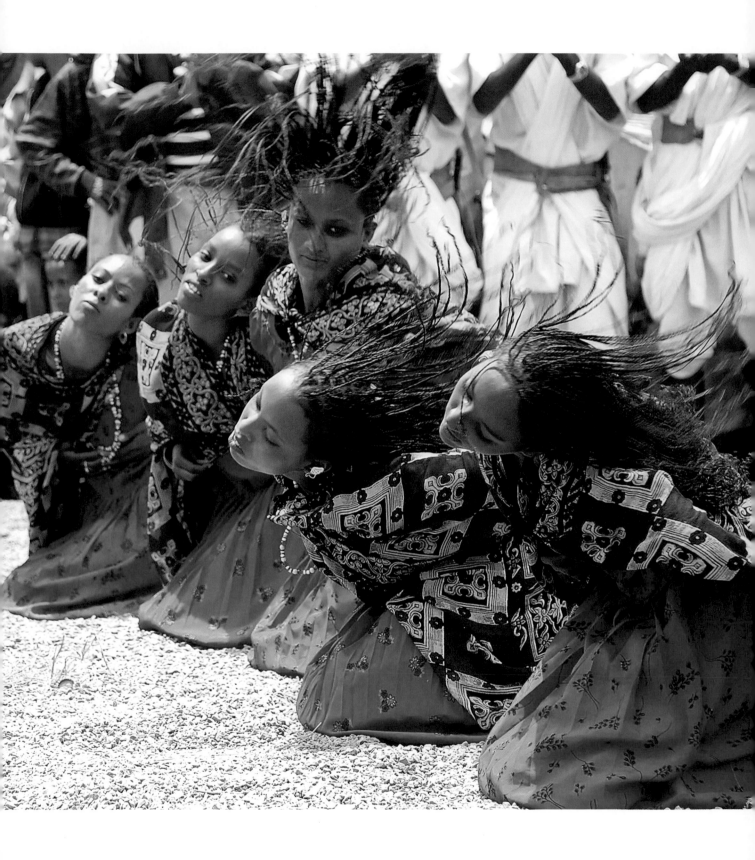

dancing with the village women, I felt timeless, as if I had been there before. It was as if I had entered a time warp and been transported to centuries in the past. There was an organic connection. There I was, dancing freely, fully grounded in the moment, but at the same time I felt tied to something from long ago. While I was in the circle, intoxicated by the rhythm, the movement, and the vibration of the communal energy, it struck me that this moment *was*, in fact, ancient. My spirit recognized it. It's this feeling, this deep knowing, that resonates within us and connects us when we dance. It's not *just* the steps; it's the connection to our truth.

There is so much inside us that needs to be expressed, and so our stories come out in our movement in such a visceral way. When I see black women dance, there is a familiar energy. It doesn't matter what their skill level is, or what their background or culture is, there is a story there. There is a rhythm there. There is a soul there; it's in our DNA. It is a story that is older than we are; it's a tie to the beginning and the forever. ⚡

ANA "ROKAFELLA" GARCIA

B-GIRLS WILL B GIRLS

"Classic hip-hop dance embraced my desire to turn things upside down . . . and the beat goes on! #onlythestrongsurvive"

Break dancing propelled Puerto Rican, Afro-Latina B-Girl "Rokafella" Garcia into international circles of dance and recognition. As a pioneering woman in the male-dominated field of break dancing, she is one of, if not the most famous B-Girl break-dancers to date. She has successfully rejuvenated the art of break dancing and continuously preserves the culture of hip-hop in its entirety in order to positively empower and educate youth.

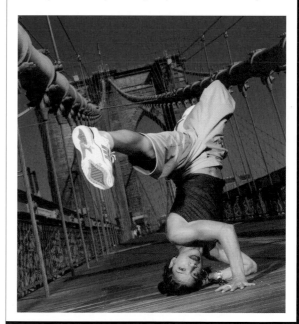

VII.

STILL
I RISE

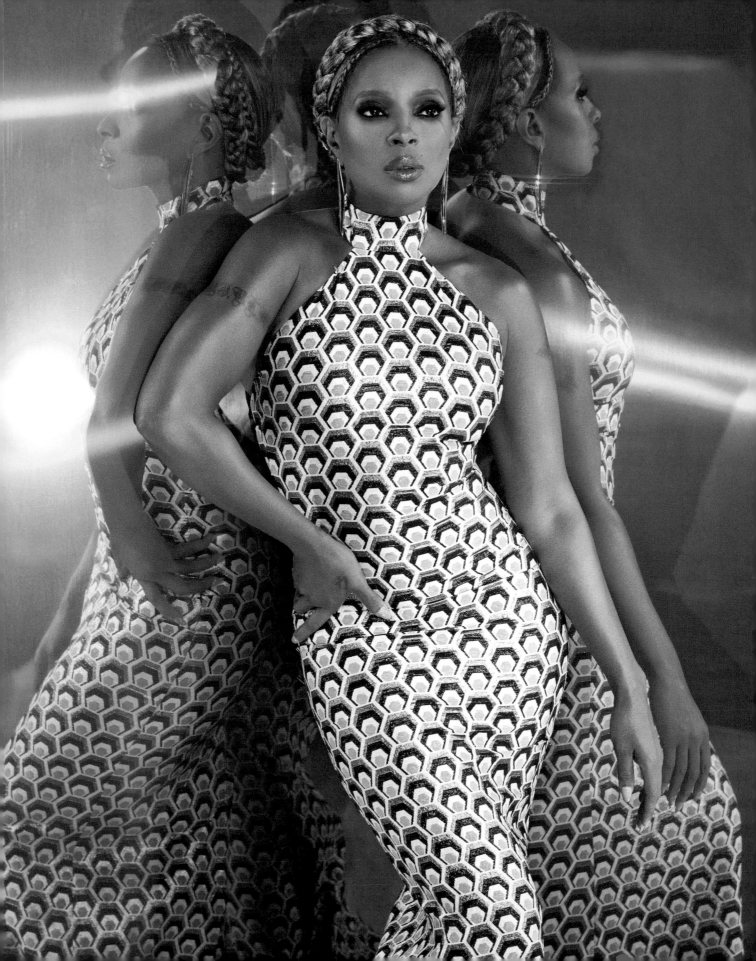

MARY J. BLIGE

MY LIFE

Grammy Award–winning singer, songwriter, actress, and the Queen of Hip-Hop Soul

WHAT I TRY TO CONVEY IN MY MUSIC IS THAT IF YOU DON'T BELIEVE IN yourself, then no one else will. If you don't love yourself and respect yourself, then no one else will. Before I was Mary J. Blige the superstar, I was afraid of dreaming too big, doing too much, being too "extra." I allowed the stigma of growing up in the projects to cause me to think small and believe that my big dreams could never happen. I had my own preconceived notions about what a girl from my neighborhood could achieve, and I placed limitations on myself based on all the stereotypes I had internalized.

The stigma and stereotypes put fear and insecurity in me, it made it hard for me to really believe in my possibility. I knew I could sing. I knew I was beautiful. I knew I was talented. I understood all that, but I was too scared to stand out and walk in my gifts. So, I would make myself small, dim my own light, and dumb myself down because I didn't want someone to think I thought more highly of myself than I should. Even after my songs hit the radio and I was still living in the projects, I attempted to shrink away from the success because I didn't want people to think I had some sort of superiority complex or that I considered myself better than they were. I thought that people would judge me or be negative about my ambitions. In fact, I was so focused on flying under the radar and lying low that I didn't even believe people when they started to tell me that I had a song on the radio.

What I didn't know at the time was that the thing I actually was dreading was the feeling of being too big and shining too bright. I was insecure about my own power, abili-

ties, and possibilities. I was frightened by the potential of growing beyond the only life I knew. Sometimes your environment can cause you to feel like you're not supposed to be happy, you're not supposed to get a new pair of sneakers, you're not supposed to excel, you're not supposed to be educated, or that it's cool to be dumb. That's not cool, that's just fear—fear of success, fear of failure, and fear of change.

Many people get held up in life when they don't step over their fears and claim their blessings. I had to overcome my own anxiety about people putting me down because I had aspirations to be a star. I had to learn to be less afraid of myself and less insecure about believing I could actually make it. When I consider all the things I thought I was going to be judged for—my realness, my attitude, my hip-hop-tomboy style—it amazes me how those things actually made me stand out. My authenticity made me edgy and relatable. It's part of the reason I became the undisputed Queen of Hip-Hop Soul out of the gate.

I thank God that I've been able to push through the fear, to get past my personal pain and sing about it. To do that, I had to gain an understanding of the good, the bad, and the ugly within myself. I had to accept that all of it was a part of my identity, but the challenge is to push past the darkness and nourish the light. Every single day, I'm growing, learning, progressing, and making mistakes like everyone else, but with the help of my family, prayer, and spending a lot of time with God, I've stopped being scared and ashamed of my past mistakes even when my life is put under the microscope. I've had to live out most of my life in front of the world's gaze. It is what it is. Life is constantly going, moving, and ticking and Mary J. Blige is always living, healing, and dealing with things as they are unfolding. Being in the limelight has meant that my deepest, most personal circumstances, whether it's my relationships with men or my financial troubles, are open to public critique.

One of the biggest lessons I've learned from dealing with my tribulations so publicly is that it doesn't matter if someone else on my team makes a mistake. No matter who is at fault in my camp, I'm the one who's blamed and shamed. When something bad happens, it's my name that's all over the news. When something goes wrong it's my name that's all over the Internet—not their names.

There comes a time in every successful person's career when they have to start managing the fruits of their labor more efficiently, rather than solely relying on others to do it for us. My personal financial journey has been turbulent, but reaching rock bottom and having my downfall be out in the public was my wake-up call.

As a black woman, artist, and entrepreneur, with all the barriers and obstacles we face, I think business education is everything. I say this because I'm not a high school graduate and I'm definitely not a college graduate, so I had to educate myself throughout my career in the music industry by learning the hard way. I've definitely gained more knowledge, but it was all through trial and error. Experience has taught me that you cannot let anyone come into your life and run your business without your knowledge and input, whether it's your husband, wife, mother, or brother. If that person is running your business, you have to be running it alongside them. It's not that you can't trust them, but if the relationship doesn't work out for any reason, then all your business affairs will fall on you, for better or worse.

When we fall into horrible situations, I believe that it's just God trying to grow us up. It's a sign and a wake-up call. The things that give me the courage to continue opening myself up, to keep going, to let go, and to let the world see me, are the energy, encouragement, and inspiration I get from other women. I'm often blown away by the stories I hear about what my

music has done for women's lives. I've heard every-thing from, "You saved my life" to "You helped me get through college" to "You helped me to get out of a bad relationship" to "You saved my marriage!" When I hear these stories, I am reminded that what I do is not just about me, it's not about my stardom, my clothes, or how big my home is. It's not about any of those things. It's about me sharing my joy and my pain. It's about how I've come out of my own trials stronger, wiser, and better.

I am blessed to be able to channel my pain through my passions, blessed to see that my music has helped other women understand the will we have to declare joy, confidence, and power over our own lives. I think there is a genuine and authentic realness in my music that deeply resonates with people because of my emotional transparency. It's relatable because it comes from a personal place. I write and sing about the necessity for women to choose ourselves and to *find our joy*. It comes from a place that is honest and truthful, that is based on my own life experiences. When I wrote "Be Happy," for example, I was in a place where I really just wanted to feel abundant hap-piness for once in my life, and no drama. The entire *My Life* album was a cry for help, and writing that album actually helped to deliver me. Then there was a different period in my life when I really started to like myself, and I was able to write "Just Fine." I really felt what I wrote. And I really loved what I saw when I looked in the mirror.

My music is not just therapeutic for everyone else, it's also therapeutic for me. I am most selfless when I am performing. I'm giving so much of myself. I don't care if I come across as raw and vulnerable because, in that moment, I need to allow myself to be free, to be naked, to be a vessel for what somebody else might be feeling. By the time I hit the stage, I've already reflected on all the experiences, challenges, and difficulties I'm trying to recover from. As I per-form, I'm trying to remember that I'm beautiful. I'm trying to remember that I'm strong. I'm trying to have no guilt, and I'm trying to feel no shame. I'm trying to cleanse myself, and get free at that very moment, so I need to sing every word in "No More Drama" and actually feel it. I need to sing every word of "Not Gonna Cry" and feel it. Performing is a healing ritual for me each and every time.

When I look back on my beginnings, I think it's amazing that I was so concerned I wouldn't fit in, when being myself actually helped me stand out and succeed in a tough industry. Being my authentic self helped me to create a new category, sound, and standard. This is a lesson that I always hold on to and share with others because it shows the importance of being confident about our truth. As human beings, we get hung up on our imperfections, but every expe-rience and testimony serves a purpose. Our success might actually be tied to the things we are most hesi-tant to share.

I am happy with who I've become, what I have gone through, and the lessons I've learned from it all. And I am proud to say that I put God first.

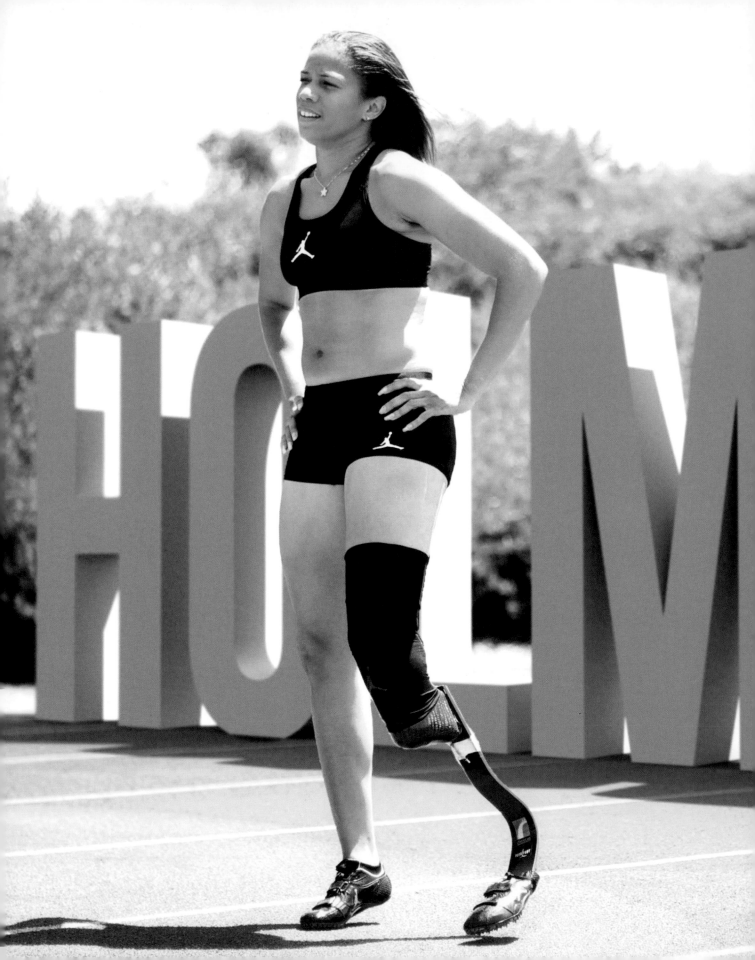

APRIL HOLMES

BENT, NOT BROKEN

Four-time Paralympian, three-time Paralympic medalist, author, motivational speaker, and first woman on the athlete roster representing Jordan Brand

IN 2001, I HEARD FIVE WORDS THAT WOULD CHANGE THE COURSE OF MY LIFE: "Did. You. Get. Her. Leg?"

I heard those words as I was being rolled into an ambulance, just after spending seventeen minutes being trapped underneath a train. My boyfriend and I were boarding an Amtrak train from Philadelphia to New York City on a cold, snowy January morning. I happened to be the very last person on the platform to board. Just as I put my foot out to get onboard, the conductor began to move the train. He didn't ring the bell. He didn't sound an alarm. He didn't say he was ready to go. He just moved the train, and I slipped! I fell underneath the platform, and the train rolled onto my leg.

I lay there for seventeen minutes—pinned under a train on the cold, wet ground. I had seventeen minutes to think about my life, to think about the things I'd done, the things I hadn't done. My initial thought was I'm probably not going to make it. Then I began to think about my family, wondering if I was ever going to see them again. I reminisced about my childhood and all the fun times I'd had. A million thoughts go through your mind when you are in a life-or-death situation. Those seventeen minutes felt like a lifetime. The longer it took to get me unpinned, the more I started to believe that I really wasn't going to make it. So, I tried to refocus my mind. I begin to think about music, thinking of songs I could sing to keep my heart beating, because I knew that if I sang, my spirits would be lifted. I was lying next to a pile of snow and picked some up

and attempted to make snowballs and to throw them. I needed to keep myself active because, I thought, if I lost consciousness, I would surely die.

The rescue team was trying to lift the train off my leg, but every time they made an attempt, the jack would slip because the track was so slippery. Although I was sedated, I was becoming increasingly impatient and anxious. So, I told the paramedic, in my groggy state, "Listen, ma'am, y'all are probably really good at your jobs and might even be experts at this, but can you please tell these people that it might be a better idea to just start the train and back it up off my leg instead of trying to lift this train!" They finally started the engines back up, and I felt the train move over my leg. I wanted to scream because it hurt so bad. But it worked: they were able to free me. They flipped me over, I was loaded into the ambulance, and that's when I heard those five words: "Did. You. Get. Her. Leg?"

When I came out of surgery, there was a brace around my neck, I was weak and disoriented, but I kept asking, "What happened to my leg?" No one would tell me, so I mustered up the strength to lift up my body to see for myself what had happened. As I rose up, I finally saw that my lower left leg was no longer there. It was gone.

I was devastated, not only because of the loss of the leg itself, but because I was an athlete. Having a leg was critical for the things I was most passionate about. I had run track and played basketball all my life. Now I had the sudden realization that I would never be able to do the two things I loved most. I remember turning to my cousin and saying to her, "You mean to tell me that I'll never be able to play basketball or run track again?" She simply said, "You will be okay," but I didn't feel okay. I felt pretty defeated at the time.

For the next three weeks, while I was recovering, my mother and my family made sure someone was with me at all times. They didn't leave my side because they didn't want me to sink into negative thoughts about what had happened to me. They didn't want me to ask, "Why me?" or to have a "Woe is me" mentality. It didn't seem productive to be sad about something I couldn't change, so I didn't sulk and I told everyone who came to visit me, "Don't come in here crying about my leg because *it's gone*! I don't care about how many times you cry, it's still not going to grow back! We can think about a plan and move forward, but we *are not* going to sit here and cry about it!"

When my surgeon came to check in on me, he'd bring me magazines about the Paralympics. I'd never heard of them, so I was disinterested at first. I'd literally take the magazines, toss them to the side, and keep watching television. But every day, he'd come to my room with something new, and one day he said, "April, I'm going to come back later to talk about these magazines!" And I was like, "Whatever, Doc. Have a nice day." My sisters came to visit me about an hour later, and they started looking through all the magazines. As they were flipping through the pages, one of them said, "April, did you see this? These people are running!"

Running? I didn't know there *was* running in the Paralympics. I couldn't snatch that magazine out of her hand fast enough!

I started searching for the section with the women runners. I wanted to see the winner of the 100 meter and 200 meter—the events in which I raced. I continued to rip through the pages frantically, and there she was, the gold medalist of the 100-meter race.

I said, "Wow, *this* is the girl who won?" She was even from the United States. I'd been an athlete my entire life. I knew the look of a competitive athlete. Despite the fact that I'd just lost my leg, there I was looking at this Paralympic athlete and sizing her up. I turned the page to see who'd won the 200 meter, and there she was again, the same girl.

Still, it was so important for me to see her because I needed to know who my competition was. It showed me that becoming a Paralympian was a real possibility. This changed everything for me. It put me on a path to achieving something in life that I had never envisioned prior to my accident, and it gave me the chance to earn my identity back as an athlete, which I had thought would be impossible.

When the doctor walked back into my room, I said, "Thank you!" He asked, "What are you thanking me for?" and I told him, "You just helped me rebuild my dreams. Because of your encouragement, I have three new dreams: I want to represent the United States in the next Paralympic Games, I want to be the fastest amputee in the world, and I want to win gold medals!" He looked at me as if he wanted to say, "But you just lost your leg!" Before he could say anything, though, I looked back at him and said, "I know I just lost my leg, but that shouldn't stop me from dreaming."

Since my accident, I've had the privilege to represent the United States at the Paralympics four times. I've earned one gold medal and two bronze medals in the Paralympics, broken the world record thirteen times, and I hold the world record as the fastest amputee in the world. I'm also the first female athlete sponsored by the Jordan Brand; a team of Jordan designers and engineers makes me customized spikes and shoes. All these amazing feats came after one of the worst experiences of my life, after I was literally stuck under the weight of an enormous train.

I never really cried about the accident—not when I was pinned down by the train or when I found out my leg was gone. But I did pray about it a lot. I remember thinking "God must know that I'm an extra-strong person, to put me through this. I am still here. So, this disability must be a part of my testimony for a reason." I knew my journey was going to be a difficult one, but I also knew that I would make it through. I just had to figure out a plan and persevere.

Not many people have a story like mine and can say, "Hey, by the way, my leg got cut off by a train," but everyone has been in a "train" situation at some point in her life—everyone has been stuck, pinned down, or hopeless. Those "trains" come in many forms, and sometimes you don't know how long you're going to be under them, why you're there, or how you got there. All those things go through your mind. But you have to have the audacity to say, "Back this train up off me so I can get to where I am going!" The faster you can figure out a way to get from underneath your "train," the sooner you can rise and get on with living your best life.

My strength and fortitude came from my faith in God and knowing that I still had purpose. That's also a black woman thing—the faith and the resilience. We rise up over trials and tribulations. It's not that others don't do this, but we black women have constantly been put in positions where we have no other choice but to rise. We've seen our mothers and grandmothers do it; they made a way out of no way, so we rise up and do the same. Whenever we have a problem, automatically black women try their best to move past sulking and get straight to the solution. We are masterful strategists, asking, "How do we fix it?" We are the "Olivia Pope" of our families and communities, coming through like "It's handled!" That's part of our Black Girl Magic. ➤

MISSY ELLIOTT

SUPA DUPA FLY

Hip-hop artist, dancer, and music producer

I THINK IT'S IMPORTANT TO SHOW OUR GIRLS IMAGES OF STRONG AND SMART black women who are innovators and trendsetters, building our own companies. It's also important to encourage the self-esteem of our girls and to raise awareness regarding the issues impacting our safety and welfare. This is personal to me.

I was sexually abused at eight years old by my sixteen-year-old cousin. Back then, such things were pushed under the rug in a lot of homes. In addition to my abuse, my mother was also physically abused at the hands of my father. When she cried, it would hurt me, because she was always everything to me. I felt helpless. When it happened, I would go into my room and write songs to block it out. Music was my outlet, and somehow writing allowed me to not have to ponder the abuse or question whether it was my fault. I always said that if I became famous, I would take my mom away from all that and take care of her so she would never have to fear anyone anymore, and that's exactly what I did. Music helped me overcome a lot. Just to see her at peace and happy means I've achieved what I set out to do.

I discovered that I wanted to be a music producer after high school. When I was recording, I'd always sit in with other producers who did tracks and observe what needed to happen during the production. I would hear the notes and say "Hey, change this part" or "This needs chords right here." I realized then that I wasn't just an artist.

When I create music, I go in the direction my heart leads me, or I tap into what I've been through or maybe what I've seen in other people's lives. I'm inspired by it,

and because I'm a female, of course a lot of my music comes from a woman's perspective. I never sit around and think about it. I hear a track and write what the music makes me feel. My music and my accomplishments show that women can do what men can do and that there should be no limits because of gender. It certainly doesn't surprise me that people consider my work to be feminist, though I personally don't put that much thought into it. My music and the many tasks I've accomplished show that women can do what men do! There should be no limits because of gender. Lil Kim, Lauryn Hill, Trina, Eve, Da Brat, Foxy, and I— we all came out at a time when the world enjoyed that balance, hearing a woman's perspective on life. Even the guys were open to listening. We also collaborated. There's more power in numbers. The "girl power" framework happened organically. I never focused on a particular audience, crowd, or gender.

The beauty I feel inside me trumps what people think is beautiful on the surface. I have talent. I've got a good head on my shoulders, and I remain humble. With that attitude, I feel sexy and I project beauty, strength, and a sense of femininity. That is my magic. It's how I prevail against the industry gatekeepers who have their own definition of what beauty is. I believe I inspire women to be fearless, bold, smart, and authentic. That's my Black Girl Magic. ⚡

MAYA ANGELOU

PHENOMENAL WOMAN

From child of the Jim Crow South to international poet laureate, Maya Angelou brought an understanding of the dilemmas, dangers, and exhilarations of black womanhood to the forefront more than almost any writer before her time. Unbeknownst to many, Maya wrote, produced, directed, and starred in productions for stage, film, and television. Her 1969 memoir *I Know Why the Caged Bird Sings*, which made literary history as the first nonfiction bestseller by an African American woman, chronicles how Angelou overcame a traumatic childhood to rise as a dancer, writer, and cultural curator, giving voice to other marginalized people.

HABEN GIRMA

INSIGHT

Disability rights lawyer, author, speaker, and first deafblind graduate of Harvard Law School

I'M DEAFBLIND. I'M DISABLED. I'M PART OF A COMMUNITY OF TALENTED people who take pride in being different.

When choosing a career, I asked myself, "What are my strengths?" I'm really good at communication, problem solving, and analytical reasoning. If I go into a field where these strengths are valued, I thought, then I'll be successful. I quickly discovered a field that valued my strengths: civil rights law.

I work as a lawyer, author, and public speaker. I travel the world teaching companies the benefits of designing accessible products and services. People with disabilities represent the largest minority group, numbering one billion worldwide. Reaching a group of this scale creates value for everyone. Organizations that prioritize accessibility benefit by gaining access to a much larger user base, improving the experience for both disabled and nondisabled users and facilitating further innovation.

A lot of nondisabled people go through life never thinking about disability access barriers. I work to teach nondisabled people about accessibility and inclusion. Disability is not the problem. Disability is not an obstacle to overcome. The biggest barriers are created by society: social, digital, and physical barriers that deny access to people with disabilities — for example, companies that refuse to serve customers with service dogs, facilities built with stairs and no elevators, websites not programmed for accessibility, and videos without captions. We need everyone to work together to help remove these barriers. Some organizations readily remove these barriers. Others stubbornly refuse. It's amazing that

this is still a problem more than twenty-seven years after Congress passed the Americans with Disabilities Act in 1990.

My mother and father, who are from Eritrea and Ethiopia, respectively, encountered many struggles growing up. During my childhood, I learned about their experiences during the Eritrean-Ethiopian War. My mother told me stories about how she had to flee her country, journeying from Eritrea to Sudan, walking only at night to avoid capture by the fighting groups. A refugee organization in Sudan helped her come to the United States. Once both my parents arrived here, they had to start from scratch: figuring out a new system, adjusting to a new culture, learning the language, and finding jobs, all without a support system. Those are the stories with which I grew up. Although their stories aren't about disability, they are about finding your way, finding a new path, and continuing on your journey. I am inspired by their strength. Knowing what my mother and father went through helps me remember to keep finding solutions.

I'm a strong leader and advocate for others now, but I wasn't a very good advocate for myself as a kid. When I was young, I didn't want people to know that I was deafblind. I didn't want people to see a cane or braille. I didn't want to be associated with anything that would mark me as different, and deafblindness is incredibly different. When I was fourteen, I had a horrible experience with yoga. It was my fault. I was in a yoga class for blind people. I couldn't hear the instructions, and I didn't tell the teacher. I felt shy. I didn't speak up. I didn't say, "Hey, I can't hear this. I need an interpreter to help facilitate communication." I just kept quiet and didn't advocate for myself. Unable to hear the instructions, I had a frustrating time trying to figure out what was going on throughout the entire class. I felt like I had failed yoga.

Later, I met a lot of successful people with disabil-ities. I started to emulate their confidence. I started to feel comfortable explaining to people that I'm deaf-blind. Slowly, I started to embrace my identity.

I now like that I am different. I love that people remember me. I love that my guide dog, my communication system, my braille all make me memorable. President Obama remembers me. If I were a non-disabled girl who was just like everyone else, I don't think he would remember me.

People are often fascinated by my story. They wonder, "How can someone be a lawyer and be deaf-blind?" When people learn that I'm the first deafblind graduate of Harvard Law School, they begin to think more deeply about disability. They see me and people like me. We become more visible.

My attendance at Harvard Law School was historic, because it highlighted how much Harvard University has changed over the years. Harvard, for a long time, denied access to people with disabilities, people of color, and women. Back when Helen Keller was looking for colleges to attend, Harvard refused admission to women. Today, Harvard has admitted, educated, and awarded a diploma to me, a woman who is deafblind and black.

We've come a long way since Helen's time, but society still creates barriers for people with disabilities. Once, when I tried to go salsa dancing in Washington, DC, the bouncer refused to let me enter the dance club. He didn't want to let me in because I have a guide dog, Maxine. I patiently explained that the law requires places of public accommodation to admit service dogs. My friend relayed what he said to me: "We're full. There's no more room." Amused, I pointed out that several people had left the dance club while we had been standing by the door. I told him that they now had room. He countered that it was standing-room only. I smiled and said that was perfect because I was planning to dance all night.

My friend relayed his next question: "What will the dog do when you dance?" I explained that I would tie Maxine to a chair off the dance floor, and she would nap while I danced. By this time there was a little crowd by the front door watching the exchange. The bouncer eventually decided to let us in. It's shocking that these incidents still happen twenty-seven years after passage of the ADA. All places of public accommodations should train their staff to welcome customers with service dogs.

It's important to have safe spaces where you don't have to worry about discrimination. Sometimes we have to develop these inclusive communities ourselves. I live in San Francisco, where I have a great group of friends. The salsa community here is amazing, and very welcoming to Maxine. I love dancing. It is soothing and rejuvenating.

I also build communities around words. When I talk with people in-person, people type on a QWERTY keyboard that connects to my braille computer. As people type, I read what they say in braille, and then I respond by voice. I connect with people, and the world, through words. After a lifetime of learning about the world through books, I'm now writing my first book. My memoir will be published in 2019.

I rock because I pioneered my own path to success. I turn challenges into opportunities, differences into assets. That's my magic. ⚡

I rock because I pioneered my own path to success. I turn challenges into opportunities, differences into assets. That's my magic.

TERRIE WILLIAMS

BLACK BLUES

Author, mental health advocate, psychotherapist, and public relations strategist

WE DON'T CHOOSE OUR CALLING; OUR CALLING CHOOSES US. THE MOST High communicates with us through our feelings. Those things that we react to passionately and without hesitation—that is our calling. If your calling is to become a doctor or healer, you were most likely the child who immediately ran for help when someone was hurt. You provided comfort, tended to their wound, and worried about their recovery. If you were born to sing, dance, paint, or become a parent, your spirit will not be at peace until you make the time to honor those passions. The problem isn't finding the calling. The problem is finding the strength and courage to pursue what you're called to do.

Blessings have a way of disguising themselves. It's an honor and a blessing to share my story so that others do not feel that they are alone. When I first spoke of my depression, it was terrifying. Along with feeling guilt and shame, I was scared that I'd be committing career suicide. But I became free once I accepted that God wanted me to shed light on the darkness I was experiencing. Since then, I've spent years sharing my personal journey with depression in front of audiences around the world. Each time I speak, the same thing happens. People come up to me to say that they didn't know what was wrong with them until they heard my story. Many have admitted that they've considered suicide.

Mental illness remains a taboo topic in black homes, families, and communities. There are many reasons for this. The specifics are associated with slavery, religious belief, and a healthy distrust of psychiatric medicine. It is also the fear of feeling less than others who we may think of as "normal."

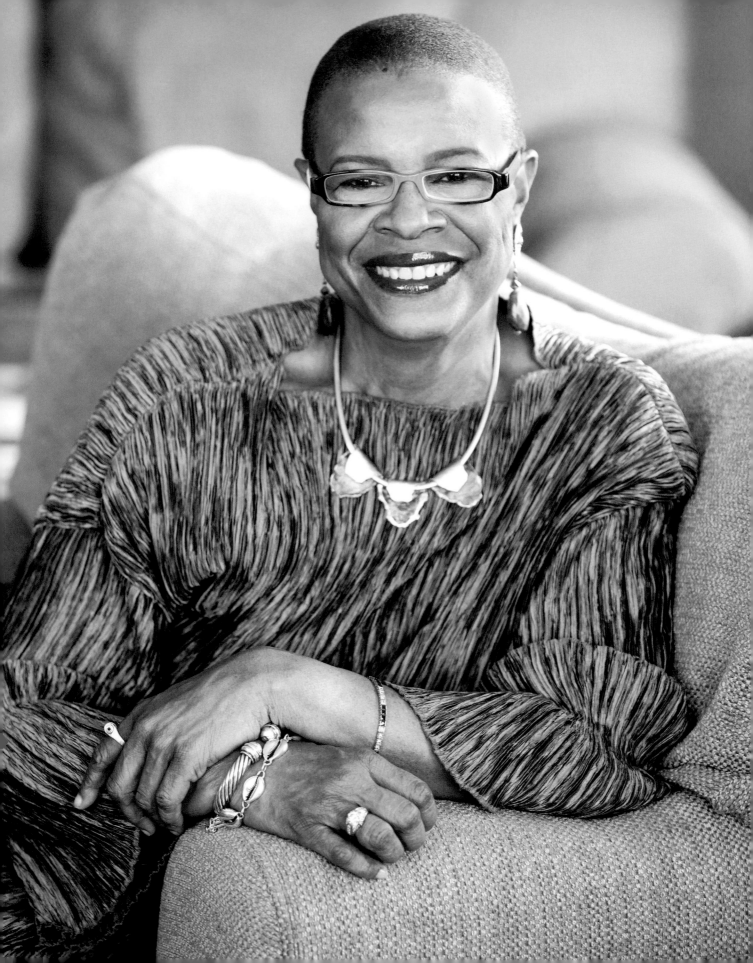

After hearing me speak, however, people often reach for the professional help they need. It's a very humbling moment when you realize that your story can uplift or save another human being from taking his or her life. It is a gift we give ourselves when we share our journeys with one another.

I opened my book *Black Pain* with Paul Laurence Dunbar's poem "We Wear the Mask," because many of us don't deal with our pain. We try to hide it behind smiles, jokes, and material possessions. We indulge and self-medicate in prescription and street drugs, alcohol, promiscuous and unprotected sex. We'll work from sunup to sundown so we can collapse into bed too exhausted to think, care, or feel anything. We wear the mask. Our pain frightens us. And we'll do just about anything not to feel or acknowledge the real pain we are experiencing. We've been taught to hide what hurts us, and we do it fairly well.

I also examine the strong black woman stereotype. This also comes from slavery. It's not that we were "superwomen." It's that, while enslaved, we didn't have the luxury of resting or openly showing any basic human emotions. It's not that we didn't cry. It's that our tears were ignored and forbidden, so we stopped crying. We were not in control of our time, our bodies, our children, or our lives. We internalized our pain. And it was mistakenly or deliberately labeled as having superhuman strength. This lie worked for the slave masters. But it also managed to find its way into our mass consciousness. This false narrative has been passed down through generations. The fact that black women survived the brutality of slavery was and is a testament to the strength and endurance of the human spirit. But the time is long overdue for us to refute this mischaracterization of black "Super"-womanhood. Our healing journey is a marathon, not a sprint. We have to name our pain to begin to heal. Our mission must be to remove the mask, to seek a healing path, and to live fully in the light.

The best way to move forward on these issues is to continue building awareness. Lives are at risk, and we cannot afford to miss opportunities to save them. I'm still on the journey of self-discovery, and most likely will be for a very long time. But I thank God for allowing me to share my voice. It is my way of rocking the Black Girl Magic.

VIII.

SHOT CALLER

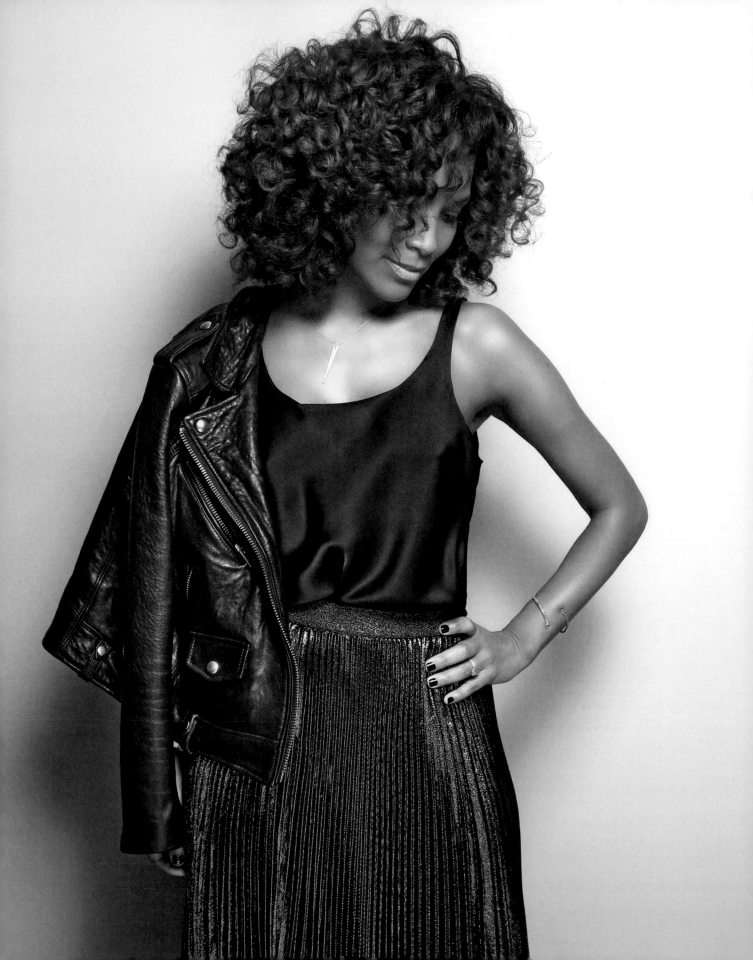

MARA BROCK AKIL

THE ART OF STORYTELLING

NAACP Award–winning writer and producer

I DECIDED EARLY ON IN MY CAREER THAT I WANTED TO CONVEY ALL THE good, the bad, the ugly, the in-between, and, in many cases, the self-critical in the characters I created. As an artist and storyteller, I always need to have the creative freedom to talk about our humanity in its entirety.

My job throughout any show I create is to lay out things without lecturing or being disjointed or forced, in order to reveal to the audience more and more about who my characters are.

Sometimes black content creators are held to a more rigid standard, expected to produce positive representations of black people as a way to counteract all the bad images that have been put out there about us. But my theory is if I participate in that reaction, I'm validating the negative. I somehow give credence to that limited negative narrative. I actually think, in some regards, that trying to purposely create positive-only stories and characters can be just as damaging as creating negative images. People are not all positive or all negative. Neither is true. Those who demand to see that actually want flawlessness,

they want perfection, and that does not exist. Trying to force this perfection in characters limits the story arc, diminishes the authenticity and richness of the narrative, and does a disservice to the integrity of the art.

When I created *Girlfriends*, I was not putting it on the air to offer only positive images of black women. I wanted to produce layered, multifaceted, honest, complex portrayals of us. The characters Joan, Maya, Toni, and Lynn were all allowed to stumble many times. That's what made them all so interesting. Similarly, on *The Game*, the representation of the character Tasha Mack is real. Her love is strong. But even I had to pause and ask myself, "By creating this character, am I contributing to that false, exploited image? Or can I help anchor this woman in some understanding and acceptance and love?" I believe I did the latter, and I believe Tasha Mack set the foundation for the character Cookie Lyon, on *Empire*, to be so loved and adored.

I created the series *Being Mary Jane* around the time of President Obama's second election. There was a lot of campaigning and focus on the middle class at that time, which prompted me to envision a story about what the Huxtables would look like today. I wanted to see what the middle class looks like as a microcosm of America, but I wanted to look at it specifically through the lens of a black woman and a black family. I was less interested in our context to white America as I was in our context to ourselves. I find the connections in our humanity and our universality fantastic, but I really wanted to have a conversation for us, by us, and I was pretty unabashed about it.

Mary Jane and her family are not perfect, but they're not bad people. What they are is fully realized human beings. Mary Jane is carrying a lot of this burden for the failed dreams of her mother, which is part of the reason she's obligated to family. I created this story line based on a common theme in black life. We as a culture sometimes, for better or worse, cannot break our ties and our obligations to family. It's something you're either going to feel guilty about or are led to feel guilty about it—so I wanted to talk about that subject. In addition, I wanted to bring to the screen this beautiful, accomplished, upper-middle-class woman who had to deal with the weight of racism, sexism, family dysfunction, and relationship challenges, but she also has love, sex, money, power, success, determination, charm, and many hot male suitors. I needed to write her because I knew people like her yet had never seen her on-screen. I had never seen those layers portrayed on television for black women, and I wanted to show what that looked like.

I think the sudden interest now in the black woman narrative in Hollywood and in media is so interesting, and long overdue. As we get stronger, we are galvanizing and fortifying for the change we want to see and the inclusion that should be our right.

I've been working for so many years to bring our stories to the forefront, and I feel very much a part of the shift. I am grateful for those who came before me and helped me get where I am. So, when I was finally handed the ball, I was able to shoot it, dunk it, flip it, and score for us.

I am very proud that I put stories and images out there that have changed the game. ⌐

REGINA KING

KING ME

Actress, producer, and director

IN 2010, I PENNED AN OPEN LETTER CRITICIZING THE EMMYS. A PERFECT storm, a culmination of things that were very disheartening, had pushed me to write it. Rutina Wesley was at the Emmys that year, and the organization had captioned a picture of her confusing her with me. We are both black and actresses, so I guess that means we look alike. To add insult to injury, the Emmys didn't bother to recognize Alaina Reed Hall, who had been on *Sesame Street* and *227* and who had passed away that year. I felt so much anxiety over these slights that I had to say something.

I was established enough that I felt comfortable speaking my piece without damaging my career. When I wrote my letter, a lot of what I mentioned were statistics and facts, information that was difficult to rebut. After I wrote it, I thought, "They'll probably never nominate me at this point," but it needed to be said and it needed to be said with respect and clarity.

Five years later, I won the Emmy. What an amazing feeling.

That moment represented so much beyond my career. When one person gets her foot in the door, she opens it up a little more for the rest of us. As black women, every time the door has opened, even if only a crack, we've claimed our opportunity to enter. You hear some people say, "I didn't get a hand up from someone," but actually, they did. Maybe they weren't present when that moment happened, but they benefited from the opportunity.

We all benefit from one another, from one another's strides, accomplishments, and

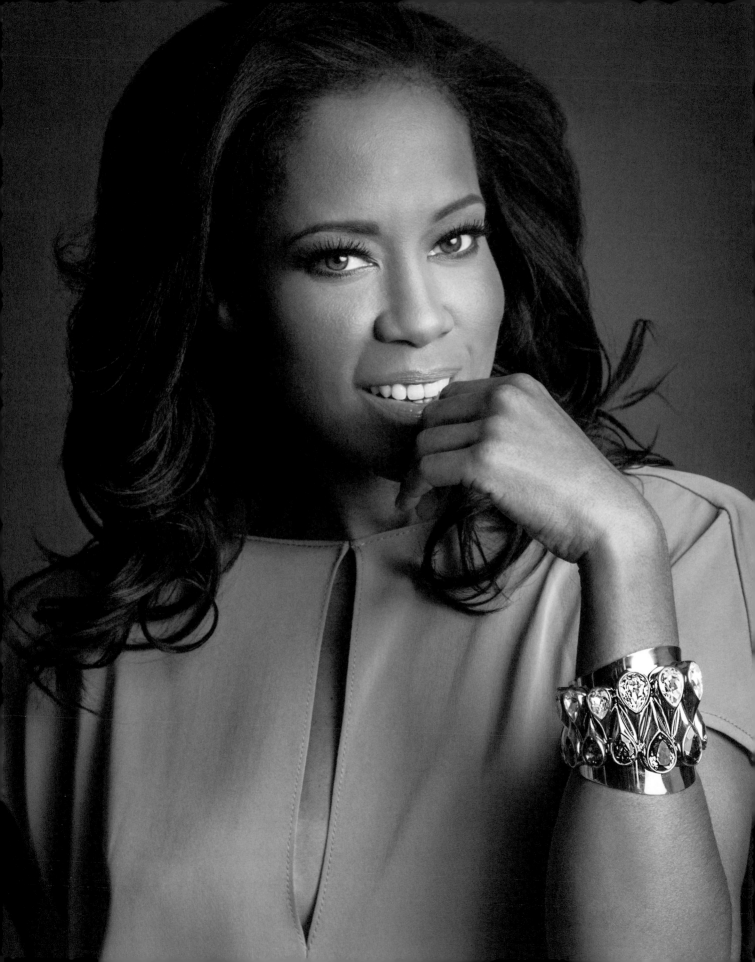

work ethic. Beyoncé, for example, is an inspiration for me. I think about her relentless work ethic at times when I want to cancel an event or check out. I'm inspired by how she controls her narrative. She determines what her content is going to be and what people are going to see. Do you know how much dedication and diligence it takes to do that *and* be a mom? This woman dropped an album with ten videos without anybody even knowing she was going to do it. That's a Houdini move. She definitely makes me strive to work harder, to be more strategic, and to make more calculated steps.

In the past four or five years, I've noticed more young sisters embracing their blackness. When I was younger, other than wearing braids, we weren't wearing natural hair. Having hair that was not being pressed or permed was not celebrated. You didn't see it as consistently as you do now with girls and young women. I know, in part, it's because movements like BLACK GIRLS ROCK! have inspired this synergy. We've come a long way from when I wrote that letter to the Emmys, but that doesn't mean we don't still have things to overcome. I hope to encourage women to still be visible, to be spiritually connected in a way that is evident, and to keep flowing, growing, and expanding. ⚡

I hope to encourage women to still be visible, to be spiritually connected in a way that is evident, and to keep flowing, growing, and expanding.

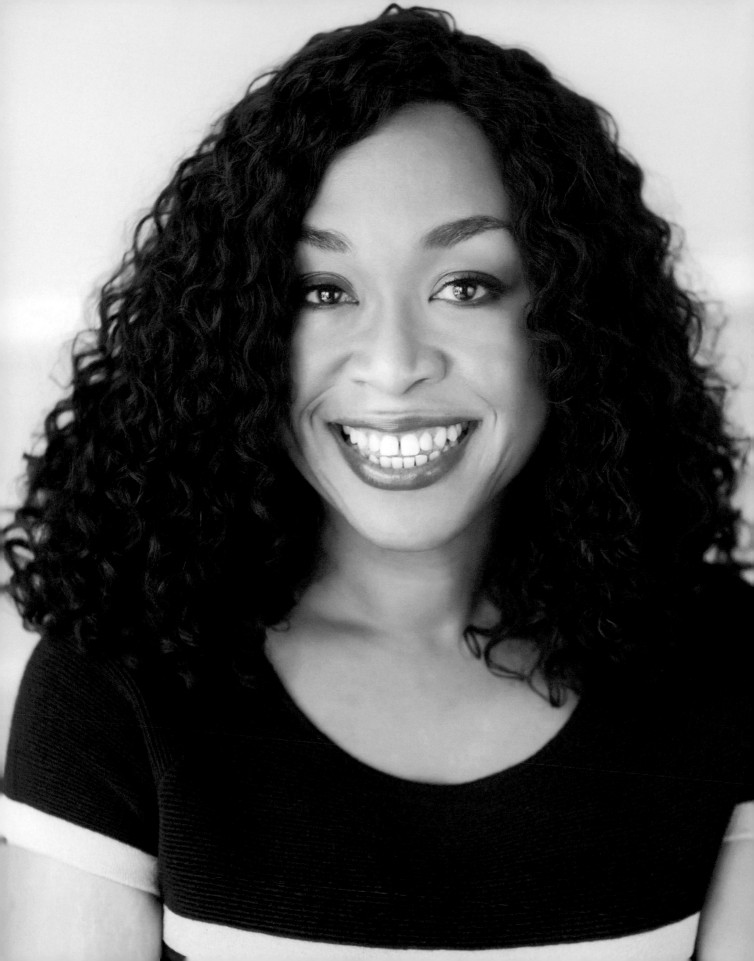

SHONDA RHIMES

FLIP THE SCRIPT

Adapted from her 2016 BLACK GIRLS ROCK! Awards speech

Writer, television producer, and author

MY INSPIRATION IS MY OLDEST DAUGHTER, HARPER, A GIRL WHO DEFINITELY rocks. I want her to be inspired not only by all of the amazing women who've been recognized by BLACK GIRLS ROCK! but also by all of her peers. By other young women her age. We have picked our mountains and started to climb them. It's important to understand that the moment when a person starts getting awards and recognition, that person is more history than future. Our careers have been named, our paths have been chosen. But you young women just starting out in the world . . . please know this: Your slates are blank. Your paths are clear. Your stories are whatever you decide they will be. You are the builders of the twenty-first century. No one can tell you that is not true. You have a right to the universe. You were given that right simply by being born. So, by breathing, you already rock. You know you do; you feel it inside. I hope you know it's possible. I hope you know that you will. I hope you know it is inside you. Mostly, I hope you ask yourself: What am I going to do with that, about that, because of that? What will you do with all this power? Don't look up to those of us who came before you, who move ahead of you. Pass us. Put us in your rearview mirrors. Be someone we could never imagine in our wildest dreams. Be somebody extraordinary. Change the world. And when you've done that, change it again. ⚡

TATYANA ALI

FRESH PRINCESS

Actress, producer, and philanthropist

I GREW UP ON TELEVISION PLAYING ASHLEY BANKS, A YOUNG, BLACK, American princess. She was a wealthy Bel-Air kid enthralled by her cousin Will, who brought with him a perspective she had never before been exposed to. The culture clash that ensued amid totally relatable teenage angst and family politics revealed the beauty and complexity of being black in America.

The Fresh Prince of Bel-Air highlighted a successful upper-class black family. It showcased black love, starred a rapper from the inner city, and organically married bougie blackness to hip-hop culture, effortlessly revealing the virtues of both and elevating a layered narrative about black life. It was fresh!

At the time, NBC was known for the diversity in its prime-time shows, thanks to the network president, the late and truly great Brandon Tartikoff, who spent a lot of time on our set in those first years. In fact, with *The Cosby Show*, *A Different World*, and *The Fresh Prince*, the black presence was so prominent at NBC that Chris Rock dubbed the network the "Negro Broadcasting Channel." It was hilariously accurate.

From the 1970s to the mid-to-late '90s, black sitcoms aired on all of the major networks. But in the late 1990s and into the early 2000s, there was an abrupt blackout on black shows, and I'm not sure anyone anticipated it. When *The Fresh Prince* ended in 1996, NBC replaced it with *The Jeff Foxworthy Show*. It was almost as if they took the entire audience that we had worked so hard to build and turned it on its head. Although I was still fairly young, I remember being aware of the cultural paradigm shift that was

taking place before my eyes. I remember being taken aback by how polarizing the change was. From that point on, the number of black sitcoms on television dwindled.

I've been in the industry long enough to notice the cyclical nature of Hollywood trends. The popularity of black faces on television has risen and fallen in waves throughout television history. In the past, African American shows most commonly arose in large numbers with the birth of new networks—their goal: to quickly grow an audience and a consumer base for advertisers. Oftentimes the color of the programming changed dramatically after the network found itself on solid ground. For this reason, and a multitude of others, I've watched our top shows and our brightest stars be on-trend for a few seasons and then suddenly go off-trend. The last dry spell was difficult, and many turned to the by-us-for-us production model in order to survive and eventually thrive. What we're witnessing now are the fruits of those independent endeavors and the mainstreaming of the success achieved despite an inhospitable environment. Cases in point: Ava DuVernay and Issa Rae.

Most exciting is the breadth of content being created by black women. Creators are not only getting into the rooms where the decisions are made but they are also calling the shots, leading the charge, and taking seats at the head of the table! More black women are becoming brokers, power players, and decision-makers, bringing our narratives and our images to the forefront with incredibly innovative storytelling and titillating complexity.

Black women who paved the way and are still doing their thing, like Debbie Allen and Winifred Hervey Stallworth, must have been mighty lonely in the writers' rooms and network offices where they reigned. There is certainly more company for the latest executive branch of brilliant black women:

Oprah, Ava DuVernay, Shonda Rhimes, Issa Rae, Robin Thede, Mara Brock Akil, and others. They are invested in our stories and intentional about ensuring that our narratives do not disappear from the television or the silver screen. As a result, we are being woven into the fabric of American storytelling more intricately, rather than simply being used as props, ornaments, and sidekicks. I can think of at least eight black women off the top of my head who are currently lead actresses in major prime-time TV shows: Kerry Washington, Gabrielle Union, Viola Davis, Taraji P. Henson, Tracee Ellis Ross, Regina King, Thandie Newton, and Danai Gurira. That would have been unfathomable just five years ago.

This turn of events in our media space is significant, especially considering a political climate that is threatening to become less inclusive, pushing an agenda of exclusion and making "whiteness" great again. It's not coincidental that the rise of more diverse images of people of color in pop culture is happening alongside the reemergence of racism, sexism, and fascism. Most of us took for granted that America's old wounds had been healed, but the 2016 presidential election proved that to be false. Donald Trump became a "Great White Hope." When declarations of white male power are used to assuage socioeconomic traumas, "grabbing pussies," taking down "bad hombres" in the form of deporting immigrant mothers, and demonizing Muslim Americans become rallying cries instead of being offensive.

The American landscape has been changing drastically, and that has been illuminated in the media. This *whitelash* isn't just about the presidency; it's also about the overall progress we've all made. It's about what people have been seeing on their screens at home. They are seeing more people of color and their stories daily—from news footage of the Obamas to seeing actresses like Kerry Washington, Danai

Gurira, and Viola Davis leading multiracial shows. Our dynamism is inescapable and must be difficult for those who long for a bygone era. You either like it or you don't like it, but you cannot ignore it, and you will definitely have a reaction to it.

As someone who has spent her whole life in entertainment, I tend to believe that storytelling has immense transformative power on many different levels. A well-told story can develop empathy that previously did not exist in an individual. Stories can and have been crafted to effect social change and forward political agendas. It is extremely important for black women in media to stand our ground and to continue to create diverse and empowering images and narratives. Our voices are unique, thought-provoking, and varied. America's story is not complete without our stories.

May we bring our younger sisters up through those same gates we have pried open until the swell of truth-telling, both beautiful and terrifying, tears the hinges off for good. May the tide never turn again.

It is extremely important for black women in media to stand our ground and to continue to create diverse and empowering images and narratives. Our voices are unique, thought-provoking, and varied. America's story is not complete without our stories.

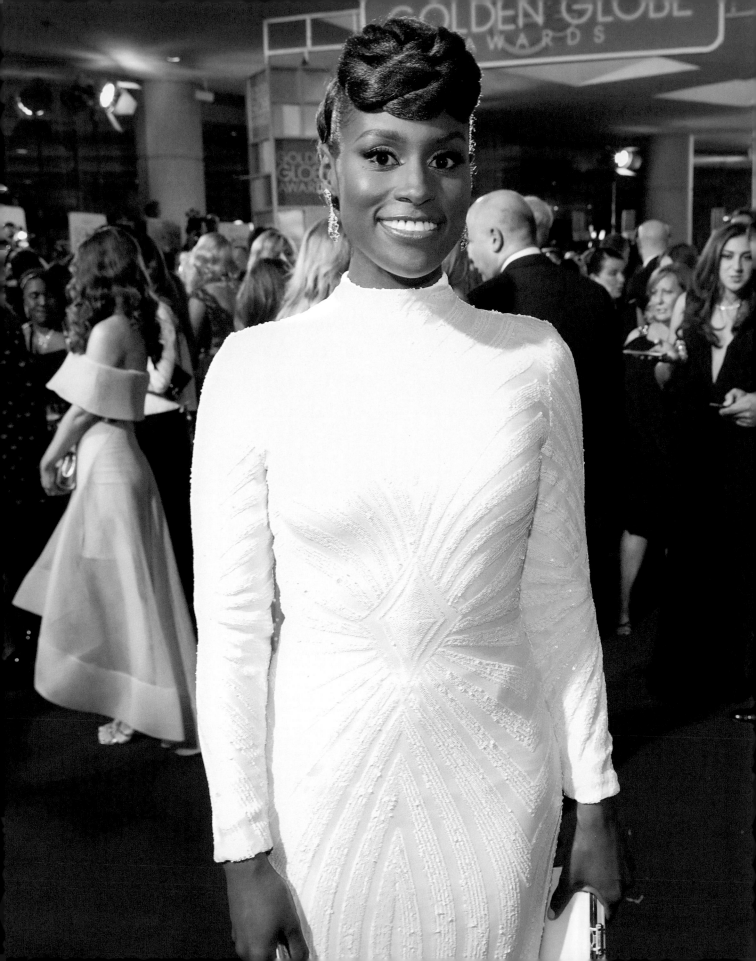

ISSA RAE

MADE YOU LOOK

Award-winning writer, producer, actress, and bestselling author

I REMEMBER GOING TO A LIVE TAPING OF *MOESHA* AND GETTING GIFTED a teleplay for that particular episode. That teleplay felt like a hidden formula for me. I began to use it as a template to write spec scripts and my own original television scripts. Then I wrote a cover letter and started submitting some of my original scripts to NBC and CBS.

When I was younger, I used to always create and share short stories. Since I was a kid, I've wanted to be a screenwriter for film or television, and moving back to Los Angeles when I was eleven actually made writing for television tangible for me. As a teen, during my high school years, for a brief period when I fell in love with acting and put writing on the side, I saw *Love & Basketball*. That movie affirmed my desire to become a screenwriter and director. I credit that movie with showing me that I could tell my own stories about "regular" black people. I learned that, through writing, I had the power to normalize and elevate authentic black experiences and to create "mirrors" that reflected our truths in the media. My desire to create these "mirrors" and to develop characters that I could relate to inspires *all* my work. I look to my real life for inspiration. I look to my friends and family—to all three-dimensional people of color —to inform how I develop my characters and stories. I rely heavily on my personal view of the world to hone my voice and to focus on what I want to say as an artist. That is part of what makes my voice and my art *my own*.

I try not to write for anybody else but myself, and to draw from my life as often as possi-

ble. For example, the feeling of *awkwardness* is a motif that I often play with in my work because I have had to deal with my own awkward sensibilities. I moved around a lot as a child—from Maryland, to Senegal, to Los Angeles— and moving around contributed to a lot of my social anxiety. While some people view moving as a strength that allows them to be chameleonlike in terms of adjusting to any environment, it made me hyperaware of my differences. I was always concerned about standing out, and if I stood out, I thought it meant I needed to be the funniest, or the smartest, or the best in some way—to make it count. Consequently, in terms of my work, I always tackle what it means to feel out of place and the minutiae of trying to fit in. This theme really resonates with fans of *Awkward Black Girl* and *Insecure*.

As a writer and producer, my goal is to create characters that people can relate to and identify with in their own lives, and it feels like we've done that with both of my shows. And while I'm thrilled with the reception, I have been quite surprised by the success and reception of *Awkward Black Girl* and *Insecure*. Hearing and seeing people talk about the shows in their downtime is surreal. I am so grateful for the successes, the opportunity to create, and the privilege to share my experiences.

When my memoir, *The Misadventures of Awkward Black Girl*, became a *New York Times* bestseller, I was completely shocked and humbled. I never set out to be a bestselling author, but being rewarded in that way gave me a sense of validation regarding my journey as a storyteller and a creative woman. I think part of what has made me successful in this industry is that I work very hard to execute my goals. I will always find a way to produce my visions, sooner or later, because I refuse to believe that "no" is the only answer. I've heard "no" often, but I create "yeses."

To other young women who want to break into this industry or be successful in any sector, I think it's important not only to develop a resilient mind-set, but to also work with other young shot-callers or people who share your vision. Collaboration is key, and it also makes the journey that much more fun.

JULIE DASH

VIEWS FROM OUR LENS

Film director, producer, screenwriter, author

EVERY FILM I MAKE HAS TO BE MEANINGFUL, SOMETHING DIFFERENT FROM anything I've made before. My goal is to always try to bite off more than I can chew and jump in head-first, swimming through that unknown. We all get blessings that come through us. I call that "signatures from the ancestors." That's my Black Girl Magic. That's why we are great innovators with music, with film, and with ideas in general. If you read Nalo Hopkinson, Nnedi Okorafor, Tananarive Due, Toni Morrison, or Toni Cade Bambara, it sounds like someone is sitting next to you speaking, whispering in your ear. It feels like you know them. It's comforting to know that you've got a friend to say exactly what you need to hear.

Starting out in New York City and then winding up in Los Angeles, I've been involved with the independent filmmaking community for many years. As part of the indie community, I traveled the world with my short films. The first time I went to the Cannes Film Festival was in 1979. From then on, there was an international group of independent filmmakers who all knew one another. Films for us were a part of making a statement, of showing up and being present and stating who we were and why we were there. It wasn't about the people attending the event or even the accolades. It was about telling stories and finding new ways to tell those stories while redefining our images. It was about reconnecting ourselves to the African Diaspora in new, exciting ways, with lyricism and poetry.

In film, we've seen the "every black woman is the same" narrative again and again. That's because our lives were pretty much shaped, carved out, or constructed by people

who knew less about us than one would suppose. We were either noble or not. There wasn't anything real about us. I, along with other filmmakers, wanted to change that because we know that film is very powerful, nurturing, and nourishing, and that it can be used to heal. So that was my intention with *Daughters of the Dust*—to be a part of that nourishing process.

Hollywood has what I like to call "the curators of culture." When you're pitching a new story with black characters the establishment has never heard of before, there is this wall that is thrown up like a Draconian shield. There is doubt. I've encountered people who, after they've heard my pitch, will propose something back to me other than *my* story. They want you to be the engine that drives *their* story about black lives, black women, or black families, stories that have nothing to do with *my* reality. We have to get past that.

Daughters of the Dust wasn't self-reflective, but it was personal to me in that it was a story I wanted to tell. It takes place at the turn of the twentieth century. There weren't any stories out there at the time about African American women—what they were thinking, doing, or what they saw for their future. It was set during the Great Migration. These people, as adults, were the first generation of free-born African Americans who still could reach back and touch the hands of their mothers and fathers who were born enslaved in the United States. It was a rich and powerful period, and I wanted to do something that explored it. There was a lot of fertile ground there as far as those concepts, events, and issues were concerned, and I enjoyed jumping into it.

The rerelease and restoration of the film was equally exciting. I was told that Beyoncé's "Lemonade" contains visual and conceptual references to *Daughters of the Dust*, and once I saw it for myself, I thought it was great. I might not have made the connection had it not been pointed out to me, because for years I have seen these images. They are diasporic— Capoeira in Brazil, women from the Gullah Islands. I've seen them all over the world. I've been looking at these images since I was an undergraduate in college.

We're seeing more black women at the forefront in film and on television than we've ever seen, and it's very exciting for several reasons. For one, we are seeing women on film we've only imagined. Years ago, whenever we went up to the studios and we met with those black women who had managed to get their feet in the door, if they didn't run from us completely, then they certainly didn't support whatever we pitched to them. They ignored it or acted like they didn't know what we were talking about. They didn't want to be near us. It's so different now. Ava DuVernay really changed the game by hiring all women on *Queen Sugar*. That could have been done twenty-six years ago, but it was not, nothing even close. Now there's ShondaLand, Ava's AFFRM, and so forth. It takes courage to believe in yourself and others equally; Ava DuVernay is certainly one such person feeding and seeding the film industry at the same time her own career expands.

Black women are coming together to make sure other talented black female creatives are getting opportunities to work on major projects. I love seeing this level of community among black women filmmakers in this period. ⚡

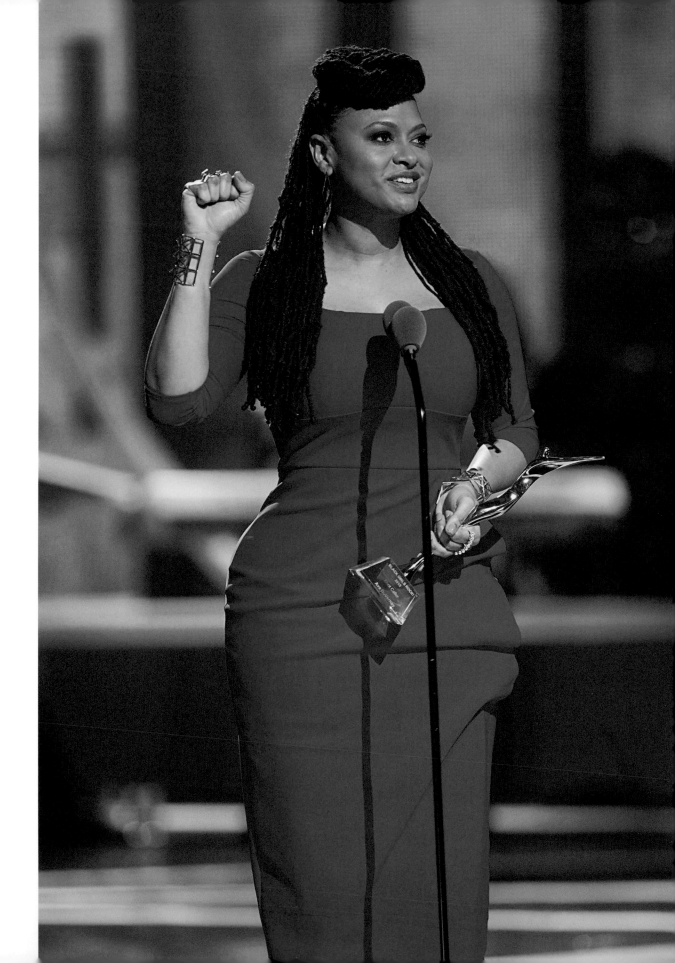

AVA DUVERNAY

LIGHTS, CAMERA, ACTION!

Adapted from her 2015 BLACK GIRLS ROCK! Awards speech

First black woman director nominated for a Golden Globe, award-winning writer, producer, distributor

I'D LIKE TO ESPECIALLY SALUTE MY FELLOW BLACK WOMEN FILMMAKERS. We are a small but mighty tribe, and most don't get the recognition they should. I salute the pioneers like Tressie Saunders, Maria Williams, and Zora Neale Hurston—people don't know it, but she was a filmmaker as well [as a writer]. I also salute the trailblazers Kathleen Collins and Julie Dash, Euzhan Palcy, Neema Barnette, Ayoka Chenzira, Debbie Allen, and Maya Angelou—who was a filmmaker also. The films that we make for our communities, the stories we tell—they are truly for you. When a black woman makes a film, it is not an *interpretation* of black womanhood; it's a *reflection*, and it's important to embrace it. I really feel strongly that you don't have to be an actress, or director, or singer, or famous to be a star. We can be a star in our own lives, my sisters, right where we are. When I am feeling shaky at any moment, in a meeting or on set, I just get into a leading lady stance. I hold my head up, put my shoulders back, close my eyes, and think to myself, "Lights," that's my spirit, "Camera," that's my mind, "Action" that's my life. Lights. Camera. Action. ONWARD! ⚡

NZINGHA STEWART

THE BIG PICTURE

Writer and film and television director

MOST PEOPLE EITHER HAVE STYLE OR TASTE. STYLE IS WHEN YOU *ARE* THE thing, and taste is when *you can recognize* the thing. Part of my magic is that I have exceptionally good taste, and I believe that is what makes me a great writer, producer, and director. I recognize what's dope, I have an affinity for beauty, and I use my taste to write narratives about black women because black women are the thing.

I feel really good about where we are currently going in media. An exciting renaissance is happening in black Hollywood, and I am thrilled to be a part of this wave. Black women are coming to the forefront both in front of and behind the camera, to create and produce amazing content that is showing so much more of our depth, our layers, our intelligence, and our flavors. It's like the genie is out of the bottle and everyone wants some of our Black Girl Magic. ⚡

MELINA MATSOUKAS

WHO SHOT YA?

Award-winning music video and television director

I EMBRACED BUDDHISM WHEN I MOVED TO LOS ANGELES FOR GRADUATE school in 2003. I have a *gohonzon* [a venerated object] and was called to ShakuBuku. At the time, I didn't have anyone to lean on. I felt under pressure, alone, and I really wanted a spiritual connection with something. I grew up with atheist and Communist parents who didn't believe in organized religion, but they still allowed me to explore different faiths so that I could develop my own philosophical beliefs. As a result, I became somewhat of a religious pluralist. I studied Islam and the Quran in college, along with the Bible, because I loved learning history and understanding people's cultural backgrounds. I used to go to various churches with my friends, and I still do now and again, but Buddhism spoke to me spiritually.

My spirituality is important because it establishes balance in my hectic work life. As a director, it's really a huge responsibility to interpret and execute someone else's artistic vision. In order to show up for people, I have to be grounded, so I chant right before I go to the set, whenever I get nervous, or when I feel overwhelmed. It helps me center myself, refocus my energy, and stay clear about my creative vision.

As a woman who has navigated a male-dominated field for my entire career, I've faced many challenges, but I don't think you can be a woman in this society and avoid dealing with sexism or misogyny. It's a part of everyday life. You have to really fight to make your voice heard in almost every sector. Oftentimes I'm the only woman on many sets, which is not easy. When I walk into the room, people assume that because I'm a woman I must be

a novice—that I cannot possibly be the boss! I had to develop a thick skin and a strong will to navigate this.

The real key to my success, though, is that I'm always prepared. I know what I'm talking about. I do my homework. I am knowledgeable. I come to work ready to win.

Preparation, education, and honing your skills builds your arsenal and gives you the proper weaponry to succeed. When I am thoroughly prepared, my vision is crystal clear, I'm more confident, and I am uncompromising! I am in my zone because I am operating in my truth, and *truth* is unquestionable.

As a video director, I am really fortunate to be in a position to constantly collaborate with some of the most creative artists in music. When you work with like-minded artists who are from similar backgrounds and whom you trust creatively, it allows you to challenge one another to dig deeper and be more imaginative. I am not dictating anything; nor am I being dictated to. We are truly cocreating and able to build off of each other's strongest ideas to make something special!

I absolutely love the women I get to work with, but I didn't intentionally go out to make a female-empowered portfolio. It kind of happened organically. I love creating content that really speaks to black women, sharing our stories and putting a spotlight on the issues that matter to us most.

Working with Beyoncé on the "Formation" video really gave both of us an opportunity, as creatives, to contribute to this legacy of artist activism and to continue the tradition of protest art and protest music from the 1950s, '60s, and '70s on which we were raised. We were able to create art that was proactive, that spoke out to the world and created an uproar. I think people were so receptive to this message at the time because it was coming from the biggest pop star of this era. She was bringing this important conversation about

black women to the forefront through her art! Creating something so bold with someone as powerful and as visible as Beyoncé Knowles Carter was definitely transformative. I was honored to be able to collaborate with her and to contribute my creative lens to an incredible message that resonated with so many people around the world.

Similarly, my work with Issa Rae on *Insecure* presents a layer of black womanhood that is rarely seen on-screen. I am so fortunate to be a part of this project, which is helping to diversify television, to normalize the black experience, and to elevate the voices and narratives of black women. I think creating more content in media that is for us and by us, making the voices heard that remain unheard, portraying women and people of color in an authentic way, and representing women, particularly women of color in media, is my form of activism. It's a blessing that my form of activism has the ability to reach a broad audience. It incites a lot of important conversations, and it truly inspires people.

Collaborating with such a dope and creative artist like Rihanna has also been inspiring. I actually made history with her as well. I don't *live* in "the accolades." However, when I became the first female director to win a Grammy for Rihanna's "We Found Love" video—that was a defining moment. It really affirmed that I am in my lane and that I am doing what I was meant to do. It made me proud to represent women directors as well, but it also spoke to how exclusive this industry can be. I remember thinking, "How can it be that *I'm* the first woman to be recognized when there have been so many talented female directors who've come before me?" I can think of several incredible women who should have gotten that honor many years ago. Still, we are starting to see a shift in our culture, and women, women of color especially, are starting to get the recognition we deserved decades ago.

The fight for diverse representation in media, on camera, and behind the camera mustn't stop. It's something we have to continue to fight for and it's something that, as black women, we're especially equipped to fight for because, historically, we've always had to. The more Ava DuVernays, Shonda Rhimeses, Debbie Allens, Issa Raes, Mara Brock Akils, and Nzingha Stewarts there are today, the more opportunities we'll have to elevate our truth and to tell stories that shine a light on our beauty, our layers, and complexities.

ZORA NEALE HURSTON

JUMP AT THE SUN

Most known as a skilled anthropologist, prolific writer, and fearless voice of the Harlem Renaissance, Zora Neale Hurston is credited as the first African American woman filmmaker. She directed her first film in 1928, and her published works posthumously inspired modern and classic films such as *Their Eyes Were Watching God.* Hurston's courage in representing blacks as autonomous during a time of extreme racist and oppressive attitudes made her a force of nature for the people.

IX.

YOUNG, GIFTED, AND BLACK

MAYA PENN

WHO ROCKS NEXT?

Philanthropist, animator, artist, and CEO of the eco-friendly fashion company Maya's Ideas

I STARTED MAYA'S IDEAS WHEN I WAS EIGHT YEARS OLD. IT WAS HARD starting out as a young girl, because sometimes people would look at me and say, "Oh, that's cute." Because I was a kid, people didn't realize I was serious. Meanwhile, I was trying to actually run a real business and trying to move my company forward.

When I was maybe three or four, I was watching a kid's program about different careers. I knew what firefighters and doctors did, but one day they started talking about animators, people who bring all these cartoon characters to life. That immediately sparked something in me. I starting thinking that I could make my own characters, my own worlds, my own stories. When most kids realize that their favorite cartoon character is not real, their dreams are crushed a little bit. For me, it was exciting, because I knew I could make my own characters and have them go on the adventures I imagined.

I created Maya's Ideas because, first, I have always had a passion for art and design, and second, because I wanted to do something that made a positive impact on the world. I didn't have much of a business plan. I had to learn along the way, pretty much through trial and error, about branding and marketing, about keeping up with your audience and customers, and about the integration of social media and business promotion.

My parents instilled in me from an early age the importance of giving back. They would take me with them to local food banks and homeless shelters in Atlanta to donate canned goods and clothes. As far as my company being eco-friendly is concerned, that also came from my parents. When you give through the heart, that's when movements are

sparked, that's when opportunities and innovation are created, and that's when ideas come to life. So, when other girls see me, not only can they think, "I can be a fashion designer, too" or "I can be CEO, too" or "I can be an animator, too," but they can also see how you can use your passion to do something about the things you care about that are happening in this world. You can do something to make the future better for the generations that are going to come after you. You can do things that will uplift our society. I think that is especially important because there are a lot of things that go on in this world that make people feel powerless.

Starting my business has taught me a lot. Not only about being a CEO but about everyday life as well. No matter what I do or go through, it is important for me to stay grounded. I apply that same lesson to my business. Even though I started making six figures by the time I was thirteen and am now scaling up into a multimillion-dollar range, I have to stay grounded and remember why I started my business in the first place. I started it because I wanted to do something that made a positive impact and that gave back to the environment. So now that I am looking to mass-produce, I still want all my products to be made with organic material.

Even though I have had my business for several years now, it is still difficult. At first, in the very, very early stages, it was a challenge getting traffic to my site. Now the challenges are about managing growth. When your company begins to grow, you have to recalibrate how you run it. I am learning how to bring other people on board. I have assembled an advisory board of other successful entrepreneurs, who are helping me with my strategic plan for moving forward with my company. It is a pretty cool experience to collaborate with others to achieve that goal.

Part of growing my business is about not being afraid to make mistakes and remembering that there are lessons in what some people see as failures. I was a kid when I started, so I created Maya's Ideas largely out of curiosity. A lot of time when people are starting out, they worry about all the things that could go wrong. That way of thinking can easily become a downfall. I'm not saying don't prepare yourself for any mishaps or failures or don't take into consideration what could go wrong, but do focus on what can go right. When something does go wrong, I think about how I can recover from that and keep moving forward. I learn from my mistakes and my mishaps. Failure is just part of the journey. We gain knowledge from all our experiences, good and bad.

There is a huge lack of exposure when it comes to STEM and girls and women of color. About 74 percent of elementary or middle school girls actually express an interest in a STEM field of some sort, whether it be chemistry or math or coding or engineering. But by the time they graduate high school, barely 1 percent study or pursue it. It is really interesting, since they use technology every day, on their phones. I try to show other girls it is possible and it can be fun. You can use technology for anything.

I taught myself HTML out of curiosity, because I wanted my own official website, one that I could customize. If I had let someone tell me that I couldn't do it, I would never have done it. As a black girl, I still find it hard to really move forward in a lot of the spaces in which I find myself. Black women and black businesses get treated just so poorly in the business world—it's awful. I have had to surround myself with positivity, and people who really believe in my ideas. I have a wall where I keep photos of the people who inspire me. There are photos of my family as well as people like Rosa Parks, Oprah Winfrey, and Michelle Obama. That wall has been super vital for me. At the top of it, it reads, "With God all things are possible," and that is what really gets me through.

IBTIHAJ MUHAMMAD

BELLE SABREUSE

Sabre fencer and first Muslim-American woman athlete to win an Olympic medal

I'M VERY PROUD TO HAVE HAD THE AMAZING OPPORTUNITY TO REPRESENT Team USA at the Olympic Games. Becoming the first Muslim-American woman to win a medal at the Games was surreal, and something that I'll carry with me for the rest of my life. I set out on this journey, in part, to help dispel stereotypes and misconceptions about who Muslim women are. I wanted to win for all those times in the sport I'd been told no, that I didn't belong, that I was too different, or that I'd never be successful. I wanted to win for people from underserved or underrepresented communities. I wanted to win for all the people who look like me, who never felt welcome in that space. I wanted to win for all of us.

I'm fortunate because I was exposed to sports at a young age; they were central to my family dynamic. My parents highly encouraged sports in my household because they saw their developmental value. They saw them as an outlet for me and my siblings to socialize in a healthy way, and they thought they'd keep us out of trouble, which they did.

I didn't discover fencing until much later in my childhood, though, when I was twelve years old. My mom and I stumbled upon it when we were driving past a sports facility. We watched the athletes at work through the windows and were taken aback by the fact that they were fully covered. As a Muslim youth who observed the hijab and covered everything except my face, I was intrigued by the uniform because it uniquely accommodated my religious beliefs. I wanted in.

While my parents weren't familiar with the sport itself, they also thought it was a

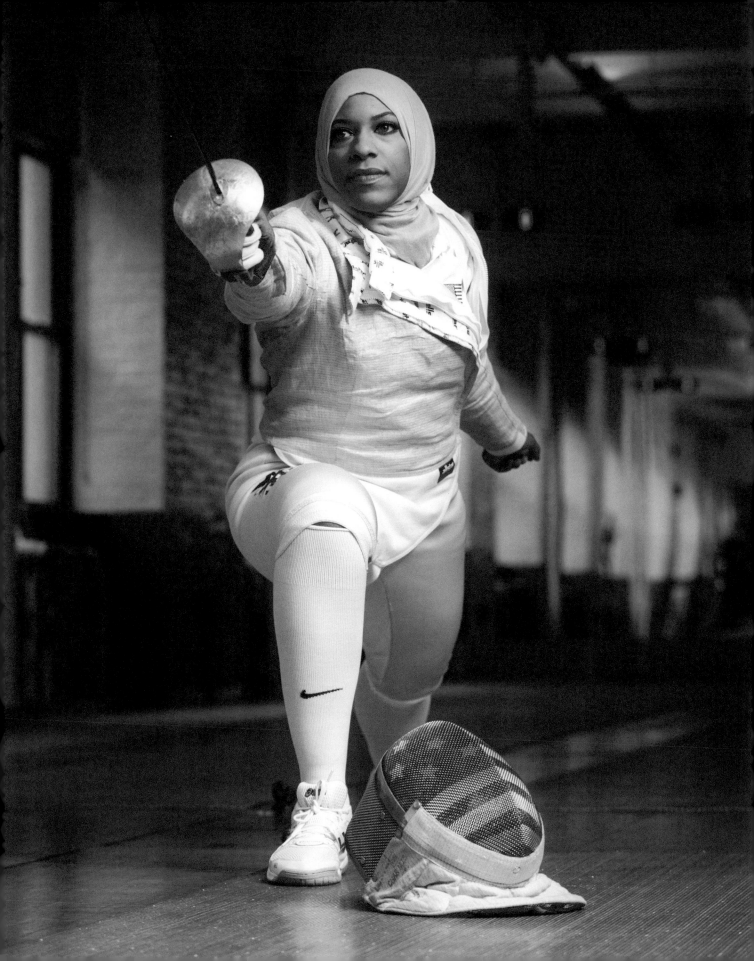

unique opportunity for me as a Muslim girl to participate in a sport where I didn't have to alter the uniform. Being a strong, confident, hijab-wearing African American Muslim woman, I've always played the part of challenging the status quo and forcing people to accept me. Throughout my athletic career, I have found that my presence often made other people uncomfortable. I found myself having to constantly speak up and out against social injustice. People take advantage of Muslim women. They think of us as being docile, meek, and oppressed. They think they can talk to us however they want. When those instances happen, I feel compelled to say something for the women, like my mother, who never say anything. I have to let people know that we're not who you think we are. We're strong individuals and come from different places. The largest population of Muslims in the United States is actually African American, the first Muslims to arrive in the United States.

When people talk about how difficult it is to be a Muslim right now, I think, "But I've been Black all my life." Being Muslim is hard, but being black is pretty tough, too. I know what profiling feels like. I know what discrimination feels like. It's difficult. As African Americans, we've dealt with it for a long time, even within the Muslim community. It's a weird space—being an African American Muslim: you're not black enough for the black community, you're not Muslim enough for the Muslim community, and you're constantly trying to find your space. It can be difficult to feel wholly accepted as someone who identifies with being both proudly black *and* Muslim.

I think the rhetoric equating Islam and terrorism is dangerous, especially for women who literally wear the religion on their sleeves. It has created this environment where racists and bigots now feel comfortable and empowered to spread their hatred. We've been facing a lot of attacks similar to the Dylan Roof attack on the Emanuel AME Church in South Carolina and the Chapel Hill, North Carolina, shooting where three young Arab American kids were killed. Multiple mosques have been burned down over the last decade. And now these acts are spreading. Bigoted remarks are becoming the norm.

When I was detained at the airport for two hours without explanation or cause in 2016, I knew I was facing the same discrimination that the Muslim community had been enduring for a long time. Yet when it happened to me as an Olympian, someone who had just served and represented my country on the largest sports stage in the world, I was shocked. I was also frustrated and hurt. They knew who I was. They recognized me. Yet still I was profiled while going through customs because I was Muslim. The customs agent wouldn't look at or talk to me. He turned beet red when he saw my sister and me. He looked at us, saw two Muslims, and decided we were going to go through secondary screening. The TSA agents recognized me and began talking about the Olympics; still, it didn't change the length of the process. We missed our connection. As we sat there, among people from Latin American and African nations on the phone with their legal aid attorneys, trying to get the proper documents in place, we were the only ones in the room who spoke English. We appeared to be the only Americans in the room who had valid passports, and yet we were being held without any explanation. Then again, as an African American woman, I know what profiling feels like. It's hurtful when it happens, and every single time, it feels brand new.

The racial divide in our country—that's a problem. Police officers shooting unarmed citizens—that's a problem. Gun violence—that's a problem. A broken education system—that's a problem. Mass incarceration—that's a problem. Not Muslim Olympians traveling through the airport.

I am so inspired by how Muhammad Ali lived. As a black Muslim American athlete and Olympian, he used his platform to fight for justice. I'm hoping to use my voice as an athlete and Olympian in the same way. Ali sacrificed financial gain for the greater human good. He didn't just advocate for himself; he chose to advocate for all of us as African Americans, as Muslims, as human beings. He wasn't *just* a silent athlete—that was not something he was willing to do. That's also not something I'm willing to do. I won't sit back and be quiet.

My goal is to please God. My faith calls on me to help the less fortunate and to speak out against injustice. I have a moral responsibility to do what I can with my platform and to be a proponent of change and good. That's what my faith encourages, and that's our shared calling as human beings. That's my purpose and that's my magic. Though I may not always do it perfectly, I am clear in intention. I know what I want my legacy to be: a woman of faith who helped to make the world a better place for everyone. ⚡

> My faith calls on me to help the less fortunate and to speak out against injustice. I have a moral responsibility to do what I can with my platform and to be a proponent of change and good. That's what my faith encourages, and that's our shared calling as human beings.

YARA SHAHIDI

WHO ROCKS NEXT

Actress, activist, and feminist

AS A TEENAGE GIRL OF COLOR, I AM PROUD TO CALL MYSELF A FEMINIST.
I think being a feminist is equivalent to being a humanitarian. The two are almost synonymous with one another. I fight for equal rights and opportunities for *all* people.

Generation Z is very engaged and outspoken about our feminism because technology has given us the ability to connect, build, and organize coalitions around our ideals almost instantly. We have been granted a freedom to advocate for justice and equity via social media, which really allow us to express our points of view openly and boldly, even at a young age. Feminism is important for me and my generation to embrace; it's all about women recognizing our power, fighting for our equality, and being proud of our voices.

Fortunately for me, I didn't have to look very far to find amazing role models who were feminist women of color when I was growing up. When it comes to families, I hit the jackpot! I come from a family of phenomenal black and Iranian women who are doing their thing and excelling in their fields. I have a cousin who is an astronaut, I have an aunt who is a dean of a school, and I have another aunt who is a professor of social work. Having these inspiring women in my life to guide me really helped to instill the idea that I had no limitations.

My entire family also reinforced the idea that black excellence was not only achievable, it was expected. I was taught that you find what your passion is, you pursue it, and you excel in it. And they made sure I had plenty of examples to go by. My grandfather would tell me personal stories and teach me about the leaders of the civil rights move-

ment. I was exposed to great black writers like James Baldwin, Langston Hughes, August Wilson, and Zora Neale Hurston.

I was insulated from many of the negative societal messages about women and girls of color because my family nurtured me. They nourished my spirit. They encouraged me to soar. They supported my creativity. They made sure I was well rounded. They taught me to always pay it forward. They taught me that black is beautiful. They made sure that I was comfortable in my own skin and reinforced that my "otherness" was special. As a result, I grew up knowing that we were smart, capable, brilliant, and beautiful people! I had a sense of pride in my black and Iranian heritage, and I walked confidently in all my Black Girl Magic.

Somehow, I assumed this was a standard message for black girls; that we all were told "the sky's the limit," "black is beautiful," and "girls can be anything they want to be." I quickly found out that the world doesn't always affirm us the way my parents affirmed me. It wasn't until I hit middle and high school that I realized that the message I was getting at home was not the same message the world was telling girls, particularly girls of color, about their value, worth, and possibilities in society. When we are not told stories about our excellence, when we are not exposed to our history, and when the media are flooded with awful stereotypes, it can really shape your perception of your possibilities in life. It becomes difficult to understand your position in the world and how to maneuver in it. That is why it is so important to have affirmations and movements like BLACK GIRLS ROCK! It says I matter. It says my life matters. My work matters. My accomplishments matter, and so do the contributions of my entire community!

As an actress and a public figure, I want to use my platform and lifestyle to help dispel any stereotypes, tropes, or misconceptions about young black women.

I try to be intentional with my image and the roles I choose to play, not in a manipulative way and not to hide who I am, but to ensure that I am in no way perpetuating a harmful stereotype. The roles available to me as a black woman are already limited, and on top of that, I always have to think about the politics of my race and gender when I am considering a role. The stakes are much higher for people of color because of how we are perceived in society. The roles that actors of color play automatically become politicized, while our white counterparts often get to choose among a variety of roles without having to consider the political implications. The sad reality is that until our society is more inclusive, every person who is an "other" or a minority becomes the default representative of her entire race.

For white actors, playing a killer won't impact their entire community; it's just an actor acting. But if a black actor plays that role, it's like we have to think, "What are the subliminal messages being taken away about blackness? Are we contributing to stereotypes? Are we influencing the kids? Are we setting back the race?" As an Iranian woman, I also have to consider if I'm adding fuel to the Islamophobia and anti-immigrant fires that are already blazing so hotly. If I play a killer, does that add to the idea that all Iranian people are terrorists? It's never just about entertainment for actors of color. We have to think about what the role or movie will mean to people in our communities, or how the greater society will perceive us. Sometimes the art outweighs the activism, sometimes the activism outweighs the art, and other times you are able to merge art and activism together perfectly.

Fortunately, *Black-ish* has been that perfect blend for me. I really want to normalize what it is to be a carefree black girl, and my character, Zoey, gives me the opportunity to do that. I get to present a layered and complex black teenage girl on television. Smart,

strategic, and hardworking, Zoey is not just a rebellious teenager; she is so multifaceted. Sometimes she is unruly, but you also see her as a unifier among her siblings. There are times when she can seem like the most confident person in the room, and then there are times when she can appear really unsure. She goes through moments when she vacillates, and that makes her so relatable, vulnerable, and authentic. When writers create characters like Zoey, they reinforce the notion that black girls don't have to have a limited, monolithic voice—many pieces of a person can coexist and thrive.

I feel privileged to be on a show that actually tackles current social and political issues. For example, while I was protesting with Black Lives Matter in Los Angeles, the *Black-ish* producers were writing Black Lives Matter into one of the episodes. While I was grappling with the outcome of the 2016 election and blogging and posting about it online, the *Black-ish* producers were creating an episode to address the general angst and divisiveness that our country was experiencing postelection. I think it's powerful and important for art to help us reflect our social climate and motivate us to take action.

As a human being, an actor, and then a philanthropist, I've found my homestead in the spaces where art and social justice meet. I just hope to remain in that space spreading love and raising awareness about the issues that impact us all.

RUBY BRIDGES

OVER TROUBLED WATERS

Ruby Bridges began her life as an activist at the tender age of six, when her parents answered the NAACP's call to integrate the New Orleans school system. Bridges's first day of school at an all-white institution required escorts by president-appointed US Marshals and prompted jeers and death threats from racist segregationists, many of whom were parents of white students. Ruby was advised to eat only the food she brought from home after a white woman threatened to poison her. Only one teacher there believed in Ruby's right to attend the school, and would become her sole instructor for over a year. Her family persevered, and little Ruby Bridges would become an icon of civil rights before it was an era.

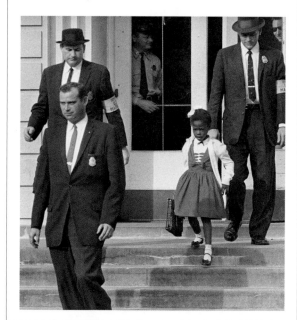

JANELLE MONÁE

FEM THE FUTURE

Artist, singer, songwriter, actress, and activist

I AM A CAREFREE BLACK GIRL. I AM NOT ANYONE'S EXPECTATION. I AM NOT trying to live up to anyone's idea of who I should be. I do not believe in being a slave to someone's interpretation of me, even if that someone *is* me. Being in full control of my magic and how I choose to use it is where I find my freedom. I won't allow anybody to take that from me. How I describe it today may be different from how I describe it tomorrow, and that's okay. I'm ever-evolving. It's my process, and having this freedom, this power and agency that so many generations of women before me didn't have—I'm thankful for it.

I love being able to tell stories through music, film, theater, and writing. Music brings people together and unites them. It has no religious belief and no political party. It is not a red state or a blue state; it's a purple state. And that's what I love. I think it's important that we, as artists with platforms, become voices for the voiceless, that we speak for those who don't get the opportunity to hold the mic. I use music as a weapon. I use music to fight against those who fight to silence us, to beat us down emotionally. I try to tell stories of otherness. I try to celebrate and tell stories about the marginalized, those whose voices are oftentimes erased because of their gender, their sexual identity, and their race. I feel a personal responsibility to be outspoken against injustices that happen in our communities and all over the world, especially for women and girls and others who are marginalized.

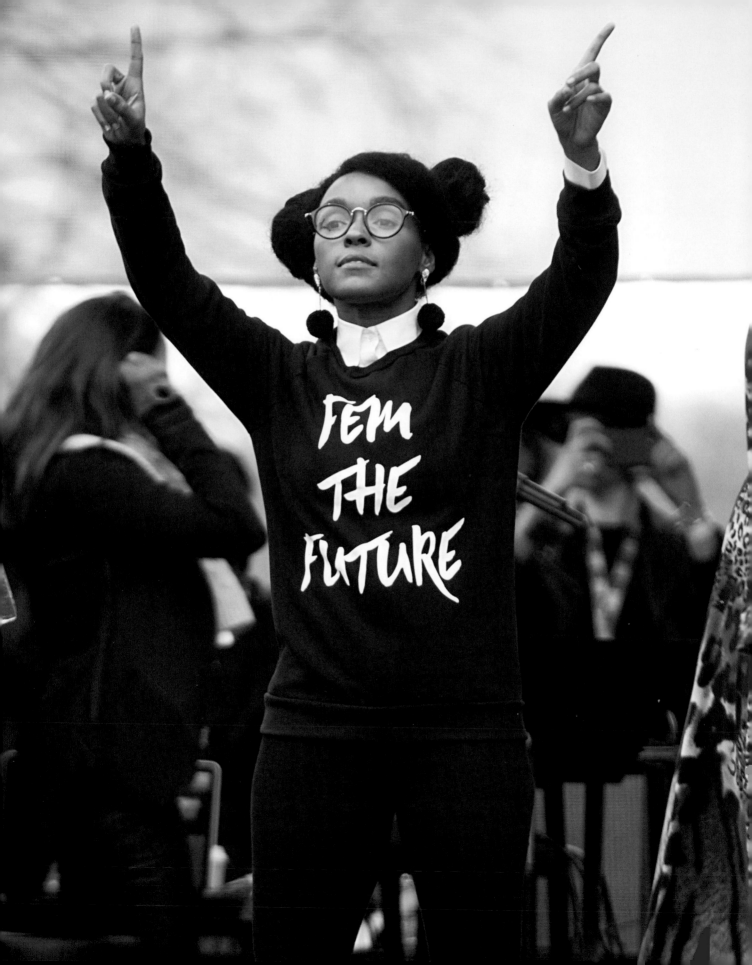

As I began to work on my new music, I really wanted to work with more female producers. So, I went on this wild-goose chase for the top ten female music producers. I read that there have been only six women total to ever be nominated for production between the Brits and the Grammys, and that no woman has ever won. I thought, "Wow, why *is* this, and why aren't more people talking about it?" I produce, and was heavily involved in my last album, and even though I had a hard time finding female music producers, I still found a lot out there. I knew it wasn't that women can't compete at a high level—we just haven't been given the opportunity. I said that something has to change. We're just too spread out, maybe; people are not hearing our voices. I came up with the name "Fem the Future" as a way to hold people accountable for not bringing more women into the room and into the conversation, whether it be music production, film production, media, or tech. We need to be in the room and be given as much opportunity as our male counterparts.

I feel I am a product of those people who walked before me, those people who saw something special in me and decided to pay it forward. So that is what I want to do for women.

Black women are my first tribe, whether it is my mom, my aunts, or women in the entertainment community. I've had a community of black women who have supported my uniqueness, my messaging, what I've had to say, and who I am. They also believed in who I was way before people knew my name—the ones who tell me, "We love you, Janelle. We love that you want to redefine what sexiness is and that you love science fiction." This type of support and encouragement is what helped me stay confident and allowed me to keep being myself. I knew my tribe was there supporting me, holding my wings up even on days I didn't feel like flying.

I had people in my community who saw something special in me and pitched in to make sure I succeeded. I am very thankful that BLACK GIRLS ROCK! was supporting me very early on during that process, and that was no small thing, because I think I was able to get my confidence from platforms like this. I'm grateful to have a community of black women who supported my uniqueness, my messaging, and what I had to say and believed in it and awarded me before anybody else knew who I was or knew that I was going to have endorsements or be in movies.

Just appreciating the freedom, the power, and the agency that so many women didn't have generations before me, having that agency and that power and knowing that I am in full control of it, is what being a black girl with Black Girl Magic is all about.

I am not to be marginalized as an artist. I am a music lover; I think that music is different sounds, different lyrics and styles, and having the liberty to inspire so many people. Music brings people together, it unites people, and that's what I love. ◄

IYANLA VANZANT

I am a Black girl. My life is important. I am the continuation of a history, legacy, and tradition of powerful people. The lives of my foremothers now have meaning through me. I stand today because of who they were.

I am a Black girl. My presence is essential. I am a demonstration of the past, an inspiration for the future, and I represent the unlimited possibilities of the present moment.

I am a Black girl. I have a voice. I say the important things that need to be said. I do not waste my voice on gossip, slander, or disrespect of myself, my sisters, or other people. I know the power of the spoken word, and I use my words wisely.

I am a Black girl. I know my worth. I hold myself in high esteem because I value who I am. I treat myself with loving care, respect, and honor. I honor and hold sacred my mind, my body, and my heart.

I am a Black girl. I am committed and confident. I am committed to a future that holds great possibilities for me, my family, and the world. As I move confidently into my next most appropriate steps, I am inspired by life, and I inspire others.

I am a Black girl. I have a vision for myself and a vision for my life. It is a vision anchored in love, propelled by integrity, and advanced by faith. I am committed to learning how I can improve all aspects of myself so that I will be the best me I can be.

I am a Black girl. I am not intimidated by anyone or anything. I bow to no one and nothing save my Creator. I move with elegance, grace, and ease, effortlessly accomplishing all that I set my heart and mind to do when it serves my highest and greatest good.

I am a Black girl. My life is connected to a loving Creator who protects and guides me at all times. Therefore, I am humble and honorable; patient and powerful; focused and flexible; determined and dynamic; loved and loving.

I am a Black girl. I say it, therefore I am it!

I AM life overflowing!

I AM success manifesting!

I AM confidence in action!

I AM fearless and free!

I AM commitment that moves obstacles!

I AM inspiration unfolding!

I AM Pure Love!

I AM a Black girl, and I Rock!

ACKNOWLEDGMENTS

I am filled with immense gratitude for the remarkable and dedicated village of supporters who've helped me throughout this process.

I'd like to thank my marvelous agents at Innovative Artists—Ross Haime, Nevin Dolcefino, and Jim Stein—and my book agent, Rob Weisbach. Thank you all for being stewards of my career, for encouraging me to reach higher and dream bigger, for believing in my vision and work, and for telling me that there was a book waiting to happen.

Thank you to my extraordinary editor, Dawn Davis of 37 INK, for your thoroughness, persistence, and guidance throughout this process. You have challenged me and taken my work ethic and grit to new heights. To Albert Tang, thank you for delivering this amazing cover. To Amy Trombat, thank you for your bold and delicious interior designs. To Lindsay Newton, our liaison in this publishing process; Yona Deshommes; Tasha Hilton; and everyone at 37 INK, Simon & Schuster, and Atria Books who had a hand in this monumental project, I thank you for your extraordinary diligence and expertise.

I have to thank my squad of fearless, boss, bad women who have pushed me, helped me, and sustained me every step of the way toward bringing this work to completion. To my project manager, Candace Jones, aka "the whip cracker," thank you for your adeptness, for your nonstop push to keep pressure on the team to deliver, for your "can't-stop-won't-stop" work ethic, and for your insight, your ideas, your resourcefulness, and your commitment to seeing this project to fruition. To my licensing and clearances manager, Quan Lateef-Hill, thank you for your creativity, drive, professionalism, and steadfast dedication. To Glenda Smiley, from your uncanny ability to decipher my reflections and to help bring them to life with words to your patience with my quest for perfection, you've been instrumental in this entire process from book proposal to book completion. You are a brilliant and beautiful soul, and I thank you for bringing your light to this work. To Helen Collen, my "day-one" comrade, thank you for bringing your exquisite gift of photography to this book, and also for your constant encouragement, support, wisdom, strength, and dedication to all aspects of this project and the BLACK GIRLS

ROCK! movement. To the other dynamic women who supported the research, copy-editing, and transcription process—Raqiyah Mays, Autumn Marie, Destiny Jackson, and Akosua Oforiwaa-Ayim—thank you for your talent, time, and contributions.

To our fierce glam squad, Tamara Delbridge, Lola Okanlawon, Pekela Riley, Taniya Arrington, Whittany Robinson, Alexis Williams, and JoJo Rodriguez, thank you all for "preserving the sexy" by bringing your craftsmanship, discerning eye, talent, and overall magic to our photo shoots. To Stephen McBride: over the years you've captured my image in your incredible photography, and quite serendipitously you shot the iconic photo that became this book's cover. Thank you for seeing me, for encouraging me to be myself, and for always affirming my intrinsic beauty. I'd also like to give a special thanks to the über-talented Udo Spreitzenbarth, Barron Claiborne, Helen Collen, Sancha McBurnie, and all the other photographers who contributed stunning shots showcasing the regality of black women. To Wayland Chew, my fierce art director, thank you for providing the creative framework for the book's cover art.

To my publicist, Lisa Sorensen, and my legal team, Lisa Davis and Matthew Middleton, thank you for your wise counsel and tremendous moral support. Thank you to Michaela Angela Davis, Nancy Grossman, Dr. Ebonierose Wade, Donna Byrd, Dr. Kamau Bobb, Ruby Bond, Todd Brown, Eugene Jackson, Anders Urmacher, and all my other friends, family, and colleagues who listened to countless revisions and added input, offered suggestions, and gave honest feedback throughout my creative process. To Yvette Noel-Schure, Jay Brown, John Boggard, Caroline Adler Morales, Erica Tucker, Vanessa Anderson, Lord Kelli Andrews, Rebecca Sides Capellan, Gilda Squire, Deborah Byrd, Dolly Adams, Maury DiMauro, and all the people who worked with me to secure the contributions to this book, thank you for going above and beyond to help during this process. Thank you to Debra Lee and everyone at BET Networks for providing the opportunity to produce content that empowers, inspires, and uplifts black women and girls. You have helped me to affirm the message that BLACK GIRLS ROCK! by giving me a platform to celebrate and elevate black girl beauty, power, and brilliance on television for the world to see.

Thank you to all the Bond girls in my life who raised me, supported me, and loved me: my original blueprint for Black Girl Magic, my mother, Mary Arthorlee Bond; my grandmother Sarah Rosetta Bond; my aunt Frances Victoria Bond; and my great-aunt Mary Christine Bond. To my husband, who displays unwavering patience, love, and support for me and all my projects, thank you for encouraging me and allowing me the space and time to bring my ideas to life.

Last but not least: to the phenomenal women who are featured in this book, thank you for lending your voices to this movement. It's not enough to simply say that black girls rock—it's also important to create platforms and spaces that illuminate *why* and *how* we rock. By sharing your narratives, you've helped me document our collective magic. ⚡

PHOTOGRAPHY CREDITS

Afya Ibomu: Jack Manning of Jaxon Photo Group (p. 128)

Ana "Rokafella" Garcia: Yu Wadee (p. 153)

Angela Davis: Bettmann/Contributor (p. 80)

April Holmes: Bradley Wentzel (p. 160)

Audre Lorde: Robert Alexander/Getty Images (p. 16)

Ava DuVernay: BLACK GIRLS ROCK! Award images provided courtesy of BET Networks (p. 194)

Bethann Hardison: Romney Mueller-Westernhagen (p. 134)

Beverly Bond: Sancha McBurnie Photography (p. viii); Mary Arthorlee Bond, the Bond Family (p. xiii); Udo Spreitzenbarth (p. xvii); Sancha McBurnie Photography (p. 230)

Beyoncé: Daniela Vesco, Courtesy of Parkwood Entertainment, LLC (p. 2)

Bridget "Biddy" Mason: Public Domain (p. 70)

Cathy Hughes: On Behalf of Catherine L. Hughes and Radio One, Inc. (p. 44)

Danai Gurira: Jennifer S. Altman/Contour By Getty Image (p. 36); Frank W. Ockenfels 3 / CPi Syndication (p. 37)

Donna Byrd: Sancha McBurnie, Helen Collen Photography (p. 54)

Erykah Badu: Elizabeth Lavin (p. 20); Barron Claiborne (p. 25)

Eunique Jones Gibson: Eunique Jones Gibson, Because of Them We Can™ (p. 92)

Harriet Tubman: Collection of the Smithsonian National Museum of African American History and Culture (p. 79)

Haben Girma: Helen Collen Photography (p. 168)

Ibtihaj Muhammad: Daniel Shea (p. 208)

Issa Rae: Trae Patton/[1/08/2017]/NBC/NBCU Photo Bank via Getty Images (p. 188)

Janelle Monáe: Noam Galail Contributor (p. 216)

Jazmine Sullivan: Courtesy of HB/SFPL/IONE Digital (p. 126)

Jessica O. Matthews: Courtesy of Uncharted Play (p. 72)

Joan Morgan: Joan Morgan (p. 4)

Joy-Ann Reid: NBC Universal (p. 84)

Judith Jamison: Collection of the Smithsonian National Museum of African American History and Culture (p. 146)

Julie Dash: Arthur Jafa (p. 192)

June Ambrose: Mangue Banzima (p. 132)

Dr. Knatokie Ford: Sancha McBurnie, Helen Collen Photography (p. 58)

Lisa Jackson: Photo courtesy of Apple Inc. (p. 66)

Luam Keflezgy: Getty/AFP (p. 150); Trevor Undi (p. 152)

Lupita Nyong'o: Art Partners/Alexi Lubomirski (p. 120)

Luvvie Ajayi: Photograph by Whitten Sabbatini (p. 62)

Mara Brock Akil: Michael Rowe Photography (pp. vi, 176)

Mary J. Blige: DENNIS LEUPOLD PHOTOGRAPHY (p. 156)

Maxine Waters: Glenn Marzano Photography and the LAX Coastal Chamber of Commerce, July 4, 2016 (p. 108)

Maya Angelou: Bettmann/Contributor (p. 166)

Maya Penn: Ernest Washington (p. 204)

MC Lyte: Courtesy of MC Lyte (p. 104)

Melina Matsoukas: Stella Berkofsky (p. 198)

Melissa Harris-Perry: Antoine Braxton, Courtesy of Tell-A-Vision Films (p. 12)

Michaela Angela Davis: Helen Collen Photography (p. 118)

Michelle Obama: Courtesy of BET Networks (p. xx)

Mickalene Thomas: Stephanie Noritz (p. 14)

Missy Elliott: Atlantic Recording Corporation (pp. vi, 164)

Misty Copeland: BLACK GIRLS ROCK! Award images provided courtesy of BET Networks (p. 142)

Nana Yaa Asantewaa: Public Domain (p. 79)

Naomi Campbell: MARIO SORRENTI (p. 114)

Nina Simone: Jack Robinson/Archive Photos (p. 38)

Nzingha Stewart: John Allen Philips (p. 196)

Patrisse Cullors: Ryan Pfluger (p. 90)

Pauline Murray: AP Photo (p. 111)

Rebecca Walker: David Fenton (p. 8)

Regina King: Diana Ragland (p. 180)

Rihanna: DENNIS LEUPOLD PHOTOGRAPHY (pp. vi, 18)

Roberta Flack: ABC Photo Archives (p. 140)

Ruby Bridges: AP Photo/Anonymous (p. 214)

Serena Williams: Yu Tsai (p. 26); Courtesy of NIKE (p. 28)

Shonda Rhimes: ABC Disney (p. 182)

Solange Knowles-Ferguson: Carlota Guerrero (p. 40)

Sojourner Truth: Collection of the Smithsonian National Museum of African American History and Culture (p. 78)

Susan L. Taylor: Dwight Carter (p. 138); BLACK GIRLS ROCK! Award images provided courtesy of BET Networks (p. 138)

Suzanne Shank: Pix by Ameen (p. 48)

Sylvia Robinson: Michael Ochs Archives (p. 75)

Tamika D. Mallory: Women's March/Alex Arbuckle (p. 96)

Tatyana Ali: Brent Weber (pp. vi, 184)

Terrie Williams: Dwight Carter (p. 172)

Toshi Reagon: Kevin Yatarola, Lincoln Center for the Performing Arts (p. 100)

Tracee Ellis Ross: Ruven Afanador/CPi Syndication (pp. vi, 30)

Valerie June: Jacob Webb (pp. vi, 32)

Venus Williams: Sal Sued Photography (p. 52)

Yara Shahidi: Vijat Mohindra/CPi Syndication (pp. vi, 212)

Zora Neale Hurston: Zora Neale Hurston Papers, Special and Area Studies Collections, George A. Smathers Libraries, University of Florida, Gainesville, Florida (p. 201)

BLACK GIRLS ROCK!: REMIXING THE REVOLUTION

At the 1851 Women's Rights Convention held in Akron, Ohio, Sojourner Truth delivered one of the most famous abolitionist and women's rights speeches in American history, "Ain't I a Woman?" Her question called out the hypocrisy of the first-wave feminist movement, which overlooked the human rights struggles of black women and other women of color. As a movement, BLACK GIRLS ROCK! challenges racist and sexist structures by confronting Sojourner's underlying questions, "Aren't we women? Aren't we human? Don't we matter? Don't we deserve justice?" BLACK GIRLS ROCK! is a modern womanist movement that was born out of the sheer need to address the marginalization and dismissal of black women's narratives, images, and contributions to society. Since 2006, BLACK GIRLS ROCK! has been remixing the revolution by instilling a sense of purpose, pride, and empowerment in a generation of girls and using media to showcase renaissance black women's excellence for the entire world to witness and emulate. BLACK GIRLS ROCK! ultimately follows the visionary, revolutionary, and humanistic work of Sojourner Truth, Fannie Lou Hamer, Barbara Jordan, Ida B. Wells, Mary McLeod Bethune, and many other sheroes who advocated for black people and who exhibited incredible resolve, unique wisdom, courageous character, unyielding spiritual fortitude, and unwavering resilience in the face of adversity. *BLACK GIRLS ROCK!* unveils the author's approach to women's empowerment and highlights her unique journey building one of the most impactful and influential women's movements of our time.

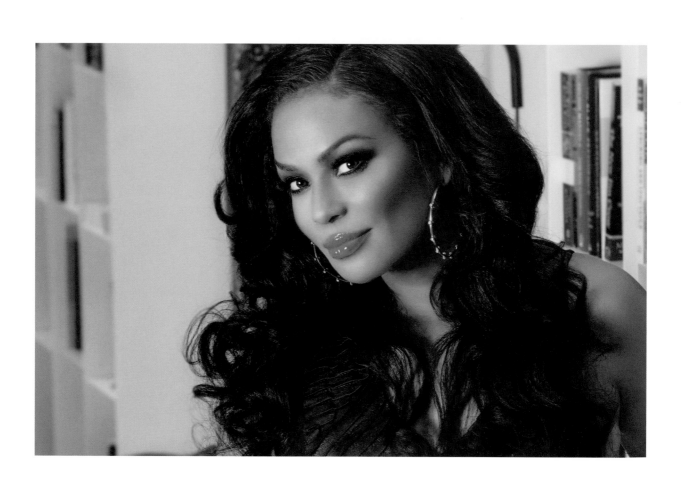

ABOUT BEVERLY BOND

Beverly Bond is an entrepreneur, television producer, celebrity DJ, cultural curator, and social innovator. She created the BLACK GIRLS ROCK! Awards in 2006 to celebrate the excellence and dynamism of black women across sectors and to counter the culture of negative media messages directed toward women of color. In 2010, Bond took the award show to BET to share its empowering message on a worldwide stage. Bond's multifaceted global platform now reaches more than fifteen million viewers annually, has garnered over a half billion media impressions, and is the recipient of two NAACP Image Awards and a Gracie Award. Beverly Bond also founded BLACK GIRLS ROCK! Inc., a 501(c)3 nonprofit organization that encourages positive identity development for black girls and offers tools to reaffirm their value, self-esteem, and self-worth. Bond's work as a thought leader has earned her a number of prestigious recognitions: *Ebony* magazine has named Bond to its Power 100 list of the "Most Influential Blacks in America," placing her in the company of such notables as President Barack Obama, First Lady Michelle Obama, Oprah Winfrey, Queen Latifah, Beyoncé, and Dr. Cornel West. Bond has shown a talent for success as she crafts a winning blueprint for women's empowerment. Her work stretches far beyond ordinary boundaries and is a true testament to reaching for the stars.